Black
Artists in
America

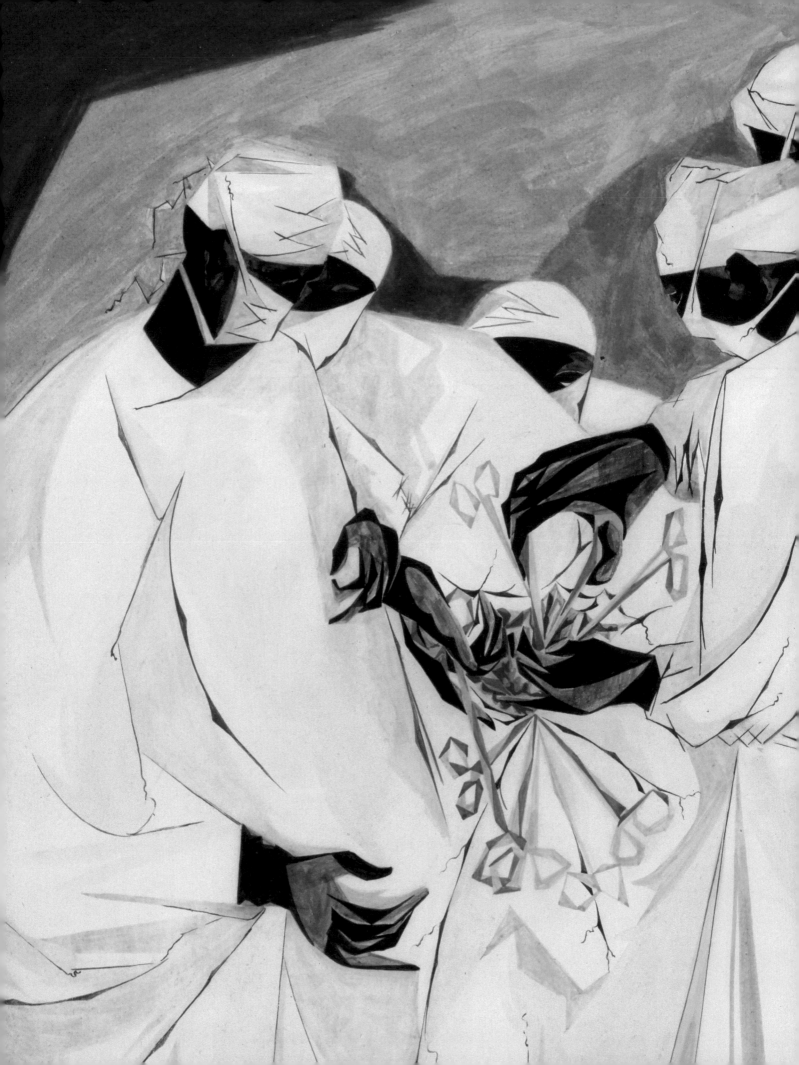

Black Artists in America

From the Great Depression to Civil Rights

Earnestine Lovelle Jenkins

Dixon Gallery and Gardens

In association with
Yale University Press, New Haven and London

Contents

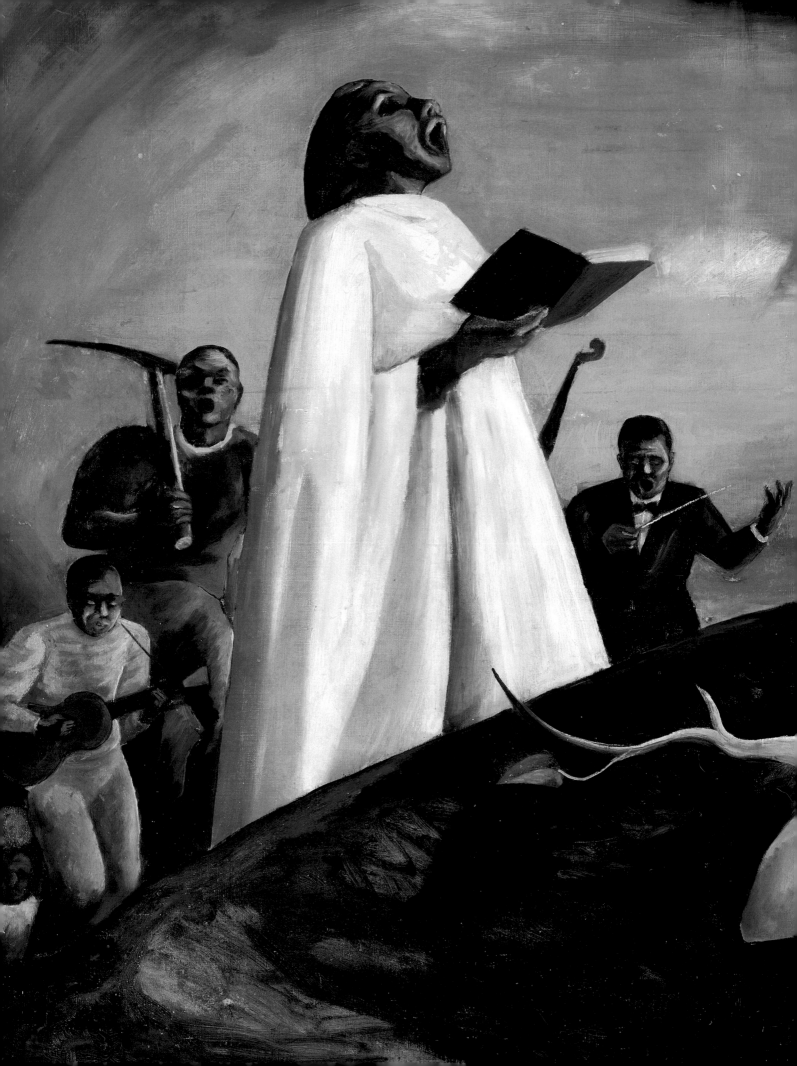

Foreword and Acknowledgments

Black Artists in America: From the Great Depression to Civil Rights is the first in a suite of three linked exhibitions and publications that will examine the African American experience in the visual arts through the last seventy years of the twentieth century. One of the most ambitious exhibition programs the Dixon has ever conceived, the series of three shows will be on view in Memphis in autumn 2021, 2023, and 2025, and we fully expect the second and third installments to travel to other museum venues as well.

Throughout the twentieth century, Black artists in the United States produced powerful works of art that expressed the joys, anxieties, social changes, economic upheavals, global conflagrations, and aesthetic concerns of the times during which they lived. That so many of their accomplishments went unrecognized by the White mainstream media, the equally White art market, and the even Whiter culture of American art museums only makes these achievements more impressive.

The first iteration of *Black Artists in America* begins with the collapse of the stock market in 1929 and the subsequent devastation of the American (and much of the world's) economy. The Great Depression interrupted one of the most powerful aesthetic flowerings this country has ever produced, the Harlem Renaissance, and thrust many artists into poverty and hardship. Federal support for artists during the Depression years—in the form of murals and other commissions—was by no means meted out fairly or equitably. And across the nation, especially in the American South, the Depression years ushered in a virulent surge in racism, White supremacy, and racial violence that had lain relatively dormant during the prosperous 1920s.

Black Artists in America further explores the works of art produced amid the dangers and privations of the Second World War. A period of patriotic fervor in which many Black artists shared, the war years saw racist policies in the American military and in the broader war effort, compounded by missed

opportunities for meaningful social progress. At the same time, some Black artists who had served in the war returned to a broad aesthetic shift toward abstraction that was not only bewildering but also convention shattering. The exhibition ends in the 1950s with the conservativism of the immediate post-war era and the emergence of a burgeoning civil rights movement.

Our guide on this journey across three crucial decades of the American twentieth century is Dr. Earnestine Lovelle Jenkins, Professor of Art History at the University of Memphis. Dr. Jenkins brought her usual rigor to the subjects she explores here as she shares carefully wrought insights into the lives and careers of sometimes inexplicably neglected artists. She is as generous and thoughtful a colleague as anyone could ever know. I offer the sincerest thanks of the staff and board of trustees of the Dixon Gallery and Gardens, and my own personal gratitude, to Dr. Jenkins for the outstanding work she has produced on our behalf. It has been a pleasure working with her.

While *Black Artists in America: From the Great Depression to Civil Rights* traces its origins as a project to as early as 2017, a good deal of the work Dr. Jenkins and the Dixon team did in building a definitive checklist, requesting and negotiating loans, and writing, editing, and designing the handsome publication you now hold was done under the pressures of the pandemic. With the stress COVID-19 placed on colleagues, collectors, and institutions across the country, we encountered dozens of challenges in the organization of this show. Among them was the regrettable withdrawal of two museum partners who would have been venues for the exhibition. Early in 2020, we were confronted with the decision of whether to go on with the show alone or defer until another time. Ultimately, we elected to hold firm to our dates and to present the exhibition at the Dixon only. While this decision created difficulties of its own, it also allowed us to consider more fully how Memphis, our iconic Southern community, factored into the larger themes of *Black Artists in America*.

Dr. Jenkins is not only a brilliant scholar of international stature, but she is also a Memphis native with a lifetime of experience and myriad contacts. We owe to her connections in Memphis some of the more intriguing works in the show. Late in 2020, Dr. Jenkins introduced us to Professor Phillip Dotson, a talented painter and longtime head of the art department at LeMoyne-Owen College, an HBCU in Memphis. Dr. Dotson shared with us the marvelous works of art and extraordinary archives at the college, and some of those objects found their way into the exhibition. We are very grateful to Professor Dotson for his aid and hospitality; to then-acting President of LeMoyne-Owen, Carol Johnson-Dean, who graciously greeted us during our first visit; and to the newly appointed president, Vernell Bennett-Fairs. The Dixon looks forward to further deepening our relationship with the faculty, staff, students, and leadership of LeMoyne-Owen College during the run of the exhibition and beyond.

Dr. Jenkins also introduced us to the leadership of the Second Congregational Church, a historically significant place of worship in Memphis that is only steps away from LeMoyne-Owen College. In the mid-1950s, Second Congregational commissioned Reginald Morris, an artist and professor at LeMoyne-Owen, to paint a five-panel mural for the altar of the church. In the autumn of last year, as the pandemic was surging in Memphis, members of the congregation kindly invited us to see the remarkable painting cycle hanging behind the church altar. Within mere days of the meeting, Second Congregational Church had generously agreed to lend this significant group of paintings to the Dixon. We very much appreciate the spirit of generosity and cooperation that Second Congregational has shown, and we extend our deepest thanks to Ronald A. Walter, a well-known Memphis news director

and a trustee of the church, for spearheading what for them must have been a rather unusual request. We also thank the Reverend Carrie Moore Black, Mr. Clarence Christian, and the entire congregation for their support of *Black Artists in America*.

Given the many difficulties the pandemic has caused, the Dixon Gallery and Gardens is very grateful to our colleagues at other museums across the country, who made tremendous efforts to support this project. It was not always easy for them, but these marvelous colleagues came through for *Black Artists in America* again and again, and we thank them for their dedication and generous spirits. At this time, I offer the Dixon's thanks to Larry Anderson, Sara Arnold, Baxter Buck, Chris Chapman, Patrina Chatman, Jane Dini, Jennifer Draffen, William U. Eiland, Maria Ferguson, Turry Flucker, Noa Fodrie, Nigel Freeman, Rosamund Garrett, Jennifer Gaudio, Shawnya Harris, halley k harrisburg, Christopher Harter, Tyler Hennings, Catrina Hill, Ashley Holland, Elizabeth Hopkin, Susan and John Horseman, Robin Howard, Rebecca Kim, Anastasia Kinigopoulo, Sabine Kretzschmar, Emily Neff, Nancy T. Nichols, Heather Nickels, Thom Pegg, Kimberly and Elliot Perry, James Rondeau, Melissa Samson, Michael C. Simon, Virginia Spottswood Simon, Christy Sinksen, Anne Collins Smith, Stephanie Spottswood, David Stark, Lily Sterling, Vanessa Thaxton-Ward, Amy Tobert, Janis A. Tomlinson, Erika Umali, Megan Valentine, Rachel Vargas, and Claudia Volpe. Dr. Jenkins wishes to particularly thank the staff at the Stuart A. Rose Manuscripts, Archives, and Rare Books Library at Emory University.

As we began planning the catalogue for *Black Artists in America*, we knew we would be wise to turn to our friends at Lucia | Marquand to bring our vision to life. We want to thank Melissa Duffes, Adrian Lucia, Heather Medlock, Ryan Polich, and Kestrel Rundle for their creativity, organization, and especially for their patience as we put this catalogue together during a pandemic. Our gratitude also goes to Amy Canonico at Yale University Press for believing in the importance of this project and helping to get this book into many more hands than the Dixon could have done alone.

The staff of the Dixon Gallery and Gardens is small but potent, and each team member contributes to the success of every exhibition we produce. I would like to take this opportunity to thank Miguel Alcantar, Charmeal Alexander, Christan Allen, Melvin Avendano, Helen Benoist, Juliana Bjork-lund, Melissa Bosdorf, Charlie Bryan, Sarah Catmur, Mary Kathryn Davis, Chantal Drake, Jenny Duggan, Chris Emanus, Erika Fuller, Jeff Goggans, Allison Hopper, Gail Hopper, Susan Johnson, Robert Jones, Kristen Kimber-ling, Sarah Lorenz, Norma Montesi, Glenn Overall, Lorenzo Perez, Julie Pierotti, Kristen Rambo, Kim Rucker, Margarita Sandino, Linley Schmidt, Charlotte Sechrist, Corkey Sinks, Dale Skaggs, Hadeer Solimon, Karen Strachan, Danielle Sumler, and John T. Wilbanks. Your hard work, especially in the year and a half leading up to the opening of this exhibition, is appreciated more than you know.

The Dixon's ambitious exhibition program is supported each year by a dedicated community of donors. Our thanks go to the Joe Orgill Family Fund for Exhibitions, Art Bridges, Alice and Phil Burnett, Karen and Preston Dorsett, the Theodore W. and Betty J. Eckles Foundation, Lucy Buchanan Garrett and Sam Young Garrett Jr., Amanda and Nick Goetze, Susan and John Horseman, Rose M. Johnston, Anne and Mike Keeney, Dorothy O. Kirsch, Nell R. Levy, Debbie and Chip Marston, Dina and Brad Martin, Mrs. Estella Mayhue-Greer and Dr. Joe C. Greer, Harriet and Jake McFadden, Nancy and Steve Morrow, Gwen and Penn Owen, Chris and Dan Richards, Trish and Carl Ring, Charlotte and Todd Robbins, Dr. R. Lemoyne Robinson, the Mary and Jeff Simpson Charitable Trust, Barbara and Vernon Stafford, Carol and Chip

Westbrook, and Barbara and Lewis Williamson for making this exhibition and publication possible through their generosity. We are also very grateful to the great people at First Horizon Bank and their generous support through ArtsFirst.

Early in 2021, the Dixon engaged a group of dynamic women in Memphis to help ensure that *Black Artists in America* reached as many people in our community as possible. We are grateful to Kontji Anthony, Essie Arrindell-Williams, Ruby Powell Dennis, Whitney Hardy, Earnestine Jenkins, Estella Mayhue-Greer, Mary McDaniel, Kimberly Perry, Arianna Poindexter, Markova Reed-Anderson, Phyllis Sims-Roy, Barbara Stafford, Shayna Steward, Kim Thomas, Sharon Wheeler, and Verushka Wilson for being such effective and enthusiastic ambassadors for this project.

The Dixon believes that the power of diversity, more than any other quality or virtue, is essential to our strength and to making us the best institution we can be. For more than a decade we have showcased Black, Latino, and Asian American artists' achievements in the visual arts. In doing so, we have been rewarded with very compelling experiences, including *Ancestry and Innovation: African American Art from the American Folk Art Museum* (2008), *Richmond Barthé: His Life in Art* (2010), *Jonathan Green* (2012), *Ashe to Amen: African Americans and Biblical Imagery* (2013), *Jun Kaneko: Sculpture at the Dixon Gallery and Gardens* (2015), *El Taller de Gráfica Popular: Vida y Arte* (2018), *Augusta Savage: Renaissance Woman* (2020), and a dozen other relevant shows. Now we bring you *Black Artists in America: From the Great Depression to Civil Rights*, with the promise of more to follow.

Kevin Sharp
Linda W. and S. Herbert Rhea Director
Dixon Gallery and Gardens

Black
Artists in
America

From the
Great Depression
to Civil Rights

Black Artists in America

From the Great Depression to Civil Rights

During the first half of the twentieth century, Black artists aggressively pursued their interests in the visual arts despite the systemic racism that locked them out of the segregated mainstream art world.[1] The Harlem Renaissance began in the 1920s and extended into the 1930s, promoting racial pride, progressive politics, cultural self-expression, economic independence, Americanism, and a broader international awareness of Africa. Black artists engaged deeply with the art movements of their time. They experimented with European aesthetic innovations, African American arts and visual cultures, visual traditions indigenous to the Americas, and African cultural forms. This was also a period when many Black students earned undergraduate degrees in the field as well as graduate degrees in art education and art history. Such academic work laid the foundations for a tradition of instruction and academic research by artists, educators, and art historians who would go on to teach generations of Black youth and promote scholarly research. *Black Artists in America: From the Great Depression to Civil Rights* investigates early twentieth-century African American art contextualized against the backdrop of the major global historical events of the period: the Great Depression, World War II, and the modern civil rights movement.[2]

American expatriate artist Henry Ossawa Tanner (1859–1937) occupies a pivotal position in the history of American art. Having attained international acclaim during the first three decades of the twentieth century, Tanner was revered by African American artists. He mentored a number of pioneering formally trained artists who sought him out in Paris, including William Harper, William Edouard Scott, and Albert H. Smith, as well as the younger generation after the Harlem Renaissance subsided: Aaron Douglas, Palmer C. Hayden, James Porter, and Hale Woodruff.

Tanner likewise earned acclaim in his hometown of Pittsburgh. He was influenced by his parents' and his community's religious faith, centered

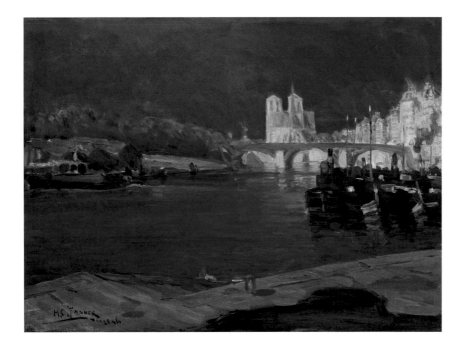

Fig. 1 Henry Ossawa Tanner (American, 1859–1937), *View of the Seine, Looking toward Notre-Dame*, 1896. Oil on canvas. Dixon Gallery and Gardens; Museum purchase in memory of Joe Orgill with funds provided by an anonymous donor, 2018.4.

Fig. 2 Charles "Teenie" Harris (American, 1908–1998), Two men unveiling Henry O. Tanner painting *Christ and His Mother*, with musicians in foreground, Centre Avenue YMCA, ca. 1938–45. Black-and-white Agfa safety film. Carnegie Museum of Art, Teenie Harris Archive, Heinz Family Fund, 2001.35.1193.

in the African Methodist Episcopal church. He became a renowned painter of religious subjects, experimenting throughout his career with techniques and materials that increasingly emphasized the spiritual intensity of his work (fig. 1).[3] Beginning in the 1930s, Charles "Teenie" Harris, the preeminent Black photographer for the *Pittsburgh Courier*, began to document Tanner's paintings where they appeared in significant cultural spaces in the city's Black community (fig. 2). His photographs preserve how Black audiences in Pittsburgh maintained a historical connection with Tanner, solidifying a long experience with African American art, artists, and art history.

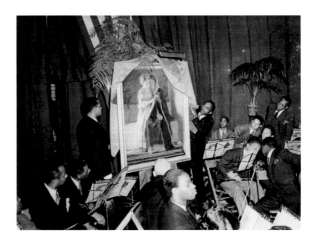

The Great Depression and Social Realism

Black Artists during the Great Depression

Over the course of the Great Depression, working-class Americans lost many of the few rights they had once enjoyed. The most destitute were the hard-core unemployed (a term popularized in the 1960s to describe the concept of structural unemployment), a class that included people homeless before the Depression, laborers, criminals, workers above the age of forty-five, and minorities. Black Americans faced extensive hardships due to job discrimination, especially within the trade union movement and public utilities. The National Association for the Advancement of Colored People (NAACP) adopted a strategy of providing legal assistance to African Americans treated unjustly in the court system, given that the legislative and executive branches of government were unlikely to promote desegregation in the political climate spawned by the Great Depression. The NAACP also prioritized morale and support as well as equal access to education.

The 1930s were also defined by the Great Migration as Black Americans left the rural South in search of opportunities in cities across the country.[4]

After the Civil War, White mob violence during Reconstruction and the disenfranchisement of Black Americans linked to the spread of Jim Crow laws had initially driven Black flight from the rural South. The outbreak of World War I in 1914 created a demand for industrial laborers in the North that likewise fueled Black migration. By 1919 about one million Black residents had left the South. The history of Black migration was a major theme in the cultural work associated with the Harlem Renaissance, that period of artistic activity originally known as the New Negro Movement.

Walter Ellison (1899–1977), featured in this exhibition, visualized his family's migratory experience from Georgia to Chicago during the 1920s. Ellison depicted the impact of moving North and the challenges of living through the Great Depression in works including *Train Station* (1936), *Old Policy Wheel* (1936), and *Just Business* (ca. 1940; cat. 14), the latter two of which depict an aspect of the numbers, or policy, game—a form of illegal gambling played mostly in poor and working-class communities in the United States.[5] The term *policy* also refers to a type of cheap insurance associated with taking a chance on the future.

Just Business depicts the interior of a Chicago church that also operates as a betting parlor. During the 1920s and 1930s, people favored the older, more complicated policy game, which was linked to the development of Black enterprise. An important part of legitimate business, policy became a vital source of employment, an organizing component of politics, and a mainstay of working-class leisure activity. By the 1940s the policy game was the best organized and most popular type of gambling on the South Side of Chicago, where it was controlled by Black operators and thus undergirded an emerging Black political machine.[6]

In postwar Chicago, Black gambling politics was beset by the reformist agenda of the mayoral administration, White organized crime figures, and the manipulation by the police force of older protection deals in their attempts to claim a greater share of the illegal income. In Ellison's painting, the congregation is divided between people, mostly women, sitting toward the front of the church, listening to the preacher in the pulpit, while the attention of those in the back pew is given to the runners and the "teller" in the number bank window in the foreground. Ellison's interpretation of Black gambling practices documents the inherent tensions between illegal activities, notions of middle-class respectability, and Christian values. The painting also demonstrates how these tensions were exacerbated by changes during the postwar era.

Throughout the Great Depression, the federal government was the major patron of the arts. President Franklin D. Roosevelt's New Deal employed millions of citizens through the Works Project Administration and numerous visual artists through its Federal Arts Project. Artists created easel paintings, murals, graphic arts, posters, sculptures, theatrical designs, photographs, and crafts.

WPA funding enabled artist Allan Rohan Crite to initiate an in-depth project interpreting the historic African American community where he had grown up: Boston's South End. In his own words, he painted the South End's inhabitants "as I saw them, as human beings, just ordinary human beings, having ordinary lives."[7] Crite rejected what he called a preoccupation with race as an interference with his work. He argued that the ordinary human being going to work and coming home to wash the dishes was invisible in the broader American culture. He was influenced by Flemish art, including Pieter Brueghel the Elder's depictions of social life in sixteenth-century Belgium. Crite believed it was important to present Black people within the context of their "Christian dignity," a type of visual storytelling that "proclaimed the good news of the Gospel."[8]

Cat. 14 Walter Ellison, *Just Business*, ca. 1940; The John and Susan Horseman Foundation for American Art

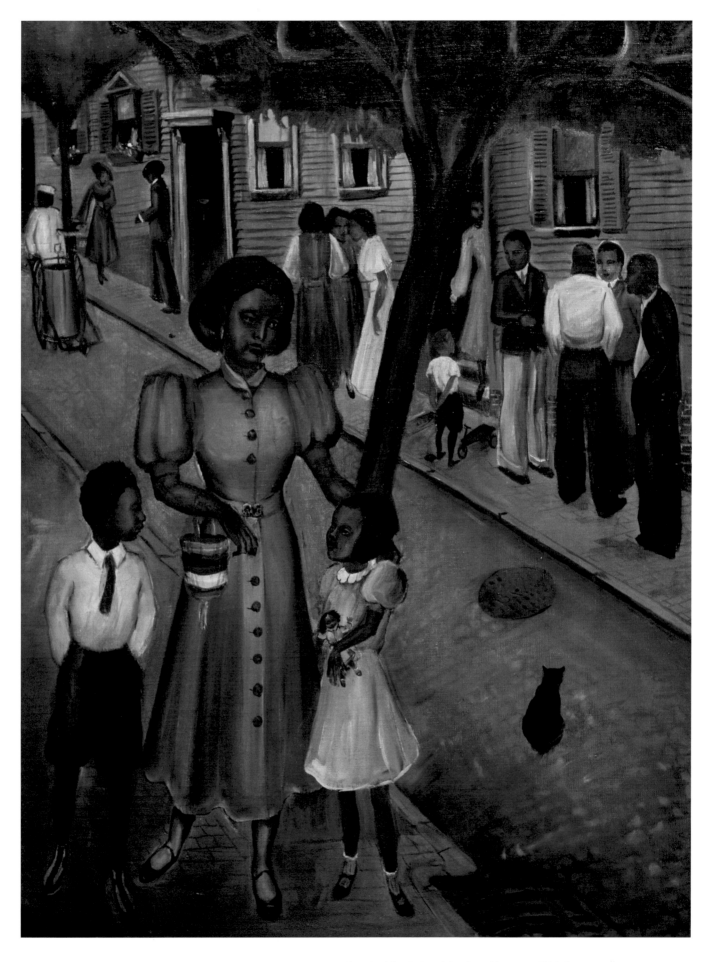

20 **Cat. 4** Hale Woodruff, *Untitled (Autumn in Georgia)*, 1931; University of Delaware

Crite's *Late Afternoon* of 1934 is a vibrant representation of the everyday rituals of urban life (cat. 5). People return from work and walk their children home from school. The dwellings appear to be row houses constructed with shared walls, but they are neatly kept, with flowerboxes in the windows. The young mother in the foreground is fashionably dressed. Her children are dressed neatly: the son wears short pants, white shirt, and tie, while the daughter, outfitted in bright yellow, holds a Black doll with pigtails. American neighborhoods in the 1930s and 1940s were segregated, but there was, as Crite points out in his community depiction, a diversity of peoples and cultures crossing those boundaries. The Black citizens in Crite's paintings led productive, dignified lives despite Jim Crow and the Great Depression. In documenting the local, Crite documented the universal in humanity.

The Enduring Legacy of Social Realism: Black Perspectives

Social Realism developed as an important art movement that best challenged the distressed economic and social conditions of the 1930s.[9] Many artists employed by the WPA aligned themselves with Social Realism and addressed poverty, the plight of the working class, and the disenfranchised in their work. Painters, actors, writers, photographers, printmakers, filmmakers, and dramatic performers viewed the arts as a means of critiquing the power structures behind the sociopolitical conditions of the poor and working class. Social Realism remained the dominant art movement into the 1940s until the advent of Abstract Expressionism.

American visual artists were influenced by the political undercurrents of the Mexican Muralist movement. During the 1930s, Diego Rivera and José Clemente Orozco were living in American cities where they carried out major mural projects and trained students. Social Realism, sometimes absent its more radical overtones, was generally encouraged under the New Deal because of its focus on American themes. The related style called American regionalism likewise arose during the 1930s. Artists characteristically depicted realistic images of small towns and rural spaces, predominantly in the Midwest. As seen in *Autumn in Georgia* (1931; cat. 4), artist Hale Woodruff experimented with these ideas at the beginning of his career as an art educator. After studying in Paris, Woodruff moved to Atlanta, where he sought to make European modernism relevant to Black students in the South.

Lynching

Leftist influence during the 1930s made it possible for Black art to tackle sociocultural issues like racial violence and domestic terrorism to effect social change. A diversity of artists increasingly experimented with imagery that attacked the brutality and oppression of lynching. Two anti-lynching art exhibitions were curated in 1935.[10] The first, *An Art Commentary on Lynching*, was organized by Walter White, Director of the NAACP, along with the College Art Association. White drew on the power of the arts to publicize and support the Costigan–Wagner Bill, anti-lynching legislation introduced for the first time in Congress in 1934.[11] The second show, *Struggle for Negro Rights*, was organized by communist-affiliated groups including the John Reed Club, the Harlem-based Vanguard group, and the International Labor Defense, as well as leftist members of the Artists' Union.

This exhibition includes a work by Vertis Hayes that contains an unusual depiction of a lynching. In *The Lynchers* (ca. 1930s; cat. 1), Hayes does not reveal the mutilated Black male body in the scene. Instead, he shows closeup views of the faces of White witnesses and perpetrators of the horror, framed by the low-hanging branches of the lynching tree. It is a multigenerational view of

old, middle-aged, and young adults, as well as innocent children. The focal point is the oldest figure in the painting, probably the grandfather of the two children standing in front of him. The young, blonde-haired, blue-eyed girl looks up at the body of the Black man hanging from the tree, all the while clasping her doll to her chest; the younger sibling refuses to look. He casts his eyes to the ground.

Black Artists in America also features Hale Woodruff's chilling linocut print Giddap (1935; cat. 8).[12] It is one of eight woodblock prints (see figs. 3–8) in his series about Black life in the American South, two of which confront lynching: Giddap and By Parties Unknown (1935; cat. 9). Both linocuts were entered in the exhibition An Art Commentary on Lynching. Giddap presents the precise moment of the lynching, activated by the word in title, a command used to urge a horse or mule into action. The Black man gags from the noose tightening around his neck, his hands tied behind his back. The White mob, made up of both women and men, directs violent gestures toward the lynched victim. Violence is likewise inflicted on the mule (identifiable by the long ears), who is about to be whipped by the White driver to make him lurch forward. Woodruff's tilted perspective and stark white-and-black contrasts heighten the criminality of the act, which takes place in the dark of night. Similar stylistic techniques make By Parties Unknown just as brutal. The depraved White mob has dumped the Black man's body on the steps of a Black church. In both pieces, Woodruff not only captures the precise moment of a lynching and its aftermath but makes the viewing audience complicit in the crime.

Black Artists and the WPA
Initially, very few Black artists participated in the Works Progress Administration programs. African American artists in New York City formed the Harlem Artists Guild to protest discriminatory practices. They successfully pressured the WPA to hire a record number of Black artists. The work of many of these artists demands further research.[13] For instance, Elmer W. Brown (1909–1971) worked for the WPA during the 1940s in Cleveland, Ohio (fig. 9). After serving time in prison, he found a home at Karamu House in the city, where he was able to study and develop above-average talents in painting, graphic design, drawing, and printmaking. Brown was hired by the WPA program in Cleveland, where he completed several major mural and sculpture projects, all firmly rooted in Social Realism: a mural for the Valleyview housing project, a relief sculpture for the Columbus Housing Project, and murals with artist Paul Riba for the Cleveland Hopkins Municipal Airport Administration Building.[14] In 1942 he was commissioned to create the mural Free Speech, whose theme was equality, for the Cleveland City Club. In 2019 the murals Cleveland Past and Cleveland Present, created for the Valleyview housing project in 1941, were removed, restored, and given a new home in the student center at Cleveland State University.

American themes were consistent throughout Elmer Brown's work, as in the powerful linocut Fifteenth Defense, a depiction of Joe Louis, who became the world heavyweight champion after he beat James Braddock in 1937 (fig. 10). This turned Joe Louis into an icon of Black achievement during the Great Depression. Scientist George Washington Carver and World War II hero Dorie Miller (Dorie Miller at Pearl Harbor) were other examples of the type of prominent cultural figures Brown represented during the 1930s.

Brown treated the Black working class as equally important subject matter, as observed in his painting Gandy Dancer's Gal (1941; cat. 23). In AlabamaNorth: African-American Migrants, Community, and Working-Class Activism in Cleveland, 1915–45 (1999), the painting is used as an illustration, with the description "Elmer W. Brown's depiction of a rent party in 1930s

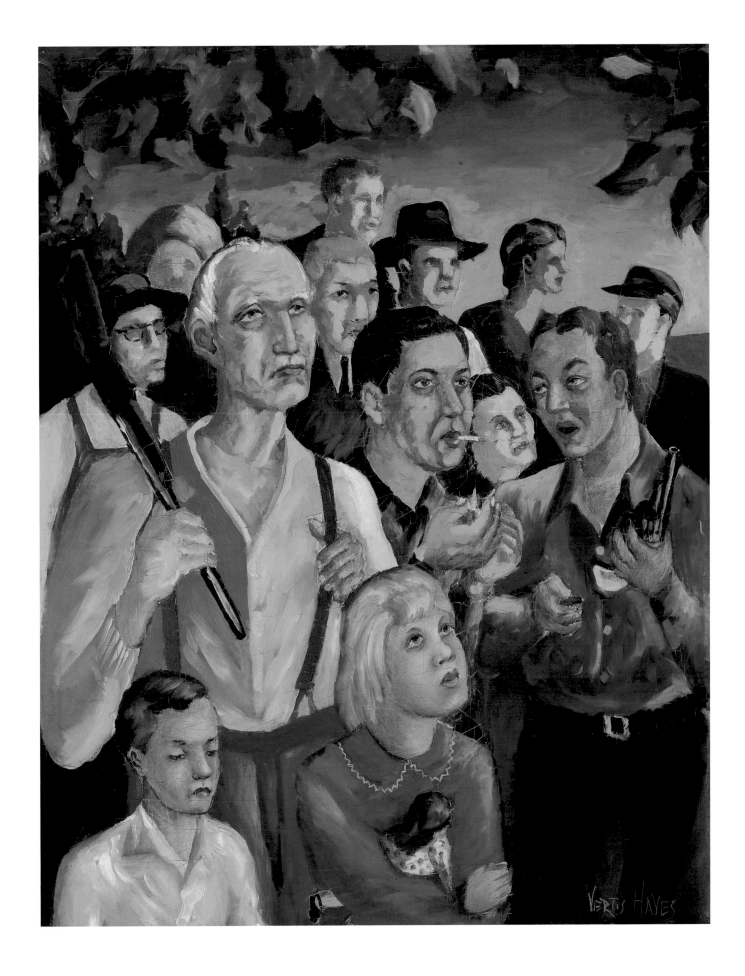

Cat. 1 Vertis Hayes, *The Lynchers*, ca. 1930s; Georgia Museum of Art 23

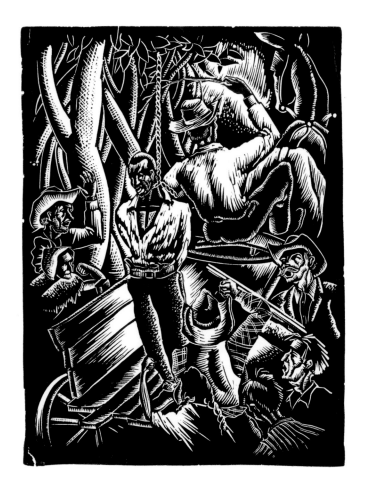

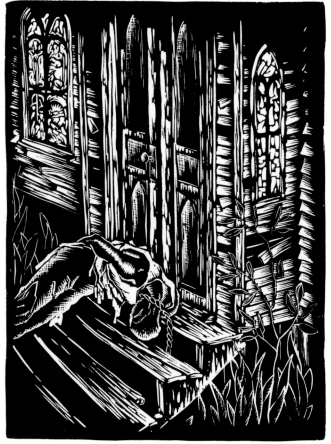

Cat. 8 Hale Woodruff, *Giddap*, 1935; LeMoyne-Owen College

Cat. 9 Hale Woodruff, *By Parties Unknown*, 1935; LeMoyne-Owen College

Figs. 3–8 (opposite, left to right, top to bottom)
Hale Woodruff (American, 1900–1980), *Relics*, *Coming Home*, *Sunday Promenade*, *Trusty on a Mule*, *Country Church*, and *African Headdress*, 1935. Linoleum cut with chine collé, variable dimensions. LeMoyne-Owen College.

Cleveland."[15] I argue that this not a rent party situated in a domestic setting. Rather, it takes place inside a railroad car with men dressed in the blue-jean overalls and caps of railroad workers. Strong, full-bodied Black figures display some of the aspects of the social life linked to migratory railroad workers. Brown's title is likewise informative. "Gandy dancers" were the section hands, predominantly Black men, who laid and maintained railroad tracks before the work was taken over by machines. It was skilled, hard, manual labor, indicated by the shovel handle in the right foreground, opposite the swollen, misshapen foot of the man resting on his bunkbed. The work is unromanticized and direct in its inclusion of sexual content. Elmer Brown was familiar with the hardships of this lifestyle. He served time on a chain gang in a Missouri state prison for illegally jumping freight trains.[16]

Aesthetically, Brown's cropped, closeup composition is strikingly similar to interior railroad car scenes in *Nothing But a Man* (1964), a landmark film about the Black experience in the South from Jewish director Michael Roemer (fig. 11).[17] Roemer escaped Nazi Germany during his childhood and brought such sensibilities to his film, made at the height of the civil rights movement. Black women play a diverse range of characters beyond the one-dimensional type portrayed in Brown's painting. Duff, the main protagonist, played by actor Ivan Dixon, aspires to more than the hard life of a section hand. He marries a middle-class schoolteacher, played by jazz great Abbey Lincoln (fig. 12). Together, both would become influential in the local civil rights movement in Birmingham, Alabama. Linked historically and as part of American visual culture, the painting and the film bookend each other, mirroring the social movements of the radical 1930s with the civil rights movement of the turbulent 1960s.

The subject matter in Brown's *Gandy Dancer's Gal* is the same depicted in Palmer C. Hayden's *Ballad of John Henry* series, begun in 1944 (fig. 13). Over the next ten years, Hayden completed twelve paintings depicting the life of John Henry, the Black American folk hero symbolizing the exploitation

Fig. 9 Unidentified artist, photograph of Elmer Brown painting WPA mural, ca. late 1930s.

Fig. 10 Elmer Brown (American, 1909–1971), *Fifteenth Defense*, 1930s. Linocut. Russell and Rowena Jelliffe Collection, Michael Schwartz Library, Cleveland State University, Ohio.

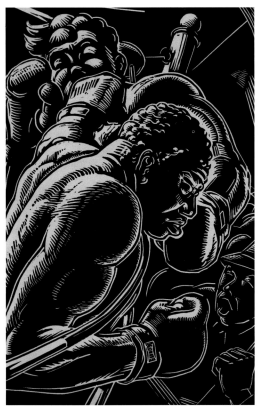

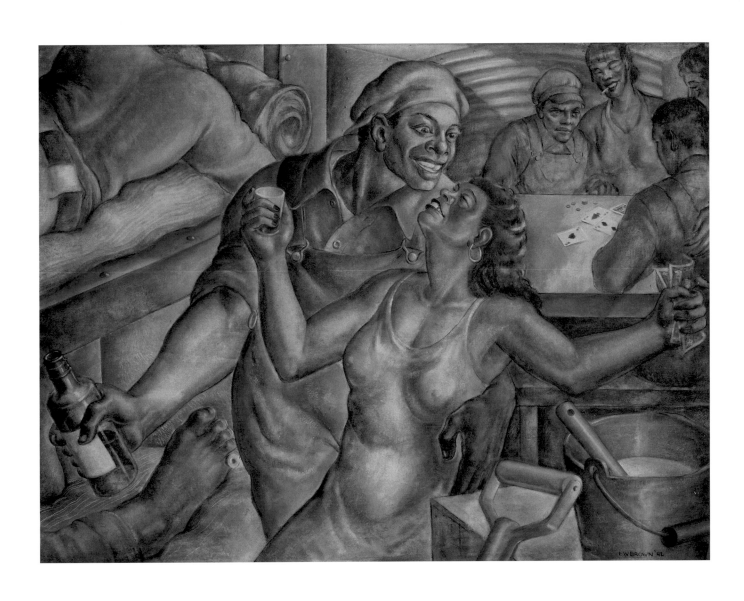

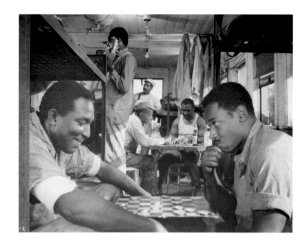

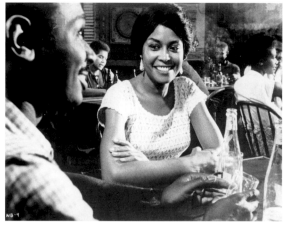

of Black male labor. Palmer romanticized John Henry as a mythical Paul Bunyan type of figure. John Henry stands tall and larger than life, with head and shoulders above the mountainous horizon; behind him, railroad tracks recede into the distance.

Black printmakers Claude Clark and Dox Thrash found that working with the WPA allowed the expression of Social Realist themes and experimentation with new technologies. Clark worked with the WPA from 1939 through 1942. Influenced by the Mexican muralists and their commitment to making art for the people, Clark joined the graphic arts shop with the Philadelphia WPA, where he became acquainted with Dox Thrash. While Clark examined issues of race and identity, his works also celebrate Black everyday culture. African American dance traditions were prevalent themes. *In the Groove* (1934–43; cat. 7) radiates an exuberant spirit and joy of movement characteristic of Clark's dance scenes detailing urban life in Black communities. *The Runner* (1945; cat. 29), as well, is representative of how many of Clark's works emphasize strength, persistence, and pride in African American heritage and achievements.

Dox Thrash achieved recognition as a painter, draftsman, and printmaker.[18] He was acknowledged in 1938 as the co-architect of the Carborundum printmaking process and was the first Black artist hired to work by the WPA at the Fine Print Workshop in Philadelphia. Thrash was one of the few Black artists during the 1930s and 1940s to consistently explore representation of the Black female form in art.[19] Some of the nudes focus on the impact of race on conceptions of beauty in American culture. There are two versions of a work titled *A Useful Imagination* that speak most strongly to the damaging impact of standards of beauty influenced by images of White women in popular culture: *A Useful Imagination (facing right)* (color Carborundum print; fig. 14) and *A Useful Imagination (facing left)* (Carborundum print).[20] In each, a Black woman holds her own decapitated head, which looks back toward her with a lighter-skinned face, while at the same time it looks at pictures of women in a beauty magazine.

The Carborundum printmaking process lent its great range of tones to Thrash's reinterpretation of the classical nude in Western art.[21] In the artist's *Nude* of 1938, the deep blackness of the background negates traditional views of mythological figures asleep in landscapes or voluptuous Titian nudes reclining on sumptuous beds in ornate surroundings and gazing meaningfully back at the

Fig. 11 Film still from *Nothing But a Man*, 1964, directed by Michael Roemer. Private collection, Memphis.

Fig. 12 Film still from *Nothing But a Man*, 1964, directed by Michael Roemer. Private collection, Memphis.

Fig. 13 Palmer C. Hayden (American, 1890–1973), *His Hammer in His Hand*, from the *Ballad of John Henry* series, ca. 1944–47. Oil on canvas, 27 × 33 inches. Museum of African American Art, Los Angeles.

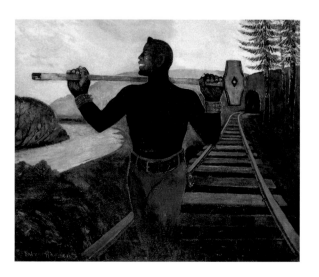

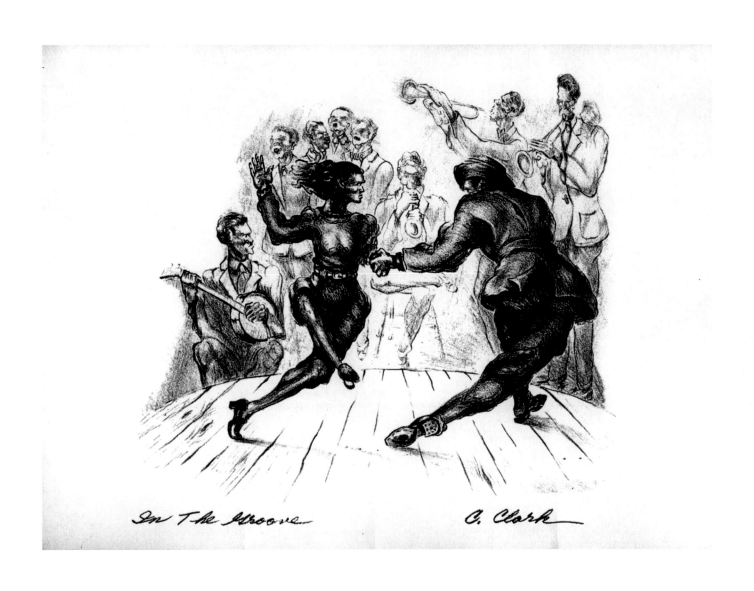

Cat. 7 Claude Clark, *In the Groove*, 1934–43; Private collection　　29

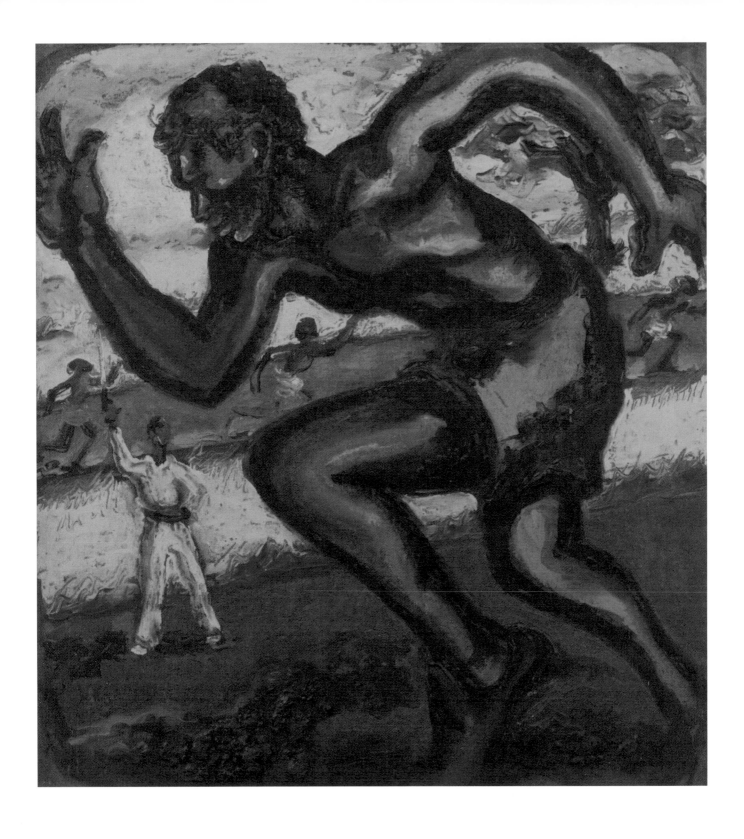

Cat. 29 Claude Clark, *The Runner*, 1945; Collection of Kimberly and Elliot Perry

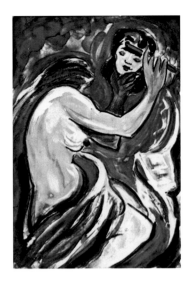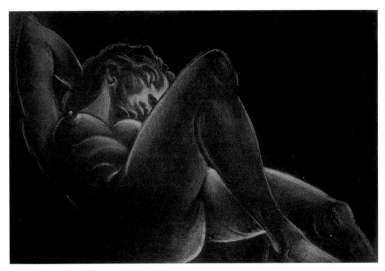

Fig. 14 Dox Thrash (American, 1893–1965), *A Useful Imagination (facing right)*, ca. 1942–44. Color Carborundum mezzotint and Carborundum relief etching. Collection of John Warren, Philadelphia.

Fig. 15 Dox Thrash (American, 1893–1965), *Nude*, ca. 1938–39. Carborundum mezzotint. Private collection, courtesy of Dolan/Maxwell.

viewer (fig. 15). The body is in a more natural, strongly angled position. The foreshortened perspective allows Thrash to create an intimate, private mood that enhances the Black female subject's sensuality.

The Southside Community Art Center

Eldzier Cortor, Frederick Jones, Hughie Lee-Smith, Gordon Parks, Charles Sebree, and Charles White worked at the South Side Community Art Center in Chicago, participating in exhibitions, classes, and social programs. Charles White was born in Chicago in 1918, the child of migrants from Georgia and Mississippi. He attended the school for children at the Art Institute of Chicago and frequented the studio of dancer Katherine Dunham, where he encountered writers and artists. White was a member of a young Black artists group called the Arts Craft Guild, comprising artists and activists who founded the South Side Community Art Center in 1941 thanks to support from the WPA. White won a full scholarship to the Art Institute of Chicago, where he developed his formidable talents as a draftsman.[22]

In 1941 White was awarded a $2,000 Rosenwald Fellowship to study in the South. As the effects of the Great Depression began to ease and New Deal projects dried up, the Julius Rosenwald Fund stepped in to fill the loss of WPA support, increasing funding for those defined as "Negro creative workers."[23] The philanthropist Julius Rosenwald (1862–1932) was inspired by the artistic success of the New Negro Movement and the influence of Booker T. Washington and Rabbi Emil Hirsh.[24] Between 1928 and 1948, the fellowship program spent $1.68 million to fund 587 Black and 278 White Southerners working in the visual arts, music, dance, creative writing, and drama; the humanities and sciences; and the fields of education, agriculture, sociology, public health, and economics. Compared to the Harmon Foundation's patronage during the Harlem Renaissance, the Julius Rosenwald Fund was active longer, supporting the generation of Black artists who matured during the Great Depression and World War II. Twenty-two Black artists and fifteen White Southerners received fellowships in painting, sculpture, and photography.[25]

Charles White wanted to study and paint "the life, the work, and the efforts of the Negro people as farmers, sharecroppers, on the wharves, in the mines, in the factories, and in the urban communities. . . ."[26] He was drawn to the life he felt his Mississippi ancestors had experienced, and was fascinated as well with the power of the blues and gospel music. White confronted the harsh realities of segregation, economic destitution, and racial violence that Black Southerners endured. For instance, the subject in *Lust for Bread*

31

(1935–45; cat. 11) speaks to the dehumanizing results of poverty. The powerful figure of the Black man contrasts with the pleading expression on his face and the bent, suppliant position of his body.

White's research in the South, which he described as "one of the deeply shaking and educative experiences"[27] of his life, was the basis for his understanding of Black people's response to a history of oppression and their continuing resistance. In *A History of African American Artists*, Romare Bearden discusses how, during the 1950s, White's experience in the South caused him to re-focus on the representation of ordinary Black men and women, envisioned as massive, larger-than-life, heroic figures with deeply felt emotional significance.[28] His portraits of Black women became the definition of strength and dignity. *Our Land* (1951; cat. 39) belongs to this pivotal period in White's career. The painting borrows from Grant Wood's *American Gothic* in its portrayal of a Black woman framed by the doorway of a house and holding a pitchfork. White moves us beyond that iconic picture of rural White America to create a subject recognizable to Black people as one of their own. Dark-skinned, robust, and standing with pitchfork in hand, the figure references Black Americans' historical relationship to the land. As enslaved laborers and sharecroppers, Black workers farmed rich, fertile soil that made White plantation owners wealthy and their own descendants poor. That experience did not erase a deep spiritual connection to the land and a knowledge of husbandry that Africans had brought with them to the Americas. White's image and title speak to this legacy and to how Black Americans have drawn on the strength that comes from this good earth, from which we all come and return to, and over which no human being is master.

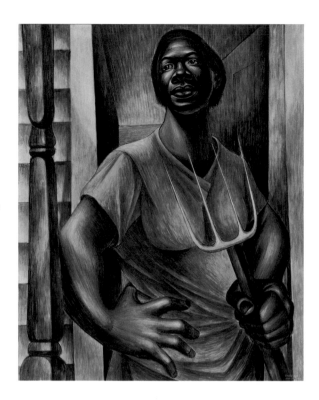

Cat. 39 Charles White, *Our Land*, 1951; Art Bridges

Elizabeth Catlett studied lithography at the South Side Community Art Center, where she became involved in the city's progressive, politically active art circles. She married Charles White in 1941, and the couple relocated to New York. Catlett took more courses in lithography at the Art Students League and began studies with the Belarusian-born French sculptor Ossip Zadkine. She then taught high school at George Washington Carver School, where instructing the primarily working-class students fundamentally shaped her thinking about the arts. Catlett identified as middle class, and teaching high school was the first time she encountered what she described as the "great hunger for art and culture of ordinary black people."[29]

Catlett's changing attitudes about the arts, social justice, and the human condition are obvious in the print series *The Negro Woman* (1946–47). The project evolved from the artist's exceptionally well-written application for a Julius Rosenwald Fellowship to create prints, paintings, and sculptures concerning the "role of Negro women in shaping the democratic progress of our country."[30] The fellowship funded Catlett and White's travel to study at the famed Taller de Gráfica Popular (People's Graphic Workshop) in Mexico City in 1945. Catlett learned to work with linoleum-cut block prints, an efficient and affordable printmaking technique. During the second year of the fellowship, in the summer of 1946, she produced linoleum cuts narrating Black women's contributions as field laborers, domestic workers, educators, and activists. The series is now known by the title *I Am the Black Woman*.

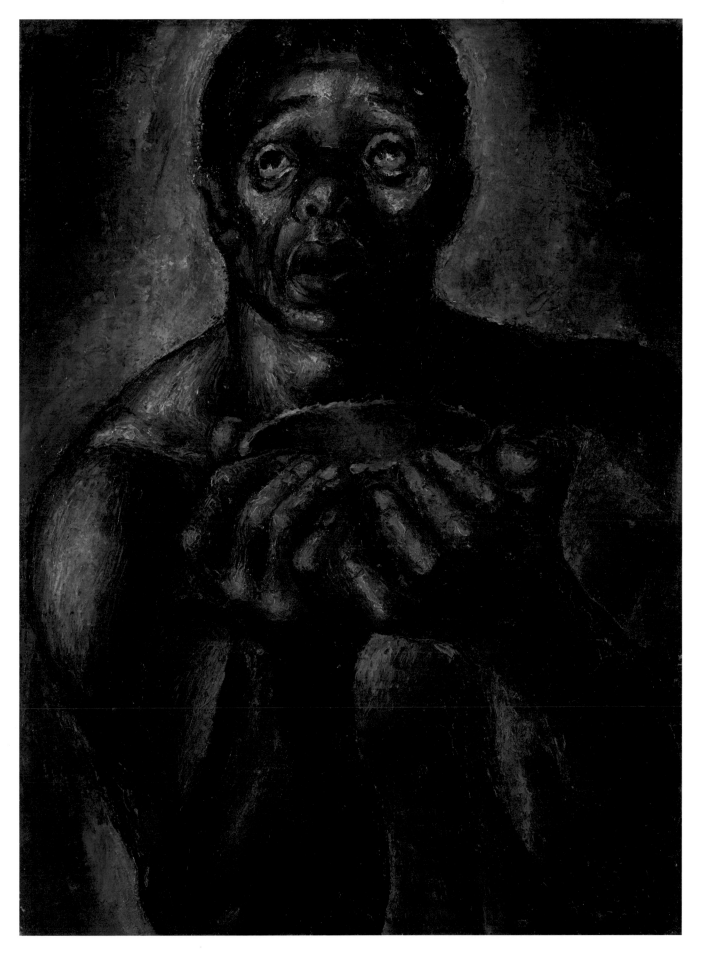

Cat. 11 Charles White, *Lust for Bread*, 1935–45; Jonathan Green Studios, LLC 33

I Have Special Reservations showcases Catlett's command of the linocut process to convey the physical and emotional struggles of Black American women. The work, which balances abstraction and realistic figurative imagery with text, was influenced by Jacob Lawrence's *Migration* series (1940–41). The relationship between word and image, expressed in verse and captions, propels the viewer through the past and present, where both ordinary people and historical figures are introduced. Plate twelve in the series, *I Have Special Reservations*, documents the impact of segregated seating on public transportation in the Jim Crow South (fig. 16). Four Black women sit at the back of the bus. They are likely domestic workers dependent on public transportation to get to their jobs in suburban White households. It was such women, everyday people, whose grassroots activism drove the momentum in civil rights activity during the 1940s and 1950s.

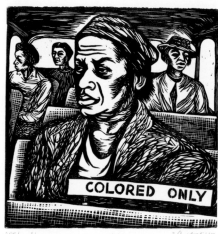

Eldzier Cortor also received a Julius Rosenwald Fund Fellowship to study Black culture in the South. He concentrated on Gullah communities living in the Sea Islands off the coasts of South Carolina and Georgia. Cortor made photographs and sketches to work from in his Chicago studio, developing an interpretation of Black Southern culture distinguished by a romantic, almost mystical, symbolism. Cortor shaped the Black female form into an archetype of the Black experience in America. While he drew from the tradition of classical European sculpture, Cortor transformed his Black nudes into a rich, dark, elongated, and elegant form reminiscent of African sculpture. The organic, agrarian power that Cortor's ancestral Black women embody was linked to his ideas about the South as a place where aspects of African culture lived on. In *Southern Landscape* (fig. 17), for example, a pensive young brown-skinned woman is lost in reverie. Is she thinking about her suitor—possibly the young man pictured in the photograph tucked into her picnic basket, along with the fruit, jug, and book? Perhaps he is away at war. She is connected to the land and to a specific Black community, indicated by the cemetery, church, and houses receding into the background. The figure exudes a palpable sense of loneliness. In this and other works, Cortor explores subjective states of consciousness that suggest the influence of European Surrealism.

When he returned to Chicago, Cortor continued to develop this figurative theme, taking into account the work of his friend, the sociologist Horace R. Cayton Jr., coauthor of the classic 1945 study on Black Chicago titled *Black Metropolis*.[31] Chicago was then being studied by sociologists due to its population growth and diverse demographics during the late nineteenth and early twentieth centuries. In a 1946 article about "Negro" artists, *Life* magazine featured a picture of Cortor's painting *Southern Gate*, expressive of his vision of Black female beauty and identity as rooted in Southern Black culture (fig. 18).

In works like *Americana* (fig. 19) and *Southern Souvenir No. II* (ca. 1948; cat. 34), Cortor interprets the impact of migration via the communicative potential of the Black female body. The Black female subject and family now inhabit conditions very different from his idyllic Southern landscapes, replaced by cramped interior views of tenement apartments. Cracked walls are covered with

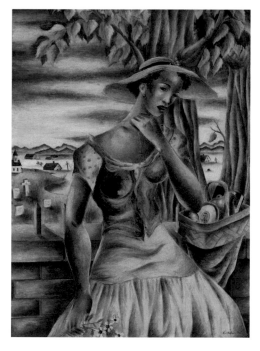

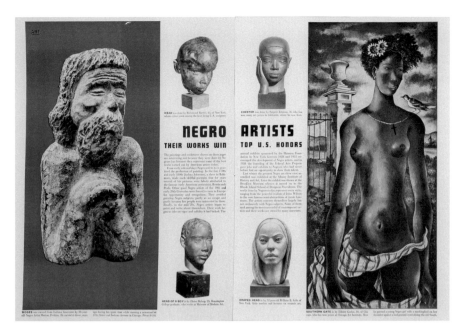

Fig. 18 "Negro Artists," in *Life* magazine, 1946. Private collection, Memphis.

newspapers and pages torn from beauty magazines. Liesl Olson writes that no other visual or literary artist associated with the Chicago Renaissance exposed the harsh social realities of settling in the South Side neighborhood of Bronzeville with such "unflinching fidelity."[32]

Social Realism had a profound effect on Black photographers such as Gordon Parks Jr. He learned how to use his camera working with photographers employed by the Farm Security Administration, the New Deal agency organized in 1937 to document the rural poverty wrought by the Great Depression. Parks was awarded a Rosenwald Fellowship to study urban conditions in Washington, DC. One of his most iconic images, *American Gothic* (1942) is a portrait of Ella Watson (fig. 20). Watson, who had migrated North to escape poverty and violence in the South, managed to raise and support children and grandchildren working as a cleaning woman in the Farm Security Administration offices. Parks contrasts her humble but strong sense of self with one of the most durable icons associated with Whiteness, rural identity, and the Midwest in American art history: Grant Wood's *American Gothic* (1930).

There are strong structural parallels between Parks's interior studies of Mrs. Watson's home (fig. 21) and Eldzier Cortor's *Americana* and *Apartment* series paintings (see fig. 19).[33] Both depict similar dilapidated interiors and the crowded conditions migrants endured in America's inner cities. Cortor set his paintings in Chicago, while Parks was photographing conditions in Washington, DC. However, each artist conveyed striking differences in the outcome of this shared experience. The young women in Cortor's works are isolated and lack social support systems. Parks, on the other hand, documented the prevalence of faith in Mrs. Watson's life and the leadership role she occupied in her church. Perhaps religious values and social networks account for why Parks and Cortor

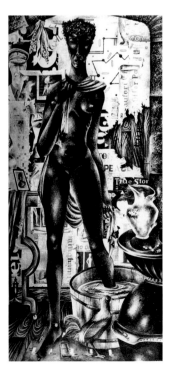

Fig. 19 Eldzier Cortor (American, 1916–2015), *Americana*, 1946. Collection of Miriam and Stephen Cortor.

35

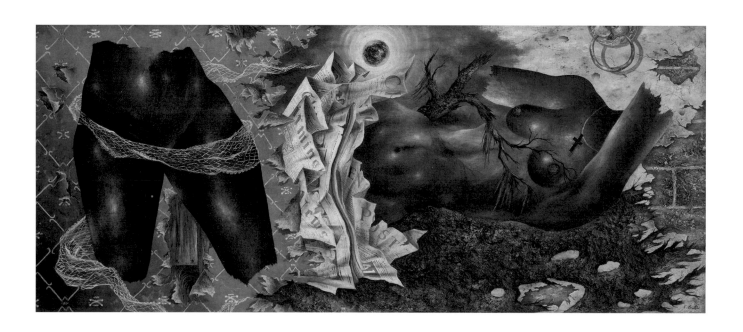

Cat. 34 Eldzier Cortor, *Southern Souvenir No. II*, ca. 1948; Art Bridges

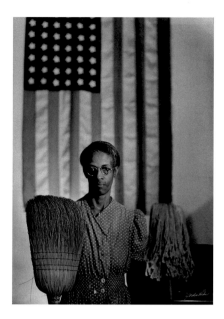

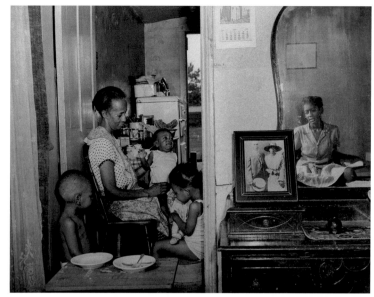

Fig. 20 Gordon Parks (American, 1912–2006), *Washington, DC, government charwoman*, or *American Gothic*, 1942, printed later. Gelatin silver print. Library of Congress, Washington, DC.

Fig. 21 Gordon Parks (American, 1912–2006), *Mrs. Ella Watson, a government charwoman, with three grandchildren and her adopted daughter*, 1942. Gelatin silver print. Library of Congress, Washington, DC.

produced divergent works of art interpreting how Black women dealt with the challenges of migrating North.

Frederick Jones, Hughie Lee-Smith, Charles Sebree, and Irene Clark—connected to what has been called the Black Chicago Renaissance—shared Cortor's interest in expressionism and Surrealism. During the 1930s, when he was a high school student, Jones was mentored by Hale Woodruff. He left Georgia in 1940 to attend the Art Institute of Chicago.[34] He also started working with artists at the South Side Community Art Center, founded that same year with support from the Works Progress Administration.

Madonna Moderne (undated; cat. 22) is typical of the distinctive imaginative style Jones developed. Like Cortor, Jones focused on Black women's experiences in urban settings. The painting portrays an environment imbued with symbolism and saturated with color. Two figures inhabit desolate landscapes and hold babies that have not survived the harsh circumstances. The Madonna figure, standing underneath a Renaissance portrait, holds a lifeless, doll-like child whose skull is cracked open. The female figure in the distance, as well as the Madonna, both depicted as Black women, share the tragedy of not having been able to protect their children from the sins of the world. The jarring juxtaposition of Christian symbolism, illogical scenes, and strange contexts for everyday objects is characteristic of Surrealism. Both Jones and Cortor were captivated by mythology and fantasy. They believed that artists could create sensitive, beautiful, and imaginative images dealing with contemporary social issues without being harsh or ugly.

Hughie Lee-Smith studied art and art education at the Cleveland Institute of Art and Wayne State University. He combined Social Realism with Surrealism into a haunting, enigmatic style that was deeply personal but still able to address political, economic, and social challenges.[35] Lee-Smith's solitary figures dwell in abandoned landscapes marked with crumbling buildings and architectural remnants. In *Contemplating My Future* of 1954, a young man looks across the street at an old nineteenth-century brick building (cat. 47). While the stage-like scene evokes the loneliness of memories, the warmth of a light reflecting off the porch, the figure's stance at the street corner or crossroads, and the road leading off into the distance point us in the direction of possibilities.

Charles Sebree (1914–1985) arrived in Chicago during the 1920s from his home state of Kentucky.[36] He attended children's Saturday art classes with classmates Eldzier Cortor and Charles White at the Art Institute of Chicago.

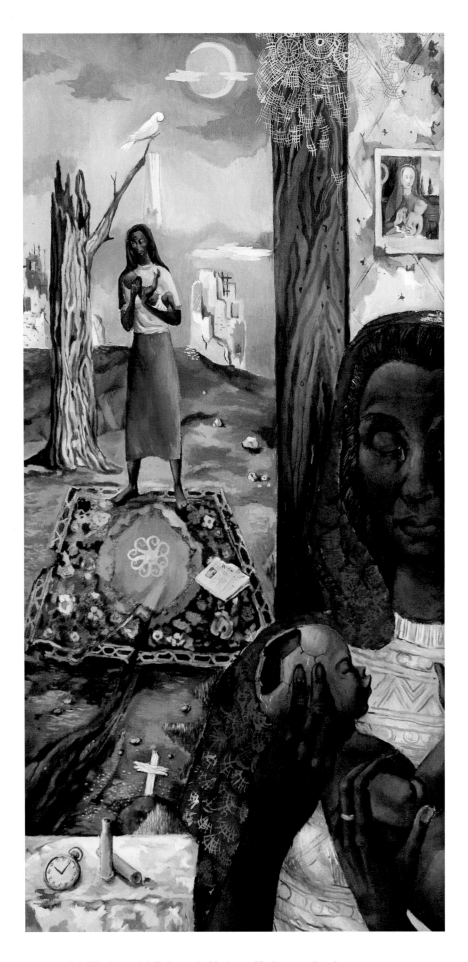

Cat. 22 Frederick D. Jones Jr., *Madonna Moderne*, undated;
Clark Atlanta University Art Museum

Sebree was also friends with the revolutionary choreographer Katherine Dunham, which led him to explore various aspects of theatrical production himself. As a result, theatrical performers figure prominently in Sebree's work. Sebree caught the attention of the University of Chicago's Renaissance Society, considered an elite but important center of modernism, where he began exhibiting and selling his work.[37] After completing his studies at the Art Institute of Chicago, Sebree remained in the city and benefited from working with some of the artists affiliated with the South Side Community Art Center. *Still Life* (1936; cat. 12) reflects the European modernist influence of the 1920s. The painting's blue-green and ochre color scheme and thick, black, curvilinear outlines recall the expressive portraits and figures of both Picasso and Rouault.

Irene Clark (1927–1984) studied at the South Side Community Art Center, the 414 Workshop (administered by the Art Institute of Chicago), and the San Francisco Art Institute.[38] Initially trained in realistic modes of painting, Clark began to experiment with expressionistic, dreamlike, and later naïve approaches to representation. She drew on childhood memories of oral and written stories. Clark later studied in Haiti, incorporating into her work folklore from Africa and the global Black diaspora.[39] She noted that generations of Africans told stories that they brought with them wherever they moved. In an interview with Samella Lewis, Clark elaborated on her interest in the imagination thus: "As a child I was always fascinated by good stories. Having a vivid imagination, I made up many fantasies of my own. After reading many stories, I had to try to paint the substance of what I had read."[40]

This exhibition features Clark's *A Mansion at Prairie Avenue* (ca. 1955; cat. 48). The painting depicts the type of late nineteenth-century mansion, constructed by wealthy residents, that once dominated the landscape of neighborhoods on the South Side of Chicago. Painted on wood using rough brushstrokes to depict masonry-style architecture, Clark conveys a strong sense of texture—specifically, the heavy stone materials used to erect these impressive structures. Over time, these same neighborhoods were altered by the Great Migration.[41] By the 1950s the historic district was beginning to suffer the damage of disinvestment in Black neighborhoods. The big stone mansion in Clark's painting has been reduced to a rooming house for multiple families. The artist uses both image and title to narrate the Black experience on the South Side of Chicago. The work was featured as part of the Johnson Publishing Company's art collection in *Ebony* magazine in 1973. Clark noted with pride that the "late Kwame Nkrumah of Ghana owned one of [her] works."[42]

Black Women Artists' Sculptural Legacy
Nancy Elizabeth Prophet, Augusta Savage, Beulah Woodard, Selma Burke, and Elizabeth Catlett (cat. 31) were important sculptors of the first half of the twentieth century. They are linked in their commitment to create dignified images of African diasporic peoples, a radical perspective during their lifetimes. They chose to work in realistic modes of representation as the most direct means of communication with Black audiences. I focus here on the lesser-known artist Beulah Woodard (1895–1955), whose career began during the New Negro Movement (fig. 22). Woodard was part of a group of artists situated along the Pacific Rim, conscious of indigenous American and Oceanic cultures as well as European modernism.[43] The Woodard family moved to California from Georgia. An African visitor to their household when Woodard was twelve sparked her lifelong interest in African culture and history. She studied painting and sculpture at the University of California and the Otis Institute of Art during the late 1920s.[44]

Woodard created work in various media: oil paint, terra-cotta, plaster, wood, copper, and bronze. By the mid-1930s she was focused on representing

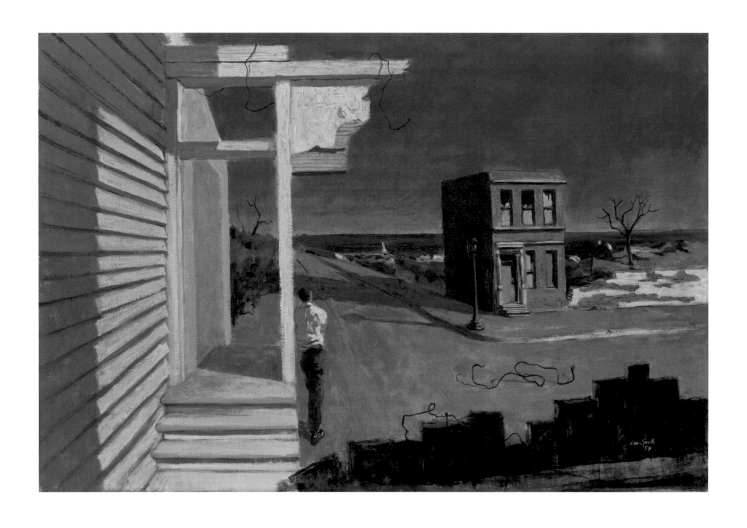

Cat. 47 Hughie Lee-Smith, *Contemplating My Future*, 1954; The John and Susan Horseman Foundation for American Art

Cat. 48 Irene Clark, *A Mansion at Prairie Avenue*, ca. 1955; The Art Institute of Chicago

peoples of African descent, interpreting their history and culture. Interested in how different cultures made and used masks, she was particularly drawn to African art. In an interview with *Opportunity* magazine in 1944, Woodard discussed her ethnographic approach to creating artworks inspired by Africa: "In the so-called 'primitive' Africa there is much of which Negroes today should be proud. I am recording types as rapidly as I can. They are at once interesting, picturesque, dramatic, and colorful."[45]

From the beginning of her career, Woodard's arts practice was linked to civic work with various organizations. In a letter to W. E. B. Du Bois dated July 6, 1935, she spoke about her work for "Negro Day" at the San Diego International Exposition.[46] She contributed six clay masks to the exhibition that illustrated the "Evolution of the Negro." Woodard portrayed three "primitive-type Africans" and three "present-day Negro-educators."[47] The latter masks depicted W. E. B. Du Bois, Booker T. Washington, and Frederick Douglass. In 1937 she co-founded the Los Angeles Negro Art Association, which presented lectures on African American history.[48]

Woodard also belonged to a Black women's organization affiliated with Carter G. Woodson's Association for the Study of Negro Life and History (later renamed the Association for the Study of African American Life and History). These activities persuaded the mayor's office to endorse Woodson's proposal for Los Angeles's first Negro History Week celebrations.

In 1935 Woodard's masks were displayed in the office windows of the *California News.* Miriam Matthews, the first Black librarian in the Los Angeles Public Library system, then invited the artist to show her work at the Vernon Branch Library. The portrait masks were then exhibited at the Los Angeles Central Library. In 1937 Woodard became the first African American artist to have a one-person show at the Los Angeles County Museum of Art. These unusual works are preserved as photographic images in the archives at the University of California, Los Angeles, and the W. E. B. Du Bois Papers at the University of Massachusetts, Amherst.

Medicine Man and *Emperor Haile Selassie* present the meticulous details of paint, plaster, papier-mâché, and appended elements Woodard used to construct her portrait masks (figs. 23–24). She attached human hair to the heads and faces and made individual eyelashes for the eyes. She also typed up didactic cards to explain and contextualize the works. The portrait mask of Emperor Haile Selassie is almost disturbing in its lifelike appearance. Woodard's choice of a living African monarch was certainly linked to Benito Mussolini's imperialist designs on the ancient African kingdom of Ethiopia. This led to Emperor Haile Selassie's famous appeal before the League of Nations in 1936, in which he condemned the use of chemical weapons against his people in the Second Italo-Ethiopian War.

The recognition Woodard achieved brought her commissions for busts of prominent African Americans in Los Angeles. One of the most significant was for a portrait of Maudelle Bass (1908–1929), executed in 1937 (cat. 13).[49] Bass achieved fame as a concert dancer and was known for her pioneering work as an artist's model. She moved from Georgia to California in 1933 to pursue her interest in dance. She became the first Black performer to study with American dancer and choreographer Lester Horton, credited with launching the modern dance movement in Los Angeles. Horton's innovative contributions were inspired by Native American culture and the modern

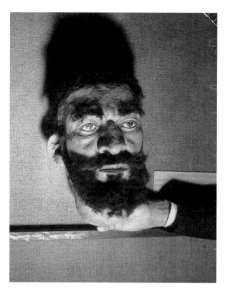

dancers of the Denishawn School of Dancing, recognized for incorporating African culture into their practice.[50] Bass specialized in modern, Brazilian, and Afro-Cuban dance. In 1940 she performed the lead role in Agnes de Mille's *Black Ritual* with the American Ballet Theatre, its first ballet featuring Black performers.

Woodard's 1937 bust *Maudelle*—she created at least two—is a terracotta portrait whose smoothly modelled contours replicate the dancer's warm, dark coloring and high cheekbones. Comparing Bass's likeness to a photograph by Carl van Vechten for her debut in *Black Ritual* (1940; fig. 25) verifies Woodard's ability to work firmly within the Social Realist tradition of portrait sculpture when representing distinguished figures. In Woodard's portrait is therefore manifest the innovative work of two Black women artists of the early twentieth century.

During the 1930s and 1940s, Bass went on to build a career as a model for major artists including Diego Rivera, Carl van Vechten, Edward Weston, and Lola Alvarez Bravo, celebrated as one of Mexico's most important photographers.[51] Not until 2019 was the first in-depth study of Black models in European art published, *Posing Modernity: The Black Model from Manet and Matisse to Today*, by African American curator Denise Murrell, to accompany the exhibition of the same name.

Institution Building and Art Education

African American artists' demands for equity in the arts during the 1930s contributed greatly to a democratization of the visual, literary, and performance arts in America. Increasingly, Black artists took on the roles of art educators, focusing on teaching and audience development in Black communities. Federally assisted community art centers were important spaces for such cultural work, even while they did not counteract segregation in the United States. Several artists in this exhibition were textbook practitioners of the Black artist educator model. Black artists founded the Harlem Artists' Guild (1935–1941) to promote independence as well as an agenda separate from that of the controlling White patrons of the Harlem Renaissance. The guild gave rise to the Harlem Community Art Center (1937–1942). Augusta Savage, in her role as director of the latter organization, emerged as

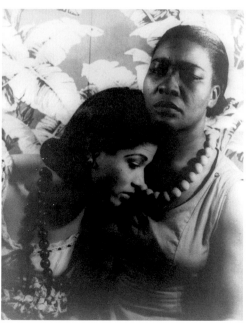

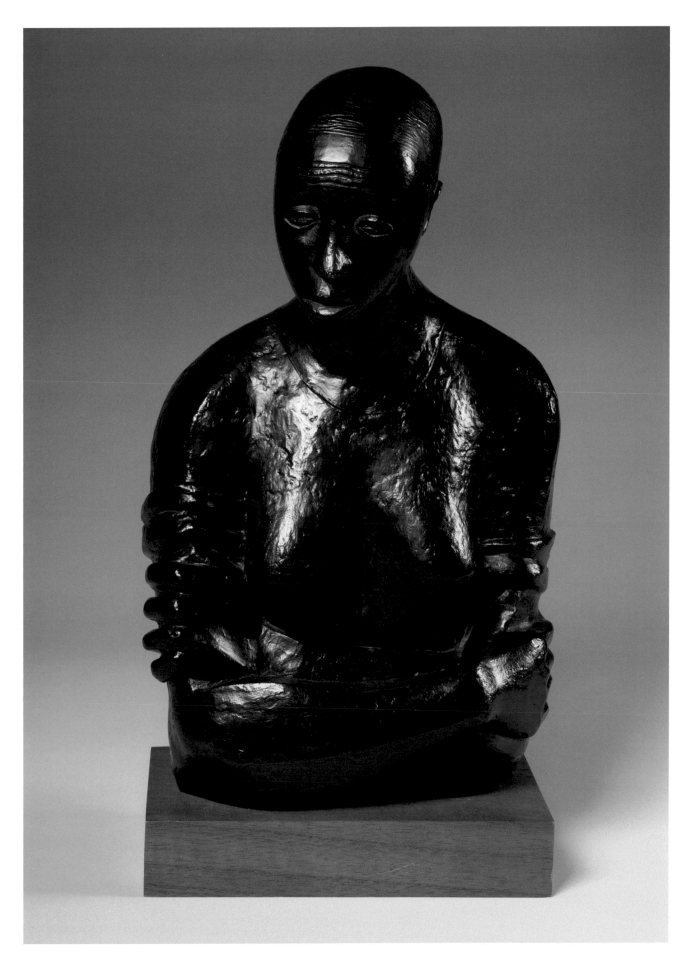

Cat. 31 Elizabeth Catlett, *Pensive [Bust of a Woman]*, 1946, recast 1995; Eli and Edythe Broad Art Museum, Michigan State University

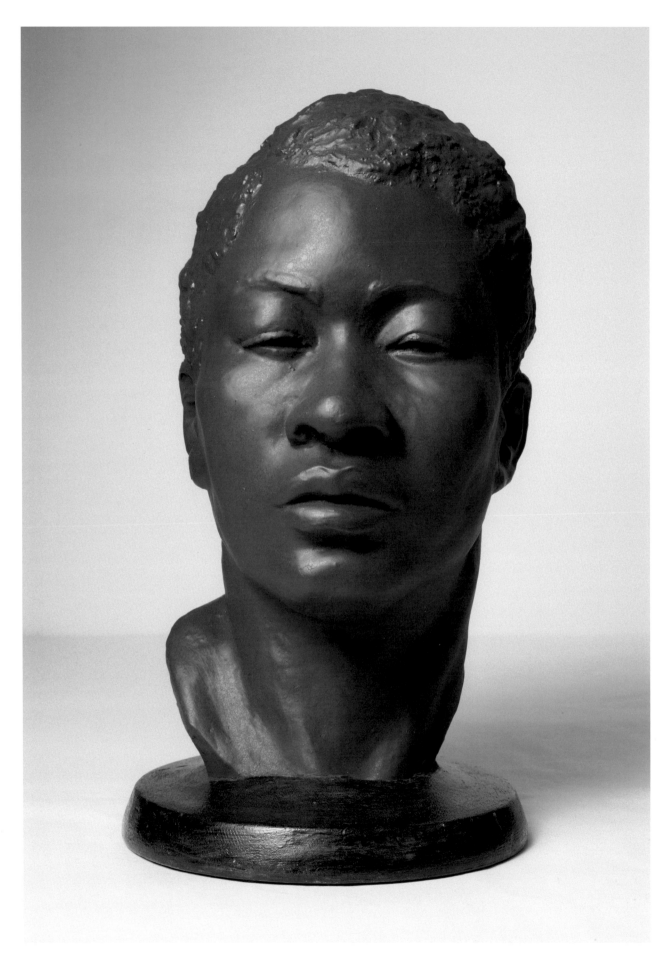

46　　**Cat. 13**　Beulah Woodard, *Maudelle*, 1937; Petrucci Family Foundation Collection of African American Art

a dynamic teacher and forceful advocate for Black artists' equity in the WPA. The center would go on to offer art instruction to some 1,500 students. As its assistant director, Savage helped to train the new generation of African American artists emerging during the 1930s and the 1940s; among them, Jacob Lawrence, William Artis, and Ernest Crichlow.[52] Crichlow worked throughout the Great Depression with the WPA, teaching and participating in mural projects. As seen in *Harriet* (1953; cat. 44), Crichlow matured into an artist able to blend Social Realism with powerful messaging about the inner strength and humanity to be found in the Black community.

Black artist educators established art programs in academia, primarily at historically Black colleges and universities (HBCUs) in the South.[53] Hale Woodruff's work at Atlanta University from 1931 to 1947 and the achievements of Aaron Douglas at Fisk University in Nashville from 1944 to 1966 are among the best known, as is the history of institution building at Howard and Hampton Universities. Aaron Douglas's *Portrait of a Lady* (cat. 16), for instance, is part of the collection at LeMoyne-Owen College, the only historically Black institution of higher learning in Memphis. The presence of this work is an example of the networking traditions established by African American artists, leading to the establishment of Black art collections at HBCUs across the South. The career of artist Samella Lewis (cat. 27), who studied with Elizabeth Catlett while at Dillard University, encompassed that of historian, critic, and art collector. Lewis completed master's and doctorate degrees in art history and cultural anthropology at Ohio State University in 1951, making her the first Black American to earn a doctorate in art history and the fine arts. She taught at Morgan State University; Florida A&M University; the State University of New York, Plattsburgh; California State University, Long Beach; and Scripps College, Claremont, California. Lewis's scholarly contributions include *African American Art and Artists* (1990) and *Black Artists on Art* (1969), co-authored with Ruth Waddy.[54] Muralist John Biggers (cat. 21) pursued master's and doctoral (1954) degrees in art education at Pennsylvania State University. He moved to Texas in 1949, where he established the art department at what is now Texas Southern University and served as chair until his retirement in 1983.[55]

Here I focus on two African American artist educators, Vertis Hayes and Reginald Morris, who established a fine arts academic center in the Black community in Memphis. In 1938 artist Vertis Hayes was appointed Director of the Federal Negro Art Center at LeMoyne College, which became LeMoyne-Owen College in 1968. The college had been chosen as a site for the center due to the successful lobbying efforts of the local Black community. LeMoyne students constructed the building, while influential community members organized into the LeMoyne Art Association. Hayes had completed two significant projects before arriving in Memphis: a mural for Textile High School in New York City and the mural *Pursuit of Happiness*, part of the Harlem Hospital mural project (1936). In the 2012 renovation, a panel from Hayes's mural was duplicated in glass on the exterior of Harlem Hospital at the corner of 135th Street, the old epicenter of WPA activity (fig. 26).

The success of the arts center extended beyond its domain in Memphis. Hayes taught courses in drawing, painting, pottery, lithography, art history, and art appreciation, and brought Harmon Foundation exhibitions to Memphis (fig. 27). The art education course he designed, called Art for Teachers, drew teachers from public and county schools. The success of the arts center translated into the establishment in 1941 of the Art Department at LeMoyne College, the single institution where African Americans in Memphis and regionally could acquire higher learning.[56]

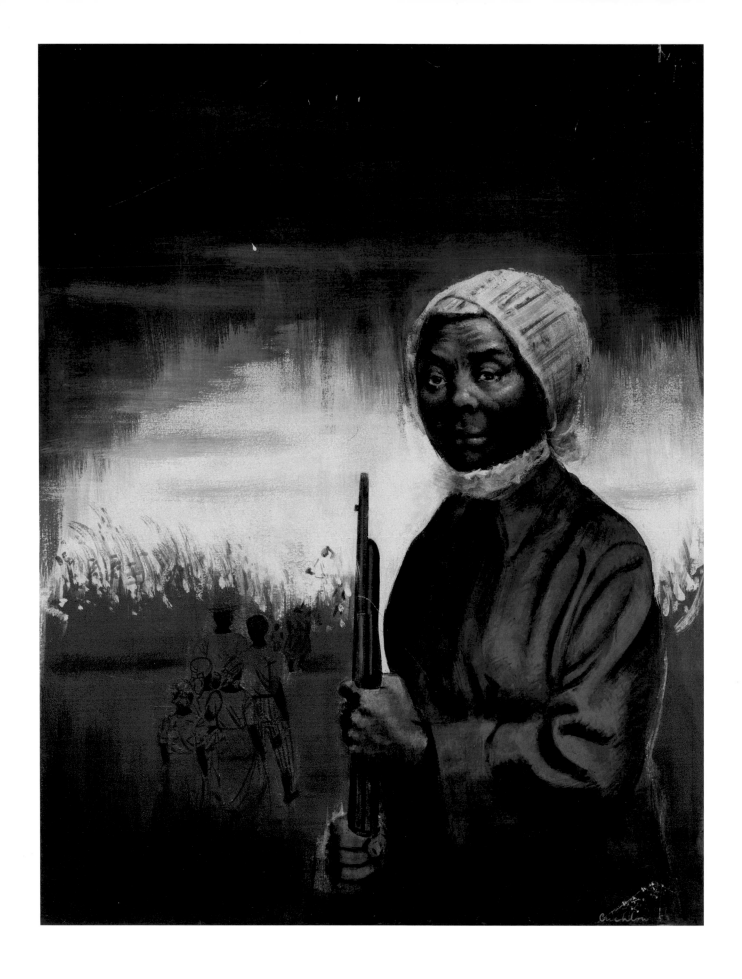

Cat. 44 Ernest Crichlow, *Harriet*, 1953; Collection of Kimberly and Elliot Perry

Cat. 16 Aaron Douglas, *Portrait of a Lady*, ca. 1940; LeMoyne-Owen College 49

Cat. 27 Samella Lewis, *Water Boy*, 1944; Hampton University Museum Collection

Today, a collection of artworks by Hayes's students at LeMoyne-Owen College is part of the archives at the Saint Louis Art Museum, donated by the Chicago regional WPA Arts Program office in 1939.[57] Twenty-six students (ages seven–fifteen) created the drawings in 1938. They were intended to serve as models of instruction at the People's Art Center then developing in St. Louis (fig. 28).

In 1936 Hayes wrote an essay about African American art education titled "The Negro Artist Today," to be included in a manuscript about American art during the Great Depression. The demise of the WPA and the United States' entrance into World War II interfered with its publication. Art historian Francis V. O'Connor began a research project on New Deal Art programs in the 1960s, finally publishing the anthology in 1973 under the title *Art for the Millions*. Connor selected Hayes's essay, along with many other seminal pieces written by artists from the period, as representative of the "interesting material" written about "Black art of the '30s."[58]

During the 1940s, Hayes completed several important mural programs in Memphis and at Jackson State University in Jackson, Mississippi, where he was commissioned to create an artwork honoring the scientist George Washington Carver (fig. 29). In addition, Hayes initiated the painting of murals in local Black churches in Memphis. The first documented commission of this type was the mural series completed in 1949 for Pilgrim Baptist Church, pastored by Rev. Herbert Brewster, a nationally known composer of gospel music (cat. 36). Hayes painted traditional scenes of *Christ's Entry into Jerusalem*, *Jesus's Procession Carrying the Cross*, and the *Crucifixion*. The church has since been demolished. Evidence of the mural series Hayes envisioned exists only in a photograph taken by the Hooks Brothers, prominent early twentieth-century photographers in Memphis. Hayes might have painted other murals in local churches that have yet to be identified, such as the artwork partly concealed by members of the congregation in this 1952 Hooks Brothers photograph (cat. 42).

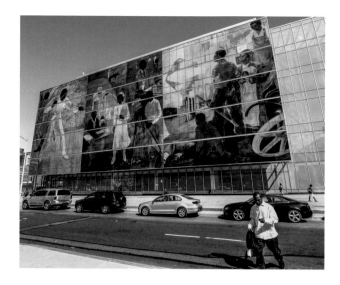

Fig. 26 Reproduction of *Pursuit of Happiness*, 1937, by Vertis Hayes (American, 1911–2000), completed 2012. Digital images between glass panels. Harlem Hospital Center.

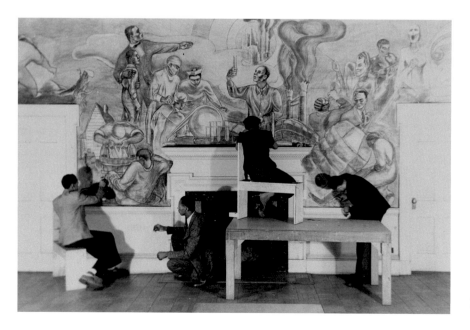

Fig. 27 Mural being executed by adult students in classes at LeMoyne Federal Art Center, March 1939. Holger Cahill Papers, Archives of American Art, Smithsonian Institution, Washington, DC.

Photograph archives located in Black communities are therefore extremely important to art historians carrying out the type of recovery research documenting the histories of artist educators at HBCUs. Extant photographs provide the only visual evidence of how Hayes's works once were displayed in administrative spaces on the LeMoyne College campus. In a Hooks Brothers picture titled *LeMoyne Alumni Day*, college administrators—including the first African American president of the college, Dr. Hollis Price (first row, third from the left)—were photographed underneath a painting by the artist (cat. 43). Hayes's Social Realist–expressionistic style is unmistakable. It closely resembles his painting *Juke Joint* of 1946 (fig. 30), which is part of the Larry D. and Brenda A. Thompson Collection of African American Art at the Georgia Museum of Art, University of Georgia. Both works suggest that regional subject matter was a persistent theme in Hayes's works from the 1940s, indicating the influence of the Regionalists and American Scene Painting. The distorted views of dry, rolling terrain and buildings are particularly reminiscent of John Steuart Curry, while the elongated figures recall the style of Thomas Hart Benton.

Curry's depiction of Midwestern life and culture, especially the destructive power of nature represented in his scenes of the dustbowl, tornadoes, and floods, perhaps influenced the subject matter in the only painting by Hayes that LeMoyne-Owen College retains in its art collection (cat. 15).[59] It depicts a disconcerting aerial view with clouds clearing to reveal a small rural town below. There is a sense of some type of destructive natural disaster having occurred, such as a cyclone or tornado. It is similar to Curry's lithograph *Mississippi Noah* (1932), used as the basis for his painting *The Mississippi* (1935), both created in response to the Kaw River flood in Kansas in 1929.[60] Both depict a Black family climbing onto a roof to escape the waters. The father in each image raises his arms in prayer, imploring God for help.

Hayes's work might also have been inspired by either one of the major floods of the Mississippi River that occurred during the first half of the twentieth century: the 1927 flood, known as the greatest natural disaster of the twentieth century, or the Great Flood of 1937. In both cases, rural Blacks, still mired in sharecropping and tenant farming, suffered disproportionately. In his painting, Hayes symbolizes the destruction with a stark, bare tree dominating the foreground. A few green leaves sprout from its branches, suggesting hope and new life. It is interesting to note that the tree is rooted in an artist's palette covered with thick dabs of paint. A Black female singer, reminiscent of the great contralto Marian Anderson, leads cultural workers up the incline. She is followed by a man playing a guitar, a man with a pickaxe, a musician playing a cello (hidden behind her white robe), and a concert conductor. They rise above a landscape dotted with a farm, a school or government building, and a white church with its tall steeple clearly visible. Both Curry and Hayes draw attention to the significance of religion in American life.[61] However, Hayes's painting speaks directly to the role

Fig. 28 Scott Bell Jr. (American, 1924–1984), *Bin Fishing*, 1938. Poster paint on brown paper, 14¼ × 18 inches. St. Louis Art Museum, Gift of the Federal Works Progress Administration, 367:1943.

Fig. 29 Unidentified artist, photograph of Vertis Hayes and students, 1940s. Margaret Walker Center, Jackson State University Archives, Mississippi.

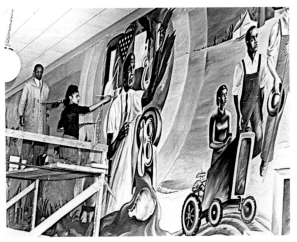

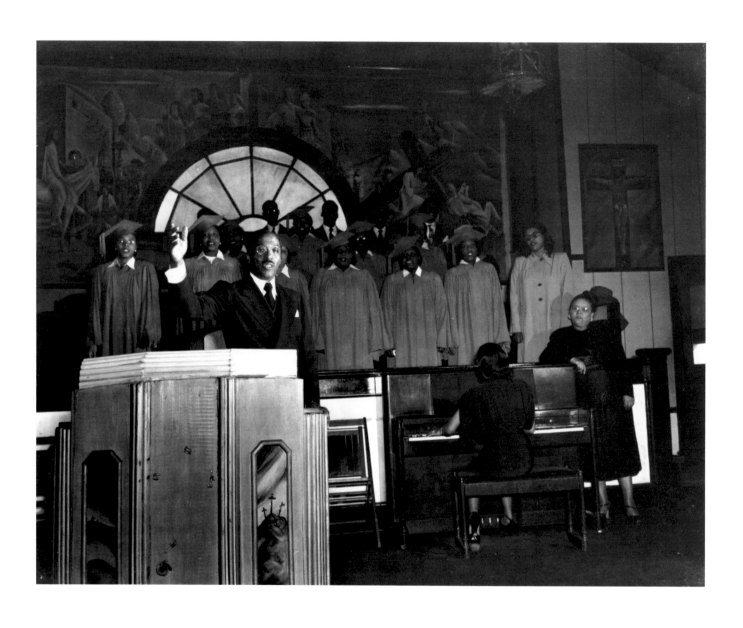

Cat. 36 Hooks Brothers Photography, *Rev. Brewster at Pilgrim Baptist Church Preaching in front of Vertis Hayes Mural*, 1949; Private collection

Cat. 42 (opposite, top) Hooks Brothers Photography, *Unidentified Church with Mural*, 1952; Private collection

Cat. 43 (opposite, bottom) Hooks Brothers Photography, *Chairman of LeMoyne Alumni Day*, 1952; Memphis Brooks Museum of Art

that the arts have played not only in the survival and rebuilding of Black communities but in the preservation of their histories and cultural legacy as well.

During the late 1950s and 1960s, painter and sculptor Reginald Morris (1920–1997) continued Hayes's legacy when he became an associate professor of art and the director of the art department at LeMoyne College (fig. 31). Morris completed three degrees: a BS in education from Tuskegee University and a BFA and MA in art education from the University of Pennsylvania. Morris was part of that second generation of African American artist educators whose significant work at HBCUs introduced Black students to the arts.

In 1960 Morris brought an important exhibition to LeMoyne featuring the work of several prominent African diaspora artists: "William H. Johnson who gained fame in America and Norway; Ben Enwonwu, the Nigerian artist who had recently completed a bronze portrait sculpture of the Queen of England; William Driscoll [sic], art director at Talladega College in Alabama, and Reginald Morris, art director at LeMoyne."[62] The career of Johnson, a major American artist, spanned several decades, while Ben Enwonwu was arguably the most important pioneer in the evolution of modern art in Africa. David C. Driskell (misnamed in the article), scholar, artist, and curator, was at the beginning of a long career investigating African American art as a distinct field of study. Morris had just been awarded a one-year sabbatical to study at Iowa State University, working toward a "doctorate degree in primitive art."[63]

During the mid-1950s, Morris completed a mural for Memphis's Second Congregational Church (fig. 32). He was commissioned to paint the artwork by Mrs. Ruth Watson, a music teacher, patron of the arts, and influential member of the church. Morris was therefore following the precedent established by Vertis Hayes in continuing to nurture close relationships between academia, the fine arts, and traditional religious institutions in Memphis's Black communities.

Morris's mural, painted between 1956 and 1957, remains in situ and was adapted to fit into the sanctuary of Second Congregational Church (see cat. 49). The congregation agreed to lend the mural for this exhibition—the first time it has been removed from the walls of the church. Three tall, vertical, painted-canvas panels are bookended by horizontal panels fitted above stained-glass windows. The mural is therefore shaped like a cross. The three center panels represent traditional Biblical subjects: *Christ's Descent into Hell*; *Christ as Salvator Mundi*, or *Savior of the World*; and the *Crucifixion*. While the subject matter and iconography are traditional, Morris reinterpreted the symbolism. He described his approach to painting as "expressionistic surrealism." From his description we can surmise that Morris combined the distortion of figural forms, the emotive content, and vivid colors of expressionism with the dreamlike world of the imagination, irrational narratives, and themes of fantasy characteristic of Surrealism. Stylistically, Surrealist artists evade abstraction, retaining a realistic manner of representation. It is the intuitive approach to iconographic

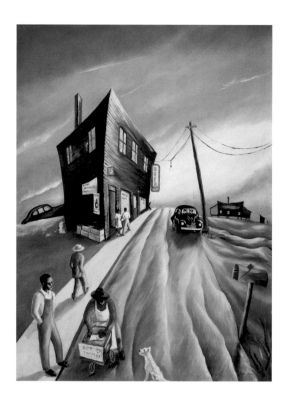

Fig. 30 Vertis Hayes (American, 1911–2000), *Juke Joint*, 1946. Oil on canvas. Georgia Museum of Art, University of Georgia, The Larry D. and Brenda A. Thompson Collection of African American Art, GMOA 2012.126.

Fig. 31 Photograph of Reginald Morris, 1960. LeMoyne-Owen College Folder #8652, Special Collections, University of Memphis, Tennessee.

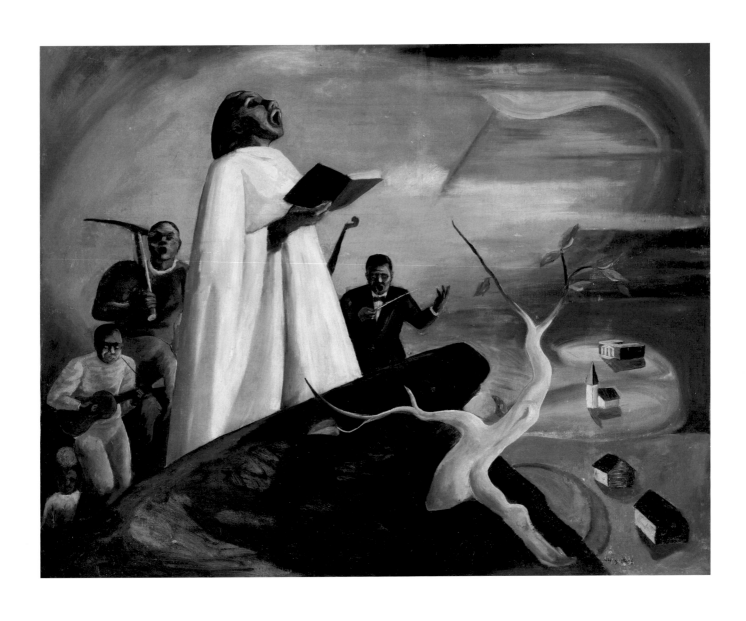

elements that accounts for the psychological power associated with the art movement.

For example, *Christ's Descent into Hell* refers to Christ's descent into the realm of the dead to bring salvation to the righteous who have died since the beginning of the world. Christ is usually portrayed as first grasping the hands of Adam and Eve to pull them from their tombs as other Old Testament figures climb from the depths of Hell. In Christian art, the iconography dates to the fifth and sixth centuries, and the figures are normally clothed in classical robes.[64] Morris depicts Adam and Eve as a young, brown-skinned couple with black hair. Their backs are turned to the viewer as they walk toward a stone archway leading to freedom. They are enveloped in rays of light emanating from an Egyptian-style udjat eye. A symbol of protection and royal power, the eye is associated with Horus, the ancient Egyptian god of the sky, normally represented as a falcon.

Morris's portrayal of Jesus Christ as a brown-skinned savior dominates the central panel. I would argue that the representation of race in relation to Christ is a direct result of Morris's interest in Mexican muralism. In 1956 or 1957, Morris completed a summer internship in Mexico.[65] An important objective of Mexican muralism was to create works that reflect what is important to the community. From a global perspective, the vibrant brown skin tones of the Christ figure, as well as those of Adam and Eve, resonate with a diversity of peoples. Specifically, Morris painted a holy figure for a Black church in Memphis that looked like the congregation. Aside from this radical intervention, the artist's depiction is traditional: Christ raises his right hand in blessing while his left hand holds a cross-bearing orb. In Western art, iconography of Christ holding the globe surmounted by a cross dates to the fifth century and symbolizes dominion over the world. The concentric circles configured behind Christ's head like a radiant crown may be likened to the traditional halo, but they more closely resemble the sun and Greco-Roman references to the solar deity, Apollo.

In the *Crucifixion*, Morris chose not to represent the physical body of Christ expiring upon the cross. Instead, the artist expresses Jesus Christ's transformation into spirit. While there is a full-length male body bound within the confines of the cross, the depiction is ephemeral, the spiritual essence of Christ becoming one with the elements of the universe. The psychological content so characteristic of Surrealism is intensified by the inclusion of designs fundamental to Chinese philosophy. Morris implanted the symbols representing the principles of yin and yang onto the ethereal body of Christ. These concepts propose that all things exist as contradictory but inseparable opposites, wherein harmony is achieved only through balance.

The two panels above each of the stained-glass windows are equally important in Morris's visual narrative. The leftmost image draws on traditional imagery of Christ crowned with thorns. The artist highlights the piercing thorns in red, behind which looms a darkened skull, perhaps prefiguring Christ's death. The opposite panel portrays a grapevine, which

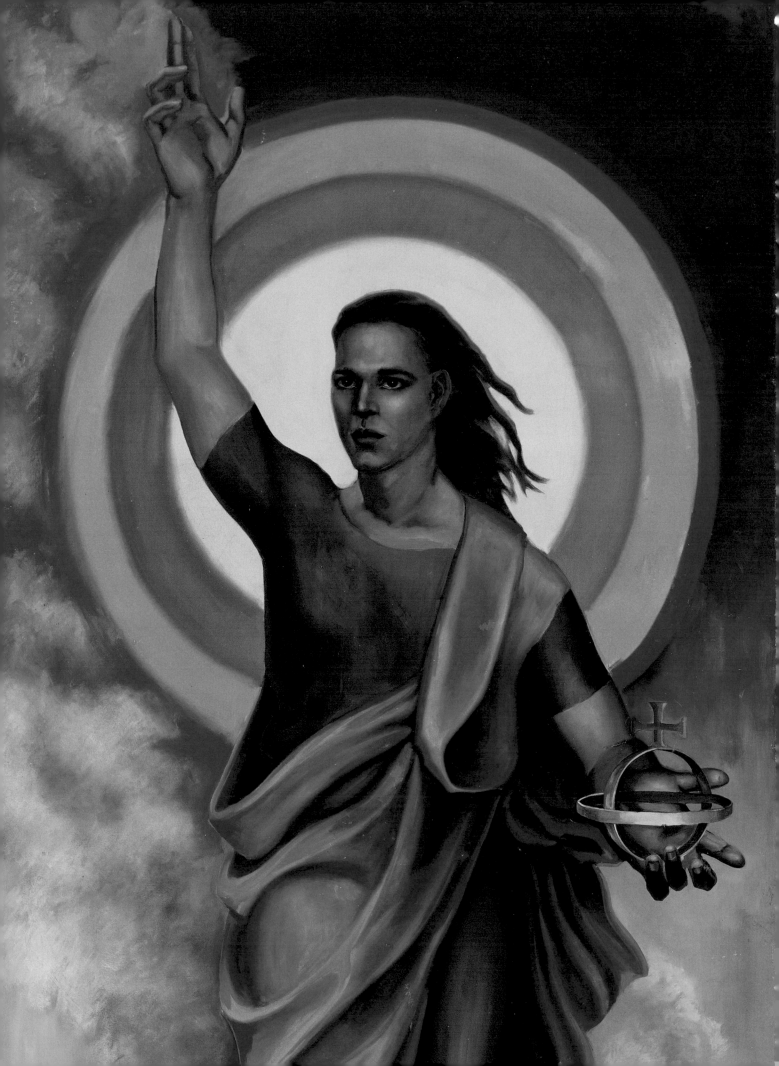

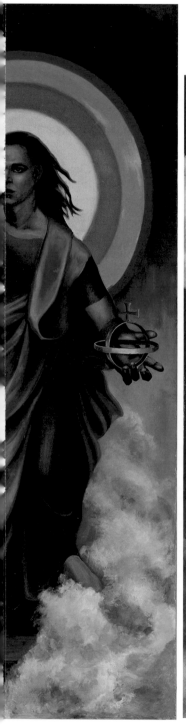

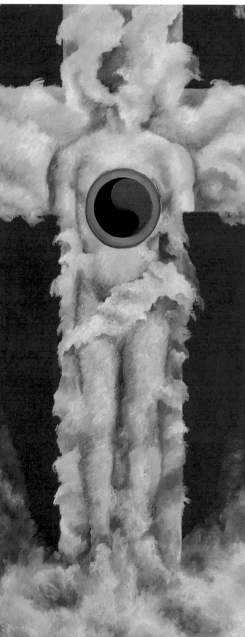

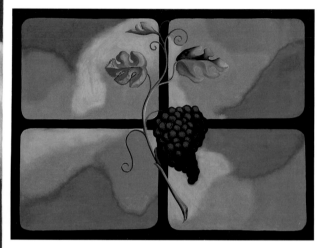

Cat. 49 Reginald Morris, *Salvator Mundi*, 1956–57; Second Congregational Church, Memphis 59

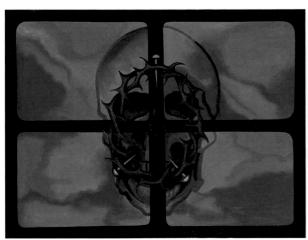
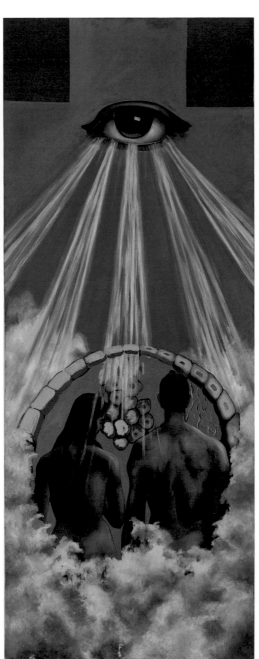
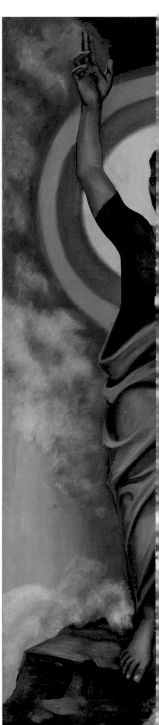

traditionally symbolizes abundance, yet might also signify the blood and sacrifice of Christ.

Morris drew on a variety of religious symbols and concepts, from ancient to modern, in his interpretation of Christian themes for the Second Congregational Church murals. He incorporated iconography from African, Asian, and Mexican cultures and histories to blend with Western expressive culture. Surrealism, as the artist noted, was the most appropriate stylistic manner of representation. Morris's broad universal approach to traditional Christian subject matter appealed even to a conservative congregation in a Black community in Memphis.

During the 1960s, the original art building at LeMoyne College was removed to make room for the construction of an architectural-award-winning library (fig. 33). The library was envisioned as a site that would display a mosaic mural created by Social Realist Ben Shahn (fig. 34).[66] The theme of the mural linked the history and experiences of African Americans and Jews in the struggle for civil rights. The mural therefore linked the historical relationship between the arts and social justice, a way of thinking about the role of the arts in the community shared by both Hayes and Shahn. The roots laid down by the first director of the Federal Negro Art Center at LeMoyne College have endured along with the educational institution itself, to be part of a legacy that will live long into the future. In 2020, influenced by the Black Lives Matter movement's response to the murder of George Floyd, the Community Foundation of Greater Memphis made a gift to LeMoyne-Owen College of $40 million, the largest endowment in the school's 158-year history.

Artist educator Rex Goreleigh (1902–1986) carried out the vital work of institution building in another part of the United States: Princeton, New Jersey. Goreleigh started his career working with numerous WPA art programs, teaching art across the country. In 1938 Goreleigh and Norman Lewis volunteered to work at North Carolina A&T State University and Bennet College, both in North Carolina, teaching and establishing community art centers. Goreleigh also studied abroad in Paris and Helsinki. He served as director of the South Side Community Art Center between 1944 and 1947, succeeding Margaret Burroughs, the first director.

Fig. 33 Hooks Brothers Photography (American, active 1907–1979), *LeMoyne-Owen Library*, 1961. LeMoyne-Owen College Folder #8652, Special Collections, University of Memphis, Tennessee.

Fig. 34 Ben Shahn (American, born Lithuania, 1898–1969), *Mosaic Mural*, 1962–63. Hollis F. Price Library, LeMoyne-Owen College, Memphis.

Fig. 35 John Collier, Jr. (American, 1913–1992), *Bridgeton, New Jersey. Seabrook Farm. Migrant's Child Working in Bean Field*, 1942. Nitrate negative, 2¼ × 2¼ inches or smaller. Library of Congress Prints and Photographs Division.

In 1947 Goreleigh was invited to Princeton and appointed Executive Director of Princeton Group Arts. He was hired to develop integrated visual and performing arts programming. After the group dissolved in 1953, Goreleigh founded his own school for the arts, Studio-on-the-Canal. In *American Negro Art*, Cedric Dover cited Goreleigh as an example of several "unusually gifted negro teachers" running various private schools for Black students, whom he believed functioned best in such workshop contexts.[67] It was during this time when Goreleigh initiated research into rural life in New Jersey, becoming fascinated with the Black laborers who had worked in the state's farm fields since the 1930s. In 2018 the Historical Society of Princeton put on the exhibition *Rex Goreleigh: Migrant Worker's Witness*. It was presented in collaboration with the Princeton Migrations Project, a community initiative examining the history of migration to the area, sponsored mainly by the Princeton University Art Museum.[68]

Many of the Black migrant laborers worked at Seabrook Farms near Bridgeport, New Jersey. By 1950 Seabrook Farms was the largest agribusiness in the United States, famous for its frozen vegetables. It employed more than 6,000 seasonal and permanent laborers.[69] White residents in the area viewed non-Black migrants employed by the company, such as Estonian refugees, in a more favorable light than Black migrants. Seabrook Farms likewise practiced discrimination by labeling Black migrant laborers from the American South and the British West Indies (Barbados, the Bahamas, and Jamaica) as more difficult to integrate into the community (fig. 35). The Black migrants therefore faced a hostile local White community, treatment as a transient workforce by Seabrook, and lower wages.

Goreleigh's images are now considered important documentation of the hidden history of the migrant worker experience in the United States. The Historical Society of Princeton exhibition emphasized that, while migrant workers today are synonymous with current ideas about immigrants, in mid-century America many of those workers were African Americans. Goreleigh's images show the full range of this experience, exhibiting the joys and pain of lives lived in challenging circumstances. *The Mourners* (1940; cat. 17), for instance, depicts grief. Loss was even more difficult to experience when individuals died in transient spaces like migratory camps. The lives of agricultural workers were rife with abuses. Migrants lived in shanties, tents, and wooden barracks that lacked indoor plumbing, facilities for storing food, and electricity. Goreleigh pictures one of the communal outhouses migrants were forced to share in the background of his painting. Goreleigh's painting preserves the importance of tight-knit family units in surviving an exploitative labor system. The use of bright colors in the women's dresses, for example, applied with thick paint and expressive brushstrokes, draws attention to the central role women played in binding families together.

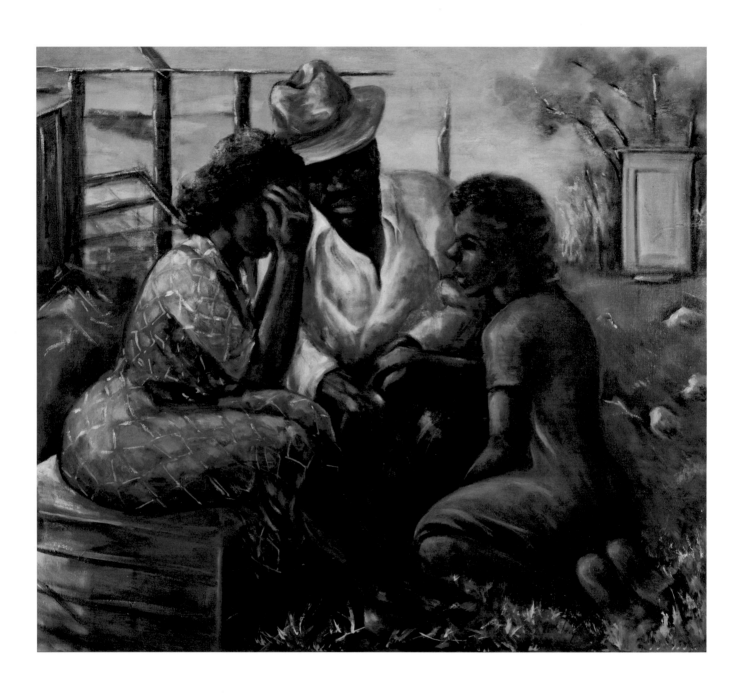

Cat. 17 Rex Goreleigh, *The Mourners*, 1940; Collection of Thom Pegg, St. Louis

World War II and Civil Rights

World War II

During the 1940s, Jim Crow laws strictly enforced racial segregation. Black and White lived in two unequal Americas. Black Americans were denied voting rights, as well as equal access to public facilities and jobs. Segregation was directed primarily at Black Southerners, but other minorities also experienced the racial prejudice of the era. Black American participation in World War II played a significant role in dismantling Jim Crow and increasing civil rights activity during the 1950s.

An example of the war's impact on civil rights is *No. 2, Main Control Panel, Nerve Center of Ship*, painted by Jacob Lawrence in 1944 (cat. 26). By the early 1940s, Lawrence was already a prominent artist with a pronounced interest in depicting social and political issues. During the war, Black and White troops were not allowed to serve together, and the Red Cross was segregating blood. In 1943 Lawrence was drafted into the segregated Coast Guard as a steward's mate, a job that required him to serve meals to White officers.[70] The Navy, however, was interested in experimenting with desegregation. As a result of its tentative integration policy, Lawrence was assigned to the Navy's first integrated crew, resulting in a promotion in rank that enabled him to serve as a combat artist. *No. 2, Main Control Panel* was one of fifty canvases Lawrence completed for the Coast Guard documenting the everyday activities of its members. It was likewise one of forty works comprising the artist's 1944 solo exhibition at the Museum of Modern Art, the institution's first solo exhibition of works by a Black artist.

In 1942 *Fortune* magazine commissioned artist Charles Alston to create illustrations for a story titled "The Negro's War." This issue was published six months after the United States officially entered the war following the bombing of Pearl Harbor on December 7, 1941. *Fortune* magazine was then a progressive, liberal-leaning publication. The article was in direct response to Black Americans' protesting racial discrimination in Northern industries during the war. *Fortune* invited Romare Bearden to create the important frontispiece. In the introduction, art director Deborah Calkins highlighted the significance of the article and the artists chosen for this project:

> Long acknowledged in the fields of music and dancing, the Negro's gift for creative expression now finds recognition in art. This season three important Manhattan galleries held exhibitions of contemporary Negro painting and sculpture. Among the most distinguished contributors to the shows were Romare Bearden and Charles Alston, whom *Fortune* invited to illustrate this article. Bearden, who painted the frontispiece, is a graduate of New York University. He worked daytime as an employee of New York City's Welfare Department, painted at night in a Harlem studio, which he shared with Alston. Lately he enlisted in the army. Alston, who made the sketches on this and the following pages, is an M.A. from Columbia. He was a teacher of Bearden, as well as of Jacob Lawrence, whose pictorial history of the migration of his people appeared in *Fortune* last November.[71]

The men in Bearden's *Factory Workers*, respectably well-dressed, have just been denied work at the steel mill pictured in the distance (fig. 36). The painting reflects the impact of Social Realism as well as Bearden's familiarity with the Mexican muralists and the influence of colleagues such as Ben Shahn. However, Bearden rejects a direct mimicking of nature. Abstract influences are apparent in the formal affinities with African sculpture visible in the lead figure's profile portrait. Directly across from Bearden's frontispiece,

63

Fig. 36 "The Negro's War," *Fortune* magazine, 1942, p. 76. Private collection, Memphis.

Alston's drawing mirrors the same lack of wartime employment opportunities for Black men in Harlem. Illustrations on the following pages depict the advantages of an integrated labor force in the steel industries in Pennsylvania and New York as well as housing discrimination (fig. 37).

Alston's illustration of housing discrimination in the North documented the building of the Sojourner Truth Housing Project in Detroit, opposed not only by White residents and descendants of European immigrants but also by middle-class African Americans who did not want federal housing in proximity to their neighborhood. Alston depicts the scene in February 1942 when the first Black defense industry workers and their families attempted to move into the new homes (see fig. 37). They were met with a billboard flying an American flag and declaring, "We Want White Tenants in Our White Community." Protests erupted into violence, and more than 40 people were injured and 220 arrested. The next year, on June 20, tensions escalated into a conflict that lasted three days.[72] It resulted in 34 fatalities: 25 were Black Americans; of those, 17 were killed by a Detroit police force dominated by ethnic Whites.

The Black military experience during the first half of the twentieth century is represented in this exhibition by Jacob Lawrence's *No. 2, Main Control Panel, Nerve Center of Ship*, Horace Pippin's *Holy Mountain I* of 1944 (cat. 28), and John Woodrow Wilson's *Deliver Us from Evil* (1943; cat. 24). Pippin served in World War I as a soldier with the 369th Infantry Regiment, better known as the Harlem Hellfighters, an all-Black infantry that served in France under White officers. It was the longest-serving regiment on the war's frontlines. Pippin was wounded by a German sniper. The injury permanently limited the range of motion in his right arm. He was awarded the French Croix de Guerre and the Purple Heart for his service and wounds in combat. During the war, he illustrated journals documenting his experience in a segregated military.[73]

In *Holy Mountain I* Pippin memorializes the events of D-Day on June 6, 1944. His complicated vision of a troubled world illustrates the intersections of racism and the destruction of war. The painting's foreground is dominated

by a Black shepherd in a white robe. His flock is composed of two children playing peacefully in the grass with domesticated animals like sheep and cows. They are untouched by the leopard, lion, bear, and wolf in their midst. Red and green cockatrices—mythical creatures with the head of a rooster and the tail of a snake—perch in the trees. In the background lurks a dark, threatening forest, where soldiers, bombs, planes, white grave markers, and red poppies signify death and the violence of war. Pippin's recollection of his experiences during World War I, brought back into view by a second global conflict, presents an uneasy alliance with the notion of peace.

Wilson's lithograph *Deliver Us from Evil* (1943) is a commentary on Black men's participation in World War II that specifically links the war to the history of domestic terrorism and White mob violence in America.[74] Wilson's parents were immigrants from Guyana, a former British colony in South America. His political views were shaped by memories of his father reading newspapers that regularly described lynchings. His professional training included study in Paris with Fernand Léger.

Wilson created *Deliver Us from Evil* while a student at the Museum of Fine Arts, Boston. The complex montage compares the violence of World War II in Europe with the legacy of systemic racism, inequality, and sanctioned violence against Black Americans. Divided into two halves, the mural is peopled with figures and scenes that narrate White racial mob violence in 1940s America alongside fascism and ethnic cleansing in Europe. A Jewish family is surrounded by marching soldiers, Nazi officers standing in front of a cannon, concentration camps encircled with barbed wire, and the broken bodies of victims weighed down by the architectural remnants of European civilization. The bodies of lynched victims, one hanging from the gallows and the other from a tree, interconnect the European and American sides of the canvas.

On the American side, a crowd of White onlookers—including women and children—gawks at the body of a Black man who has just been lynched. Tall tenement buildings signify crowded urban housing in the North, while the interior view of a dilapidated cabin reminds us why Black residents sought to escape the rural South. The old White man leading the lynching party, dressed in a suit and holding up a large noose, is supported by an oversized police officer with an upraised billy club. The petite White woman standing between them signals false innocence and femininity with a smirk and downcast eyes. This figure further alludes to the mythos of the Black

Fig. 37 "The Negro's War," *Fortune* magazine, 1942, pp. 78–79. Private collection, Memphis.

Cat. 26 Jacob Lawrence, *No. 2, Main Control Panel, Nerve Center of Ship*, 1944; United States Coast Guard Heritage Asset Collection

68 **Cat. 24** John Wilson, *Deliver Us from Evil*, 1943; Collection of Kimberly and Elliot Perry

male rapist, which functioned to obscure the history of White male sexual assault on the bodies of Black women. Lewis portrays the Black family as caught in the middle, bereft of the protection against hatred and bigotry they should be able to claim as American citizens. It is a powerful interpretation of the conditions too many Blacks faced during World War II, forcing Americans to reckon with the conflicting roles Black soldiers encountered at home while also serving abroad.

Laura Wheeler Waring, considered a conventional artist, likewise created artwork linked to the Black American experience during World War II. Like Augusta Savage and Beulah Woodard, she was known for her dignified portraits of African Americans. She was one of the first Black artists to travel to Paris during the 1920s, where she totally immersed herself in studying the European tradition. Waring approached portraiture strongly influenced by the contested issue of Black representation discussed by leaders of the New Negro Movement. For instance, W. E. B. Du Bois explored readers' feelings about the state of portraiture in America by asking seven questions in a February 1926 *Crisis* "Opinion" column titled "A Questionnaire."[75] Their consensus was respectability, best portrayed in dignified images of significant Black leaders that would effectively combat the degrading stereotypes prevalent in American culture.

In 1929, Wheeler painted twelve portraits of Black women of achievement, meant to counteract prevailing negative stereotypes. It is important to note that Wheeler painted portraits of working-class women with the same degree of self-respect and dignity associated with middle-class professionals and individuals in leadership positions. Wheeler's approach to representing Black women is evident in the two portraits showcased in this exhibition, both from 1940: *Woman with Bouquet* (cat. 19) and *After Sunday Service* (cat. 18).

During the 1940s and 1950s, such imagery helped to define an acceptable portrayal of Black identity, professionalism, and middle-class respectability. In 1944 Mary Beattie Brady, Director of the Harmon Foundation, organized the exhibition *Portraits of Outstanding Americans of Negro Origin*, fifty paintings by Waring and the White artist Betsy Graves Reyneau.[76] It was so successful that it toured for ten years. The portraits' conservative style and the subjects' demeanor, perceived as nonthreatening, forecasted the direction of the civil rights movement in the 1950s. Waring had developed close relationships with her subjects, many of them friends and colleagues from working together as members of organizations like the NAACP and the National Urban League. These institutions laid the groundwork for victories in the civil rights struggles of the 1950s and 1960s. Waring's portraits of distinguished African Americans celebrated Black success achieved as a direct result of participation in World War II, and they looked ahead to the courtroom battles of the 1950s that would legally dismantle segregation.

Harlem Hospital Surgery (1953; cat. 45) by Jacob Lawrence is likewise influenced by the successes of Black professionals and the growing intensity of civil rights activism during the 1950s. The depiction of Black doctors first appeared as a theme in Lawrence's *Migration* series in 1941. Panel 56 pictures a Black male doctor equipped with a stethoscope and medical bag.[77] A thin young patient lies on the table, his bare chest exposed to the imposing physique of the authority figure leaning over him. This image follows a panel that shows the funeral of someone who has died of tuberculosis. The doctor is framed by a pyramid of light.[78] The artist's construction of the scene, although pared down and abstract, recalls the pyramidal composition and quasi-sacred status of the scientist in *The Gross Clinic* (1875) by Thomas Eakins. The caption that Lawrence composed to accompany

Cat. 19 Laura Wheeler Waring, *Woman with Bouquet*, ca. 1940; Brooklyn Museum

Cat. 18 (opposite) Laura Wheeler Waring, *After Sunday Service*, 1940; Petrucci Family Foundation Collection of African American Art

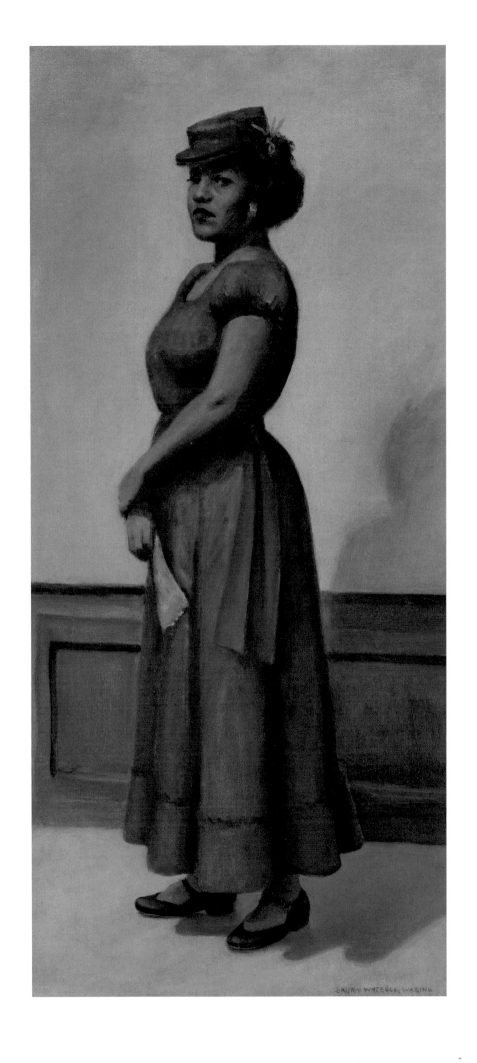

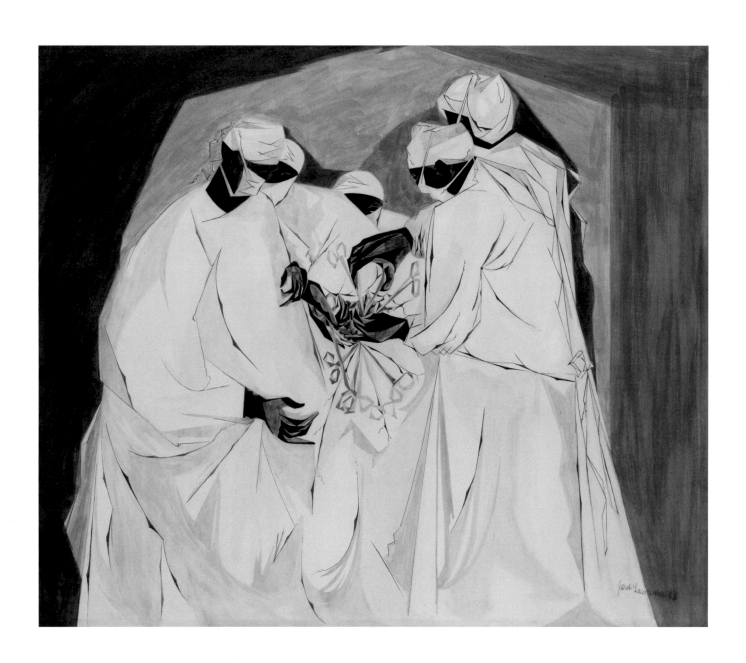

Cat. 45 Jacob Lawrence, *Harlem Hospital Surgery*, 1953; Private collection

the panel reads: "Among one of the last groups to leave the South was the Negro professional who was forced to follow his clientele to make a living." Lawrence therefore documents how Northern urban centers were filled with Black Southerners with specialized training like doctors, lawyers, teachers, social workers, the clergy, and artists who emerged to occupy leadership positions in the cities.

I would argue that Panel 56 was initially inspired by Lawrence's mentor, Charles Alston. In 1936 Alston received a Works Progress Administration commission for a mural series at Harlem Hospital Center (see fig. 26). He supervised twenty artists. Although Lawrence was not on the payroll for the project, he assisted Alston in transferring some of the drawings to the walls.[79] The hospital superintendent objected to the focus on African American subject matter, but protest from the community forced him to back down. Alston created two murals for the project: *Magic in Medicine* and *Modern Medicine*. The latter mural features a diverse group of scientists, doctors, and nurses in several vivid scenes that celebrate historical contributions and advancements. Two of the most prominent vignettes in the foreground represent a Black male doctor directing a medical team and surgeons at work in an operating room.[80] Alston's murals were restored as part of the Harlem Hospital Center renovation campaign in 2012.

Harlem Hospital Surgery replicates the visually dynamic scenes represented in *Modern Medicine*. Although Lawrence is working within the small, compact frame of an easel painting, the work has the monumental presence of a large mural. The elongated figures of the five masked doctors are compressed within a pyramid. Their heads, hands, and surgical tools interlock in a manner that weaves together a specific narrative about the history and practice of medicine in underserved communities. Even in metropolitan areas like Harlem, Black medics confronted insufficient supplies and staff as well as patients who often could not afford treatment. Still, they developed long-lasting relationships with their patients, established professional networks, and gained financial success.

In *Harlem Hospital Surgery*, the doctors gather around the draped body of the patient in the operating room in a protective manner. The white gowns of the surgeons and the patient blend together in angular peaks and folds that cascade toward the viewer. The life-and-death nature of surgery is referenced in the stylized patterns of blood and the exposure of internal organs lying next to the abstracted clamps. The rich emerald green of the background melds into a sterile hospital green. Dynamic black lines contrast with the pristine whiteness that spans the canvas in a triangular composition. Lawrence created a formal structure that effectively portrays how the psychological and the professional converge around medical care in the Black community.

Modernist Aesthetics

Sieglinde Lemke asserts in *Primitivist Modernism: Black Culture and the Origins of Transatlantic Modernism* (1998) that modernist movements should be understood as more culturally diverse than has previously been acknowledged by art historians.[81] This perspective informs the work of art historians reexamining traditional narratives concerning the evolution of modernism. From the mid-1930s to the early 1940s, abstract influences in American art were being actively promoted through exhibitions, publications, and lectures. However, there was still resistance in the academy to abstract developments. For example, during his studies at the Philadelphia Museum School of Industrial Art between 1935 and 1939, Claude Clark, following the techniques of Van Gogh and Cézanne, adapted the palette

Fig. 38 Walter Simon (American, 1916–1979), *Poor from My Mother's Womb: Lines from Villon #2*, 1947. Casein on board, 13 × 23 inches. Collection of Wynne Hollinshead, San Diego.

knife as his trademark tool of choice. Clark noted that faculty and students viewed modernist methods as oppositional to traditional art instruction. He was called a "filthy modernist" because he applied paint with a palette knife.[82] However, by the mid-1940s realistic painting was condemned as nonprogressive and abstraction was considered the height of modernism.

African American artists engaged deeply with modernism as it developed in New York City, even while restricted by racial barriers. The limited number of artists allowed into the circle, including Norman Lewis (cat. 40) and Romare Bearden, who showed with major galleries linked to Abstract Expressionism and are visible in widely circulated group photographs, were still relegated to the periphery. Hale Woodruff and Charles Alston were the first Black faculty to integrate major art institutions in New York during this period: New York University and the Art Students League, respectively. Yet their contributions to modernism were largely ignored by the mainstream.

Painter Walter Augustus Simon Jr. was likewise an important participant in these developments. Mentored by Hale Woodruff, who served on his thesis committee, Simon completed a master's in art education and a doctorate in art history, both at New York University. Once Woodruff impressed upon him that Abstract Expressionism was the future, Simon never looked back (fig. 38). Simon went on to build a career that spanned over fifty years as an artist, teacher, and foreign service and cultural affairs officer in Afghanistan, Ceylon, and Egypt. Art historians currently reexamining the history of Abstract Expressionism draw attention to the fact that modernist thinking in America was infected with racism, effectively erasing Black artists such as Simon from the scene.[83] The movement, as consecrated in New York following World War II, claimed foundations in the European experience, negating the role of non-Whites in its American incarnation.

Ann Gibson, in *The Search for Freedom: African American Abstract Painting 1945–1975* (1991), argues that one of the most instructive factors to reconsider is how artists of African descent rethought their relationship to the "primitive" or the "African" in European modernism.[84] Through their own scholarly research, artists like Sargent Johnson, Thelma Johnson Streat, and Jacob Lawrence developed complex, highly intellectual approaches to representation that fused abstraction, ancestral heritage, and collective human

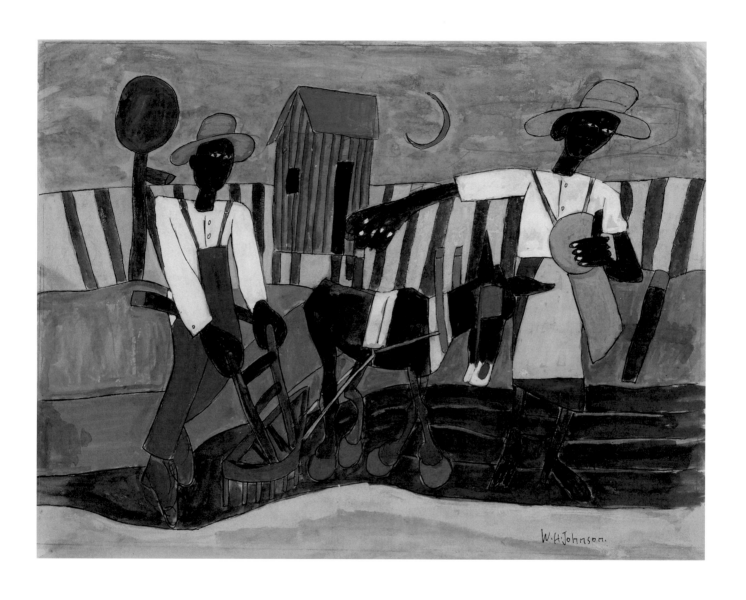

76 **Cat. 20** William H. Johnson, *Sowing*, 1940; The James E. Lewis Museum of Art, Morgan State University

experience. William H. Johnson, for instance, an expatriate who returned to the United States in 1938 after nearly a decade in Scandinavia, created art forms based on his study of both African art and the Black experience in the United States. Simplified abstract forms represent the daily rituals of life for Black Southerners in works like *Sowing* of 1940, effectively capturing the timeless quality associated with the group's collective folk heritage (cat. 20).

Black artists studying in Europe were influential in bringing avant-garde developments to the American art scene. Nancy Elizabeth Prophet and Archibald John Motley Jr. studied in Paris during the late 1920s and 1930s. Prophet took full advantage of the opportunity to experiment with new media and subject matter.[85] *Walk among the Lilies* (ca. 1935; cat. 10), a bas-relief depicting the solemn profile of a woman against a background scene of flowers and the sun, indicates that Prophet was influenced by the giant friezes Alfred Auguste Janniot created for the 1931 Paris Colonial Exposition. His monumental reliefs documenting Europe's colonial domains, executed on the façade of the Palais de la Porte Dorée in Paris, are titled *The Colonies' Contributions to France*.[86] This might account for the disturbing image of a monkey—or is it a mask?—wearing a crown, with bared teeth and staring eyes. Prophet wrote letters to her mentor, W. E. B. Du Bois, express-ing wonder at the grandeur of the Colonial Exposition. The relief raises questions about how American artists filtered the racist imagery associated with Africa and its peoples generated by colonialism. Such inquiries are inseparable from both the development of modernism and how early twenti-eth-century artists identified as artists of primarily African descent.

Archibald John Motley Jr. studied in Paris for only one year, from 1929 to 1930. The experience, however, totally transformed his interpretation of Afri-can diasporic culture. Form and color became essential to composition and the expression of diversity that so fascinated Motley. He created cropped or fragmented configurations crowded with flat shapes of color. Spatial dis-tortions and contrasting color enabled him to vividly depict a sense of Black musical culture during the Jazz Age of Paris.

On his return to the United States, Motley transferred that sense of modernism to the depiction of Black urban culture (cat. 6), documenting the lifestyle of migrants settling in the Bronzeville neighborhood on Chica-go's South Side. *Bronzeville at Night* (1949; cat. 35) is a later version of the style Motley perfected during the Great Depression. Bright, high-contrast pinks, reds, and yellows brighten night scenes dominated by dark blues, purples, and black. The compression of space intensifies the feel of bustling activity. Vice and vitality saturate Motley's portrayal of social life, populated by attractive and stylishly dressed women, well-dressed men in suits and fedoras, and children snacking on candy. The action takes place at the corner of a busy city street illuminated by the glow of artificial light from cars, streetlights, and interior rooms. Motley's paintings were used to illustrate the opening sequences of *Devil in a Blue Dress*, the 1994 film starring Denzel Washington and based on the Ezekiel "Easy" Rawlins mysteries written by Walter Mosley (fig. 39).

Motley was one of the few Black artists during the 1930s to experiment with the classical nude. *Brown Girl After the Bath* (1931; cat. 3) is an intimate scene of a young woman sitting in front of a vanity and pensively observing her reflection in the mirror. The setting borrows from the dark richness of Dutch interiors and the draped open vista techniques in Renaissance and Baroque portraiture. The creamy brown skin tones of the sitter enhance the warm redness of the gown draped across the stool, the dark brown vanity, and the gold coloring of the lampshade. She has already applied her makeup and put on earrings and buckled her fashionably plaid Mary Jane shoes. She

Cat. 10 Nancy Elizabeth Prophet, *Walk among the Lilies*, ca. 1935; Private collection

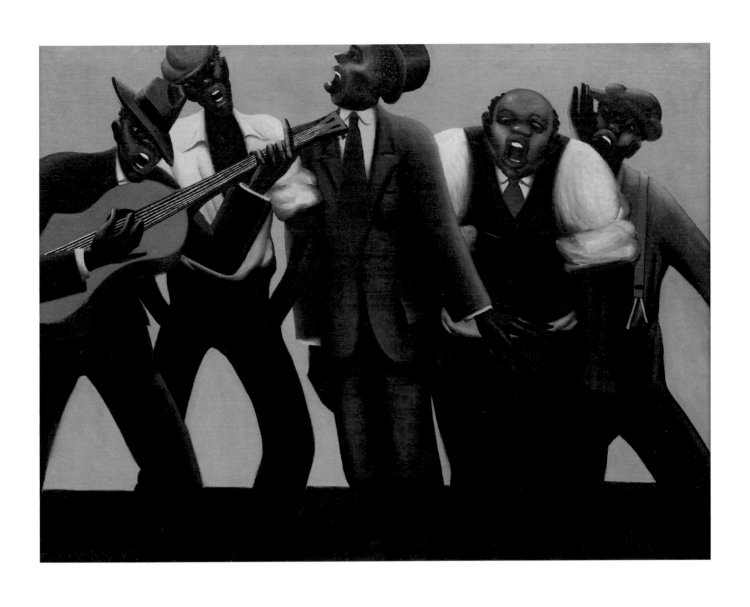

casually leans on the arm of the vanity to consider her appearance. The nudity in Motley's scene is experienced from complex perspectives. Initially, the viewer is drawn into the bedroom via the subject's seated, three-quarter position. The act of turning her body to look into the mirror redirects the gaze back toward the viewer. Or is there someone else in the room? *Brown Girl* contemplates her image with self-confidence in her sensuality and a sense of autonomy over her own body.

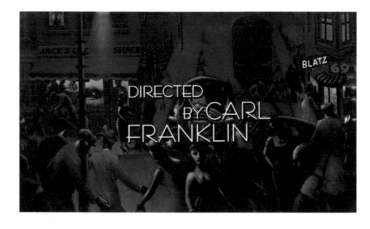

Fig. 39 Screenshot from *Devil in a Blue Dress*, 1995, written and directed by Carl Franklin.

Loïs Mailou Jones experimented with the diversity of the African diaspora by mixing African, Caribbean, American, and African American themes, iconography, and design.[87] Beginning in the 1930s Jones engaged with the African diaspora via study in Paris. During the 1940s she started traveling to the Caribbean.

While the African influences in Jones's graphic design work were usually drawn from African masks, her portrait interpretations of different peoples of African descent around the globe are equally significant visual research into the African diaspora. Jones first expressed the impact of travel to the Caribbean with an explosion of color in her painting. During the 1940s, yellow predominated as a color of her experimentation. In 1944 she painted *Eusebia Cosme,* inspired by the international fame of the Afro-Cuban poet and actress (cat. 25).[88] Gorgeous and impressionistic, the painting captures the joyful persona of Eusebia Adriana Cosme y Almanza (1908–1976), displaying an exuberance of color difficult to contain within its frame. Loosely constructed in thick swirls of paint in circular and wavy patterns, it has a rhythm that mimics song and dance. Yellow everywhere enhances the radiant brown of Cosme's skin. She is dressed in one of the flamboyant flounced costumes associated with her performances. Segregation kept her from performing in Cuban theater. Through her performances of poetry and dance, Cosme succeeded in translating identity and creating emotional connections between African descendants. For example, during her routines, Cosme translated the poems of Harlem Renaissance writers into Spanish. Her archive is housed at the Schomburg Center for Research in Black Culture in Harlem. Jones's portrait is one of the few formal artworks documenting this important Black woman artist in the field of African diasporic drama and theater.

Thelma Johnson Street was another pioneer in modern American art.[89] A visual artist and interpretive dancer, she integrated fine art, dance, music, and song that explored diversity from multiple perspectives. She studied indigenous dance, songs, and folk cultures, traveling to Haiti, Canada, Indonesia, Hawaii, Australia, France, England, and Mexico. Street grew up in Washington, Idaho, and Oregon, where she studied the arts of the Northwest Coast's Indigenous peoples, characterized by ovoids, S forms, and U forms. Bill Holm, in his seminal book *Northwest Coast Indian Art: An Analysis of Form* (1965), states that the "formline" was used to create internal design elements in abstract compositions.[90]

Street equated this approach to representation with her studies of African art and African American cultural resistance. *Baby on Bird (Untitled)* (ca. 1945; cat. 30) pictures a brown-skinned baby riding in the sky on the back of a swift eagle. Here, Street borrows from Haida totemic symbolism, wherein birds refer to the dead and the past, linking the living to ancestral wisdom and guidance from the spiritual world. The flying figures above may be owls or

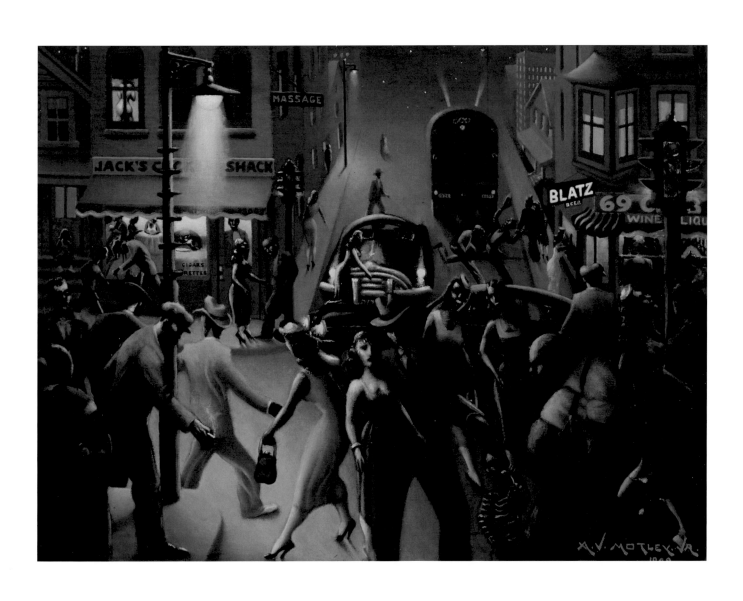

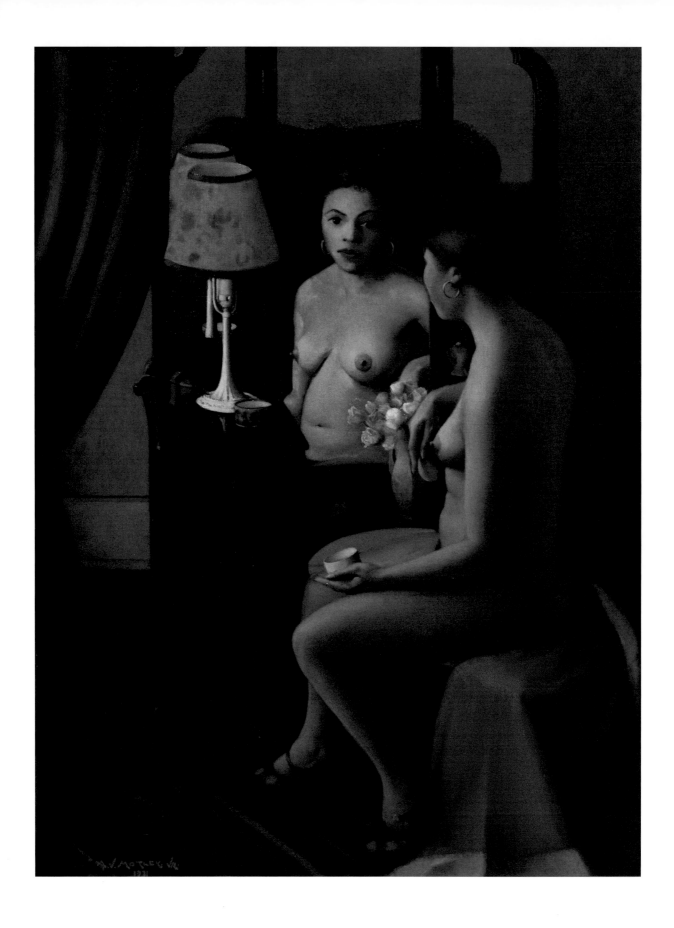

82　**Cat. 3**　Archibald John Motley Jr., *Brown Girl After the Bath*, 1931; Columbus Museum of Art, Ohio

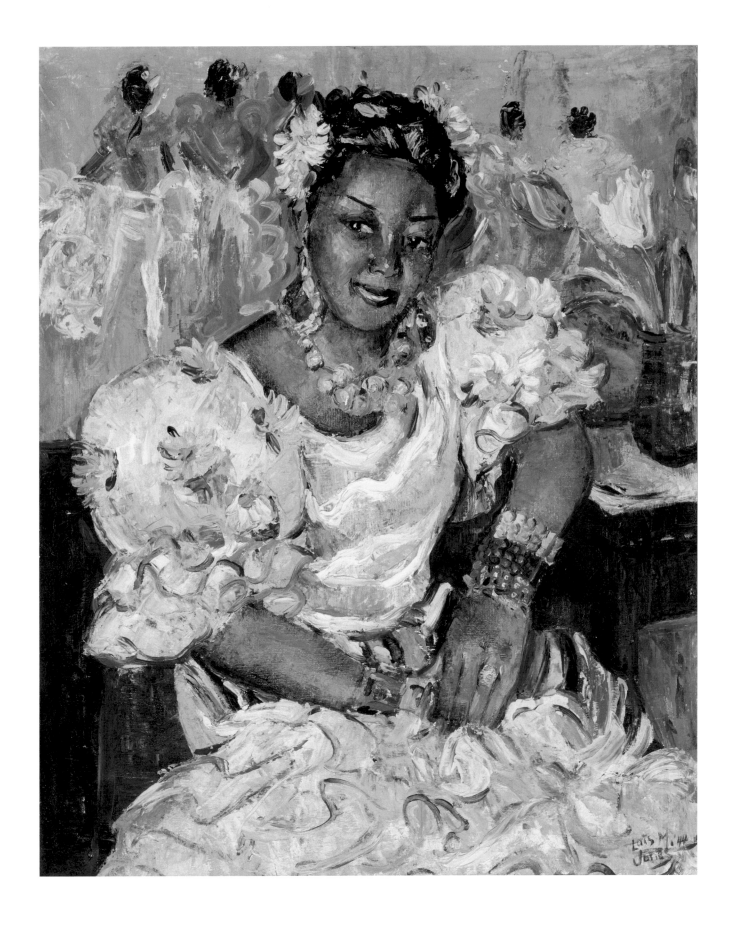

Cat. 25 Loïs Mailou Jones, *Eusebia Cosme*, 1944; Private collection 83

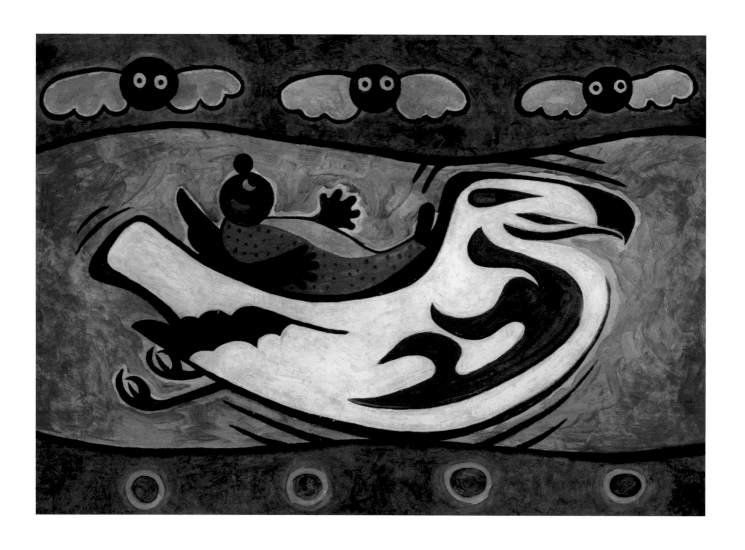

Cat. 30 Thelma Johnson Streat, *Baby on Bird (Untitled)*, ca. 1945; The John and Susan Horseman Foundation for American Art

angels.[91] I would also suggest that the Christian imagery in Streat's painting might refer to the history of Christian heritage and art that colonizers brought to Africa. Such winged cherubim or angels hover over holy figures in traditional Christian paintings of Ethiopia, as seen in the upper register of this mid-twentieth-century icon (fig. 40). The theme of flight also might refer to Black American folklore and song. In the spiritual "Swing Low, Sweet Chariot," enslaved people attain freedom from oppression in death, crossing over the River Jordan in a chariot that carries them back home to Africa. From her comparative studies across cultures, Streat understood that abstraction made possible a visual communication that could be incorporated into her artistic practice across media: painting, dance, song, and narrative.

Rose Piper (1917–2005) graduated as an art major from Hunter College, New York, in 1940.[92] She started attending the Art Students League in 1942, where professors introduced her to abstract styles. She won a Rosenwald Fellowship in 1946 to research Black folk culture, both rural and urban. Out of this was born Piper's fascination with the blues, specifically as expressed by Black women vocalists.

Piper's research on blues music and Black women's contributions to its aesthetic development led her to visually represent what they sang about: the historical struggle since the era of slavery to assert authority over their own bodies. Piper described her paintings as impressions gleaned from listening to the blues and folk songs created by Black Southerners. What she perceived from listening was the strength of Black women, particularly those among the working class, whose struggle for survival was very difficult. Piper employed a semi-abstract figurative style to portray artists like Bessie Smith, whom she most associated with the authenticity of the blues and the struggles of working-class Black women (see cat. 32). The juxtaposition of flat colors contrasts with the thin, red lines of blood seeping from Smith's body. However, the glow of bright yellow light that spills out around her head and upper body, almost like a halo, suggests the immortality Smith achieved via the artistic legacy she left behind.

Charles Alston was an educator, muralist, painter, sculptor, and illustrator whose career spanned five decades in New York. Alston had an early introduction to the influence of African art on modernism through Alain Locke, one of the architects of the New Negro Movement, whom he met during the late 1920s.[93] Alston assisted Locke in an exhibition of African sculpture and masks for the Schomburg Collection. In-depth discussions and opportunities to handle the pieces formed the foundation for African art's impact on his work. The figures present at the deathbed scene in *Midnight Vigil* (1936; fig. 41) display the elongated, angular forms characteristic of West African sculpture.

In 1938, assisted by a Rosenwald Fellowship, Alston toured the South for two years, exploring, photographing, and sketching urban and rural Black life. When Alston returned to New York, he worked as a freelance commercial artist. During the late 1940s he studied at the Pratt Institute, where he continued to build a successful career working with publishing and advertising agencies. It was at this time, however, that he made the decision to refocus on the fine arts, influenced by the growing interest in abstract movements in New York. Alston continued to experiment with abstraction and to work in a figurative mode during the 1950s. His work began to attract interest in 1950

Fig. 40 Unidentified artist, Ethiopian icon, early twentieth century. Oil on wood, 19 × 14 inches. Private collection, Memphis.

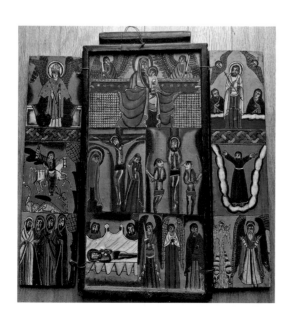

Cat. 32 Rose Piper, *The Death of Bessie Smith*, 1947; The John and Susan Horseman Foundation for American Art

Fig. 41 Charles Alston (American, 1907–1977), *Midnight Vigil*, 1936. Gouache on paper, 19¼ × 15 inches. The Harmon and Harriet Kelley Foundation for the Arts, San Antonio.

when the Metropolitan Museum of Art held its first exhibition of contemporary art and purchased the abstract oil he had submitted.

This exhibition includes *Jazz*, an example of Alston's figurative work from the same year (cat. 37). Alston's ability to represent the visual culture and sounds of jazz was nurtured during the 1930s on nocturnal visits to Harlem nightclubs such as the Savoy Ballroom. His geometric shapes and facial features, while reminiscent of his early experimentations with African sculpture, are softened by defining form with brushstrokes and smudged paint. Delicate white lines etched onto the surface delineate form. White contrasts with but also blends in with thick outlines around the figures and unifies the vocalist and horn, cello, and piano players in the collaborative act of making music. Dark and cool tones play off the performers' rich brown skin tones. The painting conveys a sense of the still, smooth sounds of cool jazz, which gradually replaced the intensity of bebop during the late 1940s. Alston's interest in Black women vocalists as muses—which began with his studies of blues singers in the 1930s—prevails. His monumental figures recall those of the Mexican masters, such as Diego Rivera and Rufino Tamayo.

Alston's commercial work—illustrations for journals, magazines, and books—was highly regarded. He worked extensively with *Fortune*, *Mademoiselle*, and the *New Yorker* magazines. He first created illustrations for *Fortune* in 1941, in collaboration with Deborah Calkins, the magazine's assistant art director, on Jacob Lawrence's *Migration* series.[94] Titled "'And the Migrants Kept Coming': A Negro Artist Paints the Story of the Great American Minority," it was the first time a mainstream publication had featured the work of an African American artist (fig. 42). Alston assisted Calkins in selecting his former student's images from the series, which were used to help tell the story about segregation in Northern industries.

One of Alston's most effective illustration projects was the commission for the October issue of *Pageant* magazine in 1956.[95] He created illustrations for an article on segregation titled "Who Is Jim Crow?: A Balanced, Informative Look at an Old Irritant." It was an unusual invitation from a women's magazine targeting a middle-class demographic that normally featured a fashionably dressed, young White female model on the cover. It may have been in response to heightened civil rights activity during 1955 and 1956, such as the murder of Emmett Till on August 28, 1955; Dr. Martin Luther King Jr.'s being sent to jail for allegedly instigating the bus boycott in Montgomery, Alabama; Autherine Lucy's admittance to the University of Alabama; or the Georgia, Mississippi, South Carolina, and Virginia governors' blocking school integration.

Listed prominently at the top of the contents page under the heading "A Pageant Report," the twenty-four page article attempts to explain segregation by examining its roots and deconstructing the elaborate ways in which "separate but equal" was enforced at all levels of Southern society. The article displays photographs of Black and White communities, a graphic photograph of a lynching victim, and photographs of separate

Cat. 37 Charles Alston, *Jazz*, 1950; Private collection

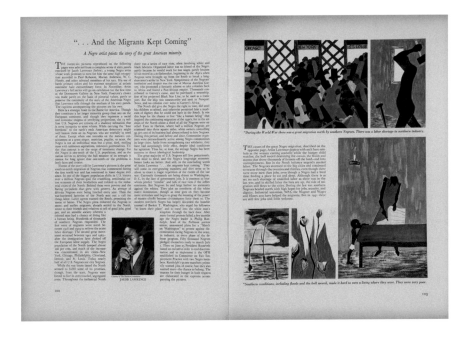

drinking fountains (fig. 43). Underneath the title, Alston's illustrations are described as "paintings." The style of the seven illustrations, unlike the *Fortune* magazine imagery, is modern, dominated by rich, dark-brown tones, and brightened by areas of white and neutral grays. Alston uses a dry smudging effect with the brown tones throughout that unifies the elements in the composition but also inverts whiteness. Visually, whiteness becomes secondary to the Black world view he presents (fig. 44). The figures are strongly sculptural, derived from his early studies of West African sculpture and masks.

It is significant that Black women are prominently featured. Visually, they read as the active agents in comparison to the male figures. In the scene depicting a sharecropper's cabin, it is the woman who is at work, while the man is portrayed in a despondent state of mind, possibly indicating unemployment (fig. 45). Alston created numerous images of Black women as mother figures. While influenced by Madonna imagery from many cultures, they also strongly resemble the cylindricality of African sculpture, as in *Mother and Child* (1950; fig. 46). Alston transferred the same tight sense of physical and emotional bonding to his two-dimensional painted images of Black maternity, as observed in *Pieta* (1956; fig. 47).

However, Alston's image of a Black domestic holding a White child lacks the motherly feelings characteristic of his maternal themes (fig. 48). The

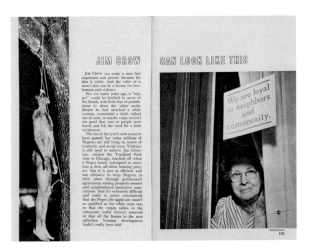

adult woman and the child do not grasp each other. Cropping the upper half of the Black woman's face also denies her identity. She is invisible to her employers, symbolic of the many Black women in the 1950s South still working in domestic service taking care of White women's children. In a scene created to illustrate the discussion about challenges to Jim Crow that were empowering Black people across the South, it is a middle-aged Black woman who looks directly at the intimidating policeman on his motorbike (fig. 49).

The most effective image may be the last. It is a portrait of a young Black woman staring directly out at the viewer (fig. 50). It is like painted sculpture, a carved portrait head composed of

angles and planes, supported by the strong, elongated column of the neck and foundational base. Underneath the portrait is a stanza from Gwendolyn Brooks's book of poetry *Annie Allen* (1949).[96] The book won the Pulitzer Prize in 1950, making Brooks the first African American to win the award. Brooks wrote politically and socially conscious poetry and prose that revealed the hidden transcript of Black life in urban twentieth-century America.

Brooks's literary work is an epic sweep (forty-three stanzas) through the life of Annie Allen, a young Black girl who grows up on the South Side of Chicago with romantic notions about happiness and fulfillment. Her social conditions are defined by poverty, violence, and racial discrimination. Brooks details how the urban environment causes Annie to mature early. She is forced to abandon youthful dreams for the realities of married life. Set against the backdrop of World War II, the narrative shows how Annie suffers the effects of the war. While White Americans generally benefitted from the postwar boom, many Black Americans failed to reap the full benefits of a country still troubled by racial tensions. Annie's husband returns from World War II with post-traumatic stress disorder. He abandons his wife, then returns home again to die. Interpreted together, the creative cultural works of Alston and Brooks more fully express the awakened racial consciousness of Black Americans during the 1950s than the *Pageant* article, which struggled to make its point.

Fig. 44 *Pageant* magazine, October 1956, pp. 128–29. Private collection, Memphis.

Fig. 45 *Pageant* magazine, October 1936, pp. 134–35. Private collection, Memphis.

Concluding Remarks

African American art history is a multifaceted enterprise. Since the fifteenth century (the birth of the modern era), we have spoken of a cultural legacy encompassing the Indigenous peoples of the Americas, people of various European and Asian ethnicities who immigrated to the United States, and the diverse peoples of primarily African descent in the Western world whose Black bodies survived the Middle Passage. According to Celeste-Marie Bernier in *Stick to the Skin: African American and Black British Art, 1965–2015*, the oppression of slavery, colonialism, and empire forged historical, political, social, and cultural situations that formed a visual arts expression out of which emerged common threads. Bernier argues that such research depends on alternative methods of investigation and analysis that challenge traditional art historical strategies.

Black Artists in America examines artists, patrons, and subjects during an especially turbulent period of American history, firmly situated within the contexts of the Great Depression, World War II, and increasing civil rights activity. African Americans were an integral part of this common experience, even while their lives were affected by systemic racism. Through an interdisciplinary and comparative methodology, the exhibition looks at well-known and under-researched artists; addresses difficulties of accessibility to resources and absences in the archives; emphasizes the importance of multiple visual resources, including slides and photographs; and promotes

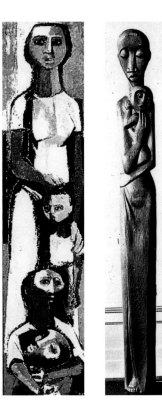

Fig. 46 Charles Alston (American, 1907–1977), *Mother and Child*, 1950. Pastel and ink on two sheets of joined onion paper, 82¾ × 10⅜ inches. National Gallery of Art, Washington, DC, Gift in honor of Ruth Fine from her friends at the National Gallery of Art and Billy E. Hodges, 2012.17.1.

Fig. 47 Charles Alston (American, 1907–1977), *Pieta*, 1956. Wood. Reproduced in photograph by unidentified artist.

Fig. 48 *Pageant* magazine, October 1956, p. 139. Private collection, Memphis.

Fig. 49 *Pageant* magazine, October 1956, pp. 142–43. Private collection, Memphis.

examinations of the artists' own intellectual contributions, such as writings and interviews.

African American artists during the first half of the twentieth century responded with an astonishing variety of work as they struggled to engage the national experience: violence and war, radical labor movements and populism, as well as racism and social protest. They experimented with methods of expression that ranged from realism to abstraction. Black artists not only participated fully but made significant contributions to the intense public dialogues about the arts' relationship to national and global identities, culture, and human rights.

Fig. 50 *Pageant* magazine, October 1956, p. 151. Private collection, Memphis.

Notes

1. For more on current developments in African American art history, see Mary Ann Calo, "The Significance of the Interwar Decades to Scholarship on African American Art," *The Routledge Companion to African American Art History*, ed. Eddie Chambers (New York and London: Routledge, 2020), 16–26.

2. On art during the Great Depression, see Judith A. Barter, *America after the Fall: Painting in the 1930s* (Chicago: Art Institute of Chicago, 2016).

3. Anna O. Marley, "Introduction," in Anna O. Marley, ed., *Henry Ossawa Tanner: Modern Spirit* (Berkeley: University of California Press, 2012), 39–41.

4. Sarah Kelly Oehler, *They Seek a City: Chicago and the Art of Migration, 1910–1950* (Chicago: Art Institute of Chicago, 2013).

5. See "The Numbers Game," https://en.wikipedia.org/wiki/Numbers_game.

6. Matthew Vaz, *Running the Numbers: Race, Police, and the History of Urban Gambling* (Chicago: The University of Chicago Press, 2020).

7. Edward Clark, "Annamae Palmer Crite and Allan Rohan Crite: Mother and Artist Son—An Interview," *Melus* 6, no. 4, *Non-Traditional Genres* (Winter 1979): 67–78.

8. Ibid., 73.

9. For more on Black artists during this period, see Stacy I. Morgan, *Rethinking Social Realism: African American Art and Literature, 1930–1953* (Athens, GA: University of Georgia Press, 2004), and *The Social and the Real: Political Art of the 1930s in the Western Hemisphere*, ed. Alejandro Anreus, Diana L. Linden, and Jonathan Weinberg (University Park, PA: Pennsylvania State University Press, 2006).

10. For more on the exhibitions, see Dora Apel, *Imagery of Lynching: Black Men, White Women, and the Mob* (New Brunswick, New Jersey: Rutgers University Press, 2004).

11. Helen Langa, "Two Anti-Lynching Art Exhibitions: Politicized Viewpoints, Racial Perspectives, Gendered Constraints," *American Art* (Spring 1999), 11–39.

12. See online exhibition curated by Paul Blom, *America's Strange Fruit: Hale Aspacio Woodruff's Giddap (1935)*, https://lynching.omeka.net/exhibits/show/giddap/giddap-analysis.

13. Mark Cole, "'I, Too, Am America': Koramu Howe and African American Artists in Cleveland," in *Transformations in Cleveland Art, 1796–1946: Community and Diversity in Early Modern America* (Cleveland Museum of Art, 1996), 146–61.

14. Alfred L. Bright, "Cleveland Karamu Artists: 1930–1945," 72–83. Library Research paper accessed at https://academic.csuohio.edu/tah/regional_arts/Cleveland_as_a_Center/p72karamu.pdf.

15. Kimberly L. Phillips, *AlabamaNorth: African-American Migrants, Community, and Working-Class Activism in Cleveland, 1915–45* (Urbana: University of Illinois Press, 1999).

16. Bright, "Cleveland Karamu Artists," p. 77.

17. Robert Young, "Nothing But a Man: Filmmaker's Perspective," *Black Camera* 3, no. 2 (Spring 2012), 91–100.

18. John Ittmann, "I Always Wanted to Be an Artist," in *Dox Thrash: An African American Master Printmaker Rediscovered* (Philadelphia Museum of Art, 2001), 23–24.

19. Kymberly M. Pindar, "'Racial Idiom' in the Work of Dox Thrash," in John Ittman, ed., *Dox Thrash: An African American Master Printmaker Rediscovered* (Philadelphia, PA: Philadelphia Museum of Art 2001), 81.

20. *A Useful Imagination (facing left)*, accessed at "Dox Thrash: Revealed," a companion site to the Philadelphia Museum of Art exhibition *Dox Thrash: An African American Master Printmaker Rediscovered*, https://www.philamuseum.org/doc_downloads/education/ex_resources/doxThrash.pdf.

21. John Ittman, *Dox Thrash*, p. 22.

22. Daniel Schulman, "African American Art and the Julius Rosenwald Fund," in *A Force for Change: African American Art and the Julius Rosenwald Fund*, ed. Daniel Schulman (Chicago, IL: Spertus Institute of Jewish Studies and Northwestern University Press, 2009), 64–65.

23. Schulman, *A Force for Change*, 51.

24. Ibid., 13.

25. Ibid., 14.

26. Ibid., 65.

27. Charles White, "Path of a Negro Artist," *Masses and Mainstream*, April 1955, 39–40.

28. Romare Bearden and Harry Henderson, *A History of African American Artists: From 1792 to the Present* (New York: Pantheon Books, 1993), 411–12.

29. Ibid., 422–23.

30. Schulman, *A Force for Change*, 69.

31. Ibid., 69–73.

32. Liesl Olson, "Seeing Eldzier Cortor," *Chicago Review* (2016): 119–42.

33. On the relationship between painting and photography during this period, see Laura Katzman, "The Politics of Media: Painting and Photography in the Art of Ben Shahn," *American Art* 7, no. 1 (Winter 1993), 60–87, and Tonya Sheehan, "Confronting Taboo: Photography and the Art of Jacob Lawrence, *American Art* 28, no. 3 (Fall 2014), 28–51.

34. For one of the few articles about the artist, see Jerry L. Longley, "The Fantasy World of Fred D. Jones: Re-Discoverig His Life in Art," *International Review of African American Art* (2012): http://iraaa.museum.hamptonu.edu/page/The-Fantasy-World-of-Fred-D%3E-Jones.

35. See Virginia Spottswood Simon, "Qualities of Loneliness and Light," *The International Review of African American Art* 16, no. 1 (1999), 2–18.

36. Melvin Marshall and Blake Kimbrough, "Above and Beyond Category: The Life and Art of Charles Sebree," *The International Review of African American Art* 18, no. 3 (2002), 2–17.

37. Schulman, *A Force for Change*, 118–19.

38. Darlene Clark Hine and John McCluskey Jr., eds., *The Black Chicago Renaissance* (Urbana, Chicago: University of Illinois Press, 2012), 189–90.

39. "Irene V. Clark Biography," https://www.askart.com/artist/Irene_Clark/101483/Irene_Clark.aspx.

40. Samella Lewis, *African American Art and Artists* (Berkeley: University of California Press, 2003), 176.

41. See Nigel Freeman, "The Hot Bid," at https://thehotbid.com/2020/01/23/an-irene-clark-painting-shown-in-ebony-magazine-could-sell-for-7000/.

42. "The JPC Art Collection," *Ebony*, December 1973, 41.

43. Leslie King-Hammond and Tritobia Hayes Benjamin, *Three Generations of American Women Sculptors: A Study in Paradox*, ed. Carolyn Shuttlesworth (Philadelphia, PA: The Afro-American Historical and Cultural Museum, 1996).

44. Lisa E. Farrington, "May Howard Jackson, Beulah Ecton Woodard, and Selma Burke," in Amy Helene Kirschke, ed., *Women Artists of the Harlem Renaissance* (Jackson, Mississippi: University Press of Mississippi, 2014), 115–56.

45. King-Hammond and Benjamin, *Three Generations of American Women Sculptors*, 39.

46. Letter from Beulah Woodard to W. E. B. Du Bois, in W. E. B. Du Bois Papers-series 1A, General Correspondence, digital collection, Special Collections and University Archives, University of Massachusetts, Amherst.

47. Ibid.

48. Daniel Widener, *Black Arts West: Culture and Struggle in Postwar Los Angeles* (Durham, NC: Duke University Press, 2010).

49. For more on Maudelle Bass, see Carla Williams, "Maudelle Bass: A Model Body," *Nka: Journal of Contemporary African Art* 21 (Fall 2007), 34–46.

50. Naomi Bloomberg, "Lester Horton: American Dancer and Choreographer." https://www.britannica.com/biography/Lester-Horton.

51. Williams, "Maudelle Bass," 36.

52. On Savage's career as an inspirational teacher, see Romare Bearden and Harry Henderson: *A History of African American Art from 1792 to the Present* (New York: Pantheon Books, 1993), 172–76.

53. For more on art collections at HBCUs, see Richard J. Powell and Jock Reynolds, *To Conserve a Legacy: African American Art from Historically Black Colleges and Universities* (Andover, MA, and New York: Addison Gallery of American Art and the Studio Museum in Harlem, 1999).

54. On Samella Lewis's significant impact on the arts, see Suzanne Muchnic, "Samella Lewis," in *Samella Lewis and the African American Experience* (West Hollywood, CA: Louis Stern Fine Arts, 2012), 12–24.

55. John Biggers's doctoral thesis was titled *The Negro Woman in American Life and Education*. See Gallery Guide for Biggers Mural, at Northeast Texas Community College: www.ntcc.edu /biggers.

56. For more on Vertis Hayes, see Earnestine Jenkins, "Muralist Vertis Hayes and the LeMoyne Federal Art Center: A Legacy of African American Fine Arts in Memphis, Tennessee, 1930s–1950s," *Tennessee Historical Quarterly* LXXIII, no. 9 (Summer 2014): 132–59.

57. Correspondence with Amy Torbert, the Andrew W. Mellon Foundation Assistant Curator of American Art at the St. Louis Museum, June 4–5, 2020.

58. Vertis Hayes, "The Negro Artist Today," in Francis V. O'Connor, ed., *Art for the Millions* (Greenwich, CT: New York Graphic Society Ltd., 1973), 210–12.

59. See Patricia Junker, *John Steuart Curry: Inventing the Middle West* (New York: Hudson Hills Press).

60. Ibid., 136–38.

61. For more on the significance of religious themes in Black art, see James Romaine and Phoebe Wolfskill, eds., *Beholding Christ and Christianity in African American Art* (University Park, PA: The Pennsylvania University Press).

62. "100 Paintings for LeMoyne," *Press-Scimitar*, April 21, 1960.

63. "LeMoyne's Morris to Study in Iowa," *Press-Scimitar*, January 25, 1960. See Special Collections, Reginald Morris, folder 8652.

64. Anita Strezova, *Hesychasm and Art: The Appearance of New Iconographic Trends in Byzantine and Slavic Lands in the 14th and 15th Centuries* (Australia National University Press, 2014), 135–36.

65. Interview with retired LeMoyne-Owen librarian Addie Golden, conducted by phone with Jeff Huebner, April 2013. Charles Christian, a current member of Second Congregational Church, recently conducted an interview with Dr. William Fletcher (November 2020), a retired mathematics professor at LeMoyne-Owen and close friend to Morris, who also recalled that Morris spent summers in Mexico.

66. Ben Shahn was asked to create the mural by Gassner-Nathan-Browne, the Memphis architectural firm that had designed the library. See Clark Porteus, "LeMoyne to Unveil and to Dedicate," *Press-Scimitar*, November 15, 1963.

67. Cedric Dover, *American Negro Art* (New York: New York Graphic Society, 1960), 40.

68. Ilene Dube, "Rex Goreleigh's *Migration* Series Remembered," at https://princetoninfo.com /rex-goreleighs-migration -series-remembered/.

69. See online exhibition by Francesca Giannetti, *Invisible Restraints: Life and Labor at Seabrook Farms*, posted March 17, 2016, https://njdigital highway.org/exhibits/seabrook _farms.

70. For more on Lawrence's experience with the Coast Guard, see Bearden and Henderson, *A History of African American Artists from 1792 to the Present*, 301–4.

71. *Fortune*, June 1947, 77.

72. See Vivian M. Baulch and Patricia Zacharias, "The 1943 Detroit Race Riots," *The Detroit News*, February 11, 1999.

73. For more on Pippin's war illustrations, see Jeffrey T. Sammons and John H. Morrow Jr., "Horace Pippin: World War I Soldier, Narrator, and Artist,"

Pennsylvania Legacies 17, no. 1 (Spring 2017), 12–19.

74. Richard J. Powell, "'I, Too, Am America': Protest and Black Power: Philosophical Continuities in Prints by Black Americans," *Black Art: An International Quarterly* 2, no. 3 (1978), 4–24.

75. Henry Louis Gates Jr., "The Black Person in Art: How Should S/He Be Portrayed?" *Black American Literature Forum* 21, no. 3 (Fall 1987): 317–32.

76. See "The Negro Artist Comes of Age: Portraits of Distinguished Negro Citizens," *Brooklyn Museum Bulletin* 7, no. 2 (November 1945). The National Portrait Gallery honored the earlier exhibition's attempt to address segregation in its 1997 exhibition *Breaking Racial Barriers: African Americans in the Harmon Foundation Collection*. For a recent article on Waring, see Valerie Horns, "Life of a Portrait: Laura Wheeler Waring's *Anna Washington Berry*," *Pennsylvania Heritage* (Summer 2019), 1–5.

77. Elizabeth Hutton Turner, *Jacob Lawrence: The Great Migration Series* (Washington: The Rappahannock Press and the Phillips Collection, 1993), 125.

78. Ibid.

79. See the blog by Lisa Herndon discussing the Works Progress Administration Collection at the Schomburg Center: https://www.nypl .org/blog/2021/04/06 /recommended-schomburg -center-art-artifacts.

80. Alvia J. Wardlaw, "Harlem Hospital Murals: 'Forming an Intelligent Part of the Community,'" in Wardlaw, *Charles Alston* (San Francisco: Pomegranate, 2007), 26–32.

81. Sieglinde Lemke, "Picasso's 'Dusty Manikins,'" in *Primitivist Modernism: Black Culture and the Origins of Transatlantic Modernism* (Oxford: Oxford University Press, 1998), 31–56.

82. Claude Clark Papers 1942–2000, pp. 64–65, digital access at *Claude Clark Artworks: Reflections of 20th-Century Life*, created in 2019.

83. See Anne Gibson, "Two Worlds: African American Abstraction in New York at

Mid-Century," in *The Search for Freedom: African American Abstract Painting, 1945–1975* (New York, NY: Kenkeleba House, 1991), 11–53.

84. Ibid., 18–21.

85. Theresa Leinenger-Miller, *New Negro Artists in Paris: African American Painters and Sculptors in the City of Light, 1922–1934* (New Brunswick, New Jersey: Rutgers University Press, 2001).

86. Ibid., 58–59.

87. See Tritobia Hayes Benjamin, *The Life and Art of Loïs Mailou Jones* (San Francisco: Pomegranate Artbooks, 1994).

88. Takkara Brunson, "Eusebia Cosme and Black Womanhood on the Transatlantic Stage," *Meridians* 15, no. 2 (2017), 389–411.

89. Judy Bullington, "Thelma Johnson Streat and Cultural Synthesis on the West Coast," *American Art* 19, no. 2 (Summer 2005): 92–107.

90. Quoted in Thom Pegg, *Thelma Johnson Street: Faith in an Ultimate Freedom* (St. Louis, MO: Tyler Fine Art, 2014).

91. Ibid., 65.

92. Schulman, "A Force for Change," 73.

93. Bearden and Henderson, *History of African American Artists*, 261–62.

94. Julia Hotten, *Charles Alston and the "306" Legacy* (New York: Cinque Gallery, 2000), 7.

95. "A Pageant Report: 'Who Is Jim Crow: A Balanced, Informative Look at an Old Irritant,'" *Pageant* 12, no. 4 (October 1956): 128–51.

96. For an analysis of Brooks's poem as social commentary, see Jill M. Parrott, "How Shall We Greet the Sun?: Form and Truth in Gwendolyn Brooks's *Annie Allen*," *Style: Public Discourse, Forms, Plots, and Consciousness* 46, no. 1 (Spring 2012), 27–41.

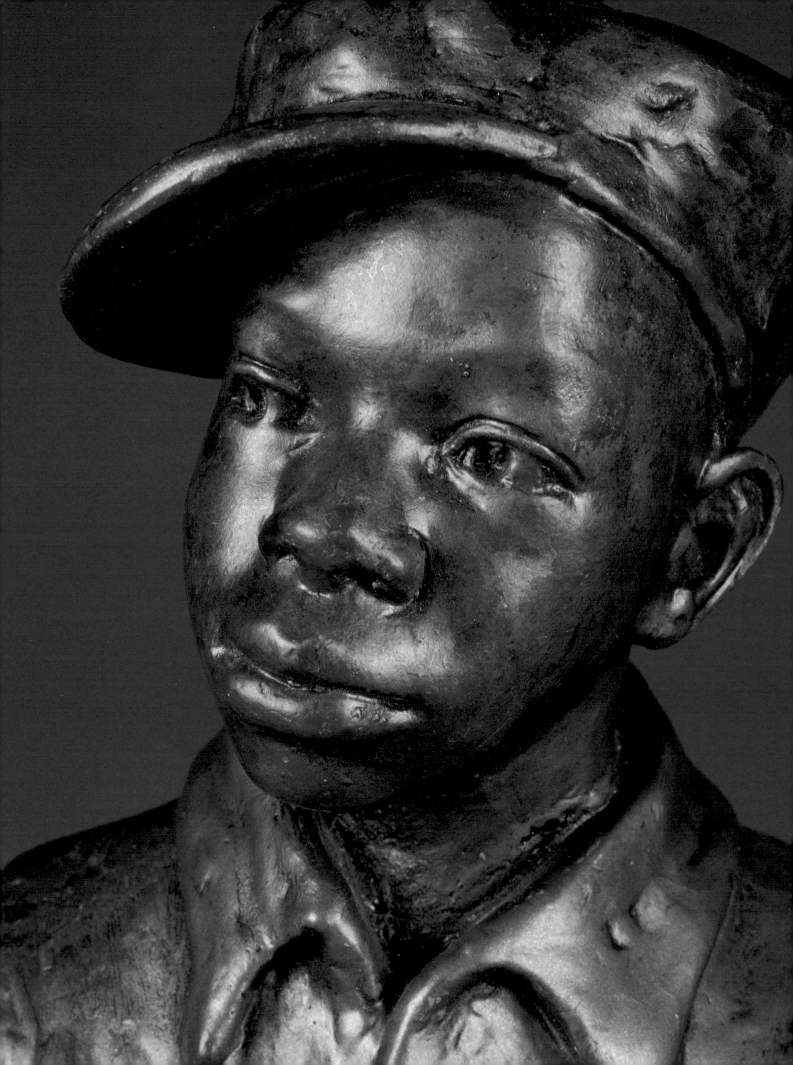

Augusta Savage in Paris

African Themes and the Black Female Body

Augusta Savage in Paris

African Themes and the Black Female Body

Augusta Savage (1892–1962) had the rare opportunity as a Black American artist to study in Paris during the 1930s when it was the global center of art, literature, music, and cinema (fig. 1). The seminal scholarly work on Savage's years in Paris was initiated by art historian Theresa Leininger-Miller in her book *New Negro Artists in Paris: African American Painters and Sculptors in the City of Light, 1922–1934*.[1] Leininger-Miller argues that this was the most original period of the artist's career, when she experimented with different media and subject matter to create artworks influenced by classical art, European romanticism of the nineteenth century, modern aesthetics, and African themes. The latter is significant, as Savage arrived in Paris strongly influenced by the New Negro Movement, the racial consciousness crusade of the 1920s. Like other Black American artists abroad, she encountered an African diaspora increasingly engaged in broad international discussions about peoples of African descent around the globe, linked by shared histories of slavery and colonialism. Black artists likewise witnessed firsthand the exploitation of African diasporic cultural expression by European artists. This essay explores how Savage responded to these developments, focusing on what Leininger-Miller refers to as the "Amazon series."[2] The three artworks, created in 1930, were inspired by the artist's confrontation with African history, art, and culture in late 1920s Paris as the city prepared for the Paris Colonial Exposition of 1931.

The New Negro Movement and the Evolution of a "Race Woman"

Augusta Savage moved North as part of the Great Migration, arriving in New York from Florida in 1921. She enrolled in Cooper Union and completed the four-year program in three years. She paid for her expenses by working as a domestic and won a working scholarship from the school. She studied modeling from the living figure under the direction of the eminent portrait sculptor George T. Brewster.[3]

Savage arrived in New York during a period of history known initially as the New Negro Movement but later, by the 1930s, as the Harlem Renaissance. The description defined strategies that challenged racism, violence, and inequality. In 1920 A. Philip Randolph and Chandler Owen published "The New Negro—What Is He?" in the radical journal *The Messenger*, asserting that the "New Negro" would be relentless in pursuit of political and social equality, unlike the "Old Negro" of the past, who advocated non-resistance.[4] Alain Locke published his seminal article "Enter the New Negro" in 1925, emphasizing the power of self-expression in confronting the weight of the history enslaved Africans brought to America in chains.[5] The new "race men" and "race women" were committed to awakening Black national consciousness and pride and improving African Americans' social status through racial uplift. Harlem's cultural revival soon manifested itself in urban centers with significant Black populations across the country.[6] Fueled by the migrants who had fled the American South during the Great Migration, the Harlem neighborhood of the borough of Manhattan in New York City considered itself the capital of the New Negro Movement. However, the New Negro Movement was a global phenomenon that included, for example, Black writers from the Caribbean and African colonists who lived in European metropolises such as Paris.

Fig. 1 Carl van Vechten (American, 1880–1964), *Augusta Savage*, 1937. Gelatin silver print, 9¹⁵⁄₁₆ × 7¹⁵⁄₁₆ inches. James Weldon Johnson Memorial Collection in the Yale Collection of American Literature, Beinecke Rare Book and Manuscript Library, Yale University.

In 1923 Augusta Savage was involved in what became an international incident symptomatic of the very issues that concerned activists identified with the New Negro Movement. During the spring she had applied to and was awarded a summer scholarship to the Fontainebleau School of Fine Arts in France.[7] She was included among the one hundred women provided with travel and study awards. The American selection committee of White male painters, architects, and sculptors was unaware, however, that a Black woman artist had been selected. When White women from the South protested sharing accommodations with Savage, the committee stripped her of the scholarship. As a "race woman," Savage protested the injustice by writing a letter that was published in the May issue of the *New York World,* concluding with these words: "I don't much care for myself because I will get along alright here, but other and better colored students might wish to apply sometime. This is the first year the school is open, and I am the first colored girl to apply. I don't like to see them establish a precedent."[8]

The uproar continued for several weeks, reaping newspaper coverage on both sides of the Atlantic. New York papers running the story included the *New York Amsterdam News, New York World,* the *New York Times,* and the *New York Herald Tribune.* The African American press, like the *Negro World* and the *Richmond Planet,* highlighted the racial consequences. The headlines "Americans Kept Girl from Art School" and "Protest Ban on Colored Student: Member of Ethical Culture Society Sails to France on Behalf of Miss Savage" both appeared in *The Richmond Planet.*[9] The French fiasco also generated declarations and letters of support from distinguished individuals such as respected scholar and leading figure of the New Negro Movement W. E. B. Du Bois and the eminent anthropologist Franz Boas.

While the pressure heaped upon the American committee did not persuade them to rescind their decision, the episode brought Savage a degree of celebrity that broadened her social circle amongst the Harlem elite. She

was befriended by Black artists and writers like Gwendolyn Bennett, Countee Cullen, Jessie Fauset, Langston Hughes, Zora Neale Hurston, Richard Bruce Nugent, Wallace Thurman, and Laura Wheeler Waring.[10] The groundswell of support for Savage following the American committee's decision even resulted in commissions. It was in the spring of 1923 that Savage was asked to sculpt a bust of Du Bois, which was presented in April to the 135th Street branch of the New York Public Library, where it remained on view for more than twenty-five years.[11] A similar commission from this period is the bust of Marcus Garvey, considered a fine portrait of the Black nationalist.[12] While both artworks are now lost and visible only in photographs, they communicate how well Savage had learned the techniques of portrait realism from her instructor at Cooper Union, William Brewster. Important for the patrons beginning to support her as a Black woman artist during the New Negro Movement was her depiction of humane, dignified Black leadership that rejected ignoble stereotypes.

Concurrently, Augusta Savage established one of her most important relationships in Harlem with the Garveyite movement.[13] Garvey was influential in exposing Harlemites to nationalist ideology via his Back to Africa movement, organized as the Universal Negro Improvement Association. While Savage did not believe in "returning" to Africa, she supported the Garveyite movement's philosophy of economic self-reliance and racial pride. Eric D. Walrond, associate editor of the *Negro World*—the newspaper founded by Garvey—published a story about Savage in 1922 titled "Florida Girl Shows Amazing Gift for Sculpture."[14] Walrond compared her to the Black woman sculptor Meta Warrick Fuller, reminding his readers that Warrick had studied with the great French artist Auguste Rodin. Garvey sat for a portrait Savage completed in 1922 and sold reproductions of the bust to support the movement by advertising the artwork in the *Negro World*. Savage also published her poetry in Garvey's newspaper.[15] She was also linked to the movement through her 1923 marriage to Robert Poston, an activist and colleague of Garvey's. The union was a happy one, and the couple were well-matched as activists. But Poston died suddenly on a boat returning from Africa, only five months after they married. Savage also lost their child: the infant lived only ten days after birth.

In 1925, Du Bois helped Savage obtain a scholarship to the Royal Academy of Fine Arts in Rome.[16] It covered only tuition, however, and she was not able to raise the money for travel and living expenses. Undaunted, Savage participated in exhibitions and continued her studies. She displayed her work at the *America Welcomes the World* exhibition in Philadelphia and at the 135th Street branch of the New York Public Library, both in 1926. That year she also showed twenty-two works at the Baltimore Federation of Parent Teacher clubs at the Frederick Douglass High School in Baltimore. The exhibition attracted more than 50,000 visitors and included work by Henry Ossawa Tanner and Meta Warrick Fuller. Savage was able to work with Italian-American sculptor Onorio Ruotolo, known for his realistic portraits of notable figures including Lenin, Enrico Caruso, and Abraham Lincoln. He regarded Savage as exceptionally talented and stated that she could attain some renown as a sculptor if properly assisted.[17] She also worked with Antonio Salemme (1892–1995), an Italian-American artist (sculptor, photographer, and painter), who was one of the most prominent artists of the 1920s and 1930s. Salemme was considered a major figure in American sculpture, but little is documented concerning his training of Savage. He was known for an expressive, portrait style of sculpture and for working with notable African American figures. Salemme's best-known works represent Black singers and actors Ethel Waters and Paul Robeson.

Finally, in 1929, with assistance from the Julius Rosenwald Fund, Savage got her chance to study abroad. Instrumental in this accomplishment was the executive secretary of the National Urban League, sociologist Eugene Kinckle Jones. Savage applied to study for two years in Paris with sculptor Antoine Bourdelle. While waiting to see if she would receive the funding, Savage was advised to work with the sculptor Victor Salvatore, who closely tutored her to prepare for working abroad. He also advised that "Miss Savage consider her future work largely in relation to her own people."[18] It was in September of 1929 that Savage completed *Gamin* (cat. 2), which was influential in the artist's being strongly recommended for the Rosenwald scholarship.

A Black Woman Artist in Paris

Augusta Savage was awarded a scholarship from the Julius Rosenwald Fund, making her the first visual artist granted one of its fellowships. When Savage arrived in Paris for her two-year study, she was based at the Académie de la Grande Chaumière, founded in 1904 and dedicated to both painting and sculpture. She was to study with master teacher Antoine Bourdelle (1861–1929), the influential sculptor taught by Auguste Rodin. The sculptor Alberto Giacometti and the painter Henri Matisse were among his students. Bourdelle's Art Deco sculptures helped create a bridge between the Beaux-Arts style and twentieth-century modernism. However, Bourdelle died within a few weeks of Savage's arrival. On its website, the school does list Augusta Savage and Laura Wheeler Waring, the African American painter, among its American students.[19] Waring studied at the school before Savage, first in 1914 and again in 1924–1925, which is probably why Savage chose the Académie de la Grande Chaumière in the first place.

Savage was then assigned to work with the sculptor Félix Benneteau-Desgrois, the professor at the Académie de la Grande Chaumière who had won the Grand Prix de Rome in 1909.[20] Benneteau-Desgrois allowed Savage to use his studio and wrote a very positive report for the Rosenwald Foundation, stating that Savage had obtained encouraging results and was very gifted.[21] After six weeks, however, she struck out on her own in order, she claimed, to develop an original style. Savage argued that the European masters were rather autocratic and controlling, expecting pupils to follow their model exactly. She intended to have a critic come in every few weeks to assess her work, but it seems that person never materialized. She claimed to have worked privately for one year with the sculptor Charles Despiau and a teacher named Madame Hadiji, both at the Académie de la Grande Chaumière.[22] Despiau, trained as an assistant under Rodin, was known for classical portraits and nudes. While Despiau was an instructor at the Académie, there is no record of a Madame Hadiji.

What we find, then, is that Savage was working independently in Paris. The reasons for her selecting self-study are unknown. Existing records do not reveal the circumstances of her reception as a Black student at the Académie de la Grande Chaumière. A Black woman artist working alone in the late 1920s may have found it difficult to construct supportive relationships with European artists built on trust, or to establish important social and professional networks within those circles. Nevertheless, she had access to the classroom studios at the Académie, where she could study the works of professors and students.[23] In fact, the initial works she produced, including *Terpischore at Rest* (*Reclining Woman*) and *La Citadelle—Freedom*, all seem to reflect her initial experiments with European romanticism, modernist trends in sculpture, and exposure to the classical tradition, particularly the female nude.

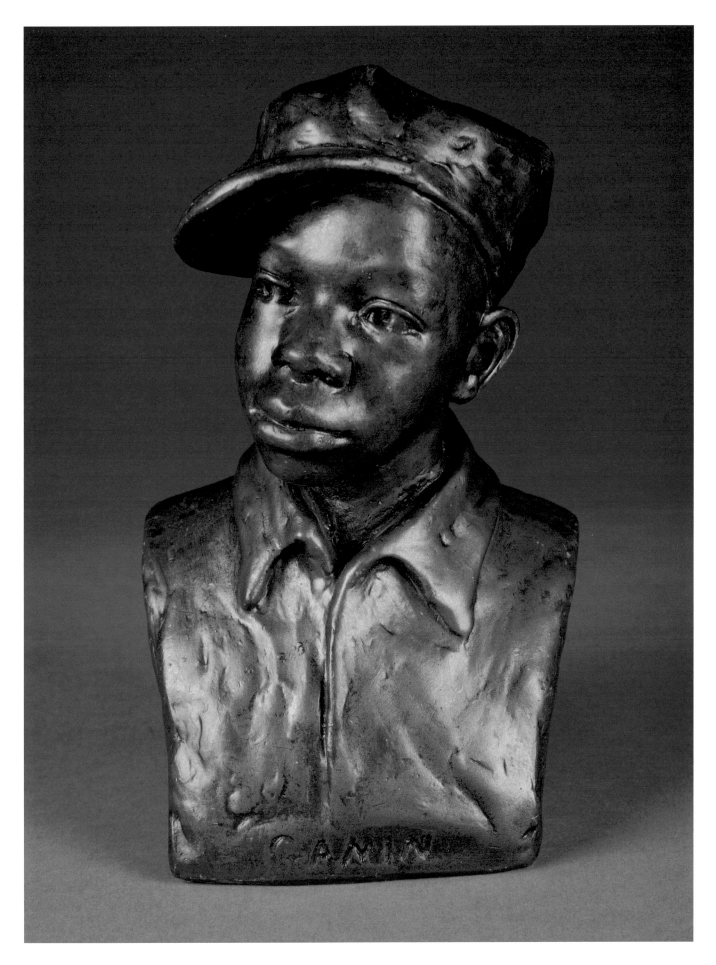

On the other hand, Savage was a vital participant in the diverse group of African American visual artists living in 1920s Paris, among them Aaron Douglas, Palmer C. Hayden, William H. Johnson, Nancy Elizabeth Prophet, and Hale Woodruff.[24] For these artists, Paris was a source of new subject matter and exposed them to novel styles of both European and African origin. Parisian landmarks were painted alongside the nightlife in jazz clubs that inspired Hayden and Archibald John Motley Jr. Looking to modernists Cézanne and Picasso, Hale Woodruff experimented with Cubism. The exposure to African art was linked to the vital role it played in the development of Cubism. Woodruff, Prophet, Hayden, and Savage were all successful in having their work exhibited in Parisian galleries.[25] Black painters and sculptors formed an integral part of the broader African American community in Paris. They visited and regularly dined with intellectuals including philosopher and art critic Alain Locke, poets Countee Cullen and Claude McKay, writer Eric Walrond, and journalist J. A. Rogers. Many musicians and entertainers made up what was known as the Negro Colony in Paris, including performers Sidney Bechet, Josephine Baker, and Florence Mills, the latter already famous when she first traveled to Paris on a tour of Lew Leslie's Broadway production *The Blackbirds*.[26]

The exposure to African art had a great impact on Savage as well, who began to integrate some of these visual themes into her work. I would argue that her most significant experimentation resulted in an innovative blend of African content with the tradition of the classical female nude in Western art. Savage created three sculptures stimulated by the history of women warriors in the African country of Dahomey: *Head of a Young Girl (Martiniquaise)*, a bust usually referred to as *Amazon*, and a figure Savage titled *Mourning Victory*, all dated to ca. 1930. Lost works of art, they are documented only through photographs in the Fisk University archives.[27]

These works may be lost and this period in the artist's life not extensively examined, but they nonetheless demand the attention of art historians. This is even more critical when we confront the reality that Savage did not continue in this direction upon her return to the United States. These works present challenging problems of investigation: How did Augusta Savage respond to being introduced to African culture and history in European environments during the height of colonization? How do scholars interpret the artist's confrontation with the French obsession with all things African, especially the impact of African art forms on Western artists? What are we to make of Savage's international encounters with African diasporic intellectuals, which are just as noteworthy as her interactions with Black American expatriates in Paris? I investigate these themes by focusing on what I will discuss as the artist's Dahomean series, as I argue that Savage was not representing European Amazons.

Paulette Nardal and the Negritude Movement

One of the most important Caribbean intellectuals Savage encountered was the writer Paulette Nardal. She produced the only significant writing and documentation about the artist in Paris.[28] Jane and Paulette Nardal were sisters from Martinique who came to Paris in the early 1920s to study classical literature at the Sorbonne, Paulette being the first person of African descent to attend the university when she enrolled to study English. Paulette studied African American and other Black literatures and completed her dissertation on Harriet Beecher Stowe's *Uncle Tom's Cabin*. Paulette Nardal was one of the founders in 1928 of *La Dépêche Africaine*, a radical bimonthly journal that ran for four years (fig. 2). Her sister Jane then joined the group as a staff writer. Hosting a salon with her sisters Jane and Andrée, Paulette Nardal

brought together Black intellectuals from Africa, the Caribbean, and the United States to discuss their experiences of being part of an extensive and complicated African diaspora intensely engaged in the search for identity.[29]

The Nardal sisters strengthened the newspaper's African diasporic perspectives. Their writings and concepts became central to the early Negritude movement and to the idea of a global Black diasporic community. Negritude evolved as a literary, poetic, cultural, and intellectual movement driven by Francophone writers of African descent. French-speaking Black expatriates living in Paris credited the New Negro Movement in the United States as a primary influence on their thinking about race consciousness and identity. Nardal viewed Black Americans as pioneers of cultural innovation, resistance, and preservation. She argued that their race consciousness was combined with a "fierce Americanism" that gave birth to a unique "Afro-American culture and expression that spoke to the specifics of their historical, socio-economic and political experience in America."[30] Nardal's writings on politics and culture addressed the tensions based on class differences within these communities, arguing for an African diasporic identity that was accepting of multiple heritages. She believed that having pride in her African heritage did not mean that she had to give up her French identity, despite its colonial history. She sought a middle ground that celebrated African, Caribbean, and French histories and traditions. Nardal's viewpoints were comparable to those of Savage as an African American, and it is the perspective from which she anticipated writing an article about a Black woman artist living and working in jazz age Paris.

Nardal visited Savage's studio in the summer of 1930. Impressed with the artist's work, she interviewed Savage as the basis for a feature article in *La Dépêche Africaine* titled "Une femme sculpteur noire" (fig. 3). Even at this early date, Nardal emphasized the unique experiences of Black women. She had written previously about Black women abroad in "In Exile" (1929), a short story about an exiled Caribbean woman. Nardal illustrated her article about Savage with three photographs: *Gamin*, *Head of a Young Girl*, and *Divinité Nègre.* Nardal's article was therefore a piece about Savage as a Black woman, an artist, and a Black American.

The title of the article is posed as a question at the end of the first paragraph, pointing out that Savage is the only sculptor among the musicians, dancers, and singers of color living in Paris and that, as the author notes, most of them are Black Americans. Savage told Nardal the core details of her life and the pursuit of her passion to be an artist: the child who formed clay inspired by the world around her; the student who fast-tracked her way through Cooper Union while working in a laundromat, Blanchisserie; the White American students whose refusal to accept a Black student initiated the Fontainebleau scandal; how W. E. B. Du Bois helped to get her a fellowship to study in Rome and her inability to raise the rest of the money to accept it; and how the artist finally arrived in Europe to study, largely because of the Julius Rosenwald Fund. Nardal used this information, including a list of the venues where the artist had shown work and a list of newspapers and magazines that had published pieces on Savage, to highlight her unique status as a Black female artist in France. Nardal ultimately characterized the slender young woman with the extraordinarily soft voice as, to use her own translation into English, as "a self-made waman [*sic*]."[31]

Savage showed Nardal several works in progress. She determined that Savage was an artist already at ease with a classical training that allowed originality to reveal itself. Nardal felt that Savage's approach to the arts came from a deeply embedded racial identity that contributed to her success in working with modernist influences. Savage informed the writer that the

sculpture *Divinité Nègre* was the result of her imagination and entirely symbolic, nourished by legends and stories as well as lectures about Africa (fig. 4). The sculpture portrays four heads aligned with two female forms connected back to back, supporting a globe held in place by their upraised arms. The two bodies' bent legs, parallel to the ground, form the shape of a star, which is also the base of the sculpture. While Savage claimed that her imagination was solely responsible for the piece, its distinctive construction is similar to the position common to female offering statues indigenous to West and Central African art forms. There would have been many opportunities in Paris for Savage to see, for example, Yoruba artworks like the figure represented in this postcard from the period, dated to 1910 (fig. 5). Nardal found that the severity of the piece, which she described as having a "restraint of details," lent the artwork a contained intensity. Nardal briefly discussed two other nudes Savage was working on as a series, a bust and a figure of a Black female. She described both as "Amazons" and added that the artist seemed to be obsessed with the histories of these formidable African women warriors. While Nardal criticized the severity or pared-down aspect of the sculptures, she nevertheless admired the expression of strength paired with femininity.

Nardal's article thus provides the initial entryway into exploring Savage's work with African themes via experimentation with the Black female form. Her interview with the artist documents that the bust and nude figure she labeled "Amazons" actually were linked to the legendary female warriors of Dahomey. She did not include pictures of these two sculptures in the article. However, Savage, who needed to document her work as required by the Rosenwald Fellowship, sent her sponsors photographs identifying the pieces; the photographs are

Figs. 2, 3 *La Dépêche Africaine*, August–September 1930, pp. 1, 5.

Fig. 4 Augusta Savage, *Divinité Nègre*, detail from *La Dépêche Africaine*, August–September 1930, p. 5.

Divinité nègre

Tête de jeune fille

Fig. 5 French postcard, 1910. Private collection.

Fig. 6 Augusta Savage, *Head of a Young Girl*, ca. 1930, detail from *La Dépêche Africaine*, August–September 1930, p. 5.

now in the Fisk University archives.[32] Art historian Theresa Leininger-Miller first noted the resemblance of the two photographed sculptures to *Head of a Young Girl*, pictured in Nardal's article (fig. 6).[33] It appears that the same young woman of African descent was the model for all three sculptures.

Depicting African Women Warriors: European Fantasies

Representing Black women as African warriors was a radical choice. Where did such a specific theme originate? In Nardal's interview, Savage told the writer that stories and lectures about Africa were her inspiration. References in her correspondence with the Rosenwald sponsors note that Savage was asked to participate in the 1931 Colonial Exposition, indicating a more direct reason for her creating the sculptures. Both explanations highlight the impact of being in Paris during the era of world fairs and expositions that popularized France's colonial exploitation. There had been five previous expositions, all created to impress upon the colonized the benefits of European exploitation and dominance.[34]

The African country of Dahomey was a significant part of Black visual culture in 1920s Paris.[35] The kingdom (located within present-day Benin) endured from about 1600 until it was defeated and annexed by the French as part of its vast colonial empire during the 1890s. Dahomey was founded by the Fon during the early seventeenth century and expanded by war and conquest, establishing itself as a major regional power by the eighteenth century. Through its sophisticated government, military, and trade systems, as well as its involvement in the slave trade, Dahomey dominated the Atlantic coast along the Bight of Benin. Dahomey was also an important religious (Vodun) center and epicenter for the arts in West Africa. However, Dahomey as an indigenous power from an African perspective situated

within the context of the continent's history was not how Parisians experienced the kingdom.

One of the first Europeans to write about Dahomey's female militia was Frederick Edwyn Forbes in his book *Dahomey and the Dahomans; Being the Journals of Two Missions to the King of Dahomey, and Residence at His Capital, in the year 1849 and 1850, Volume 1* (1851). Forbes was a British naval officer attempting to persuade Guezo, the King of Dahomey (1818–1858), to end the country's participation in the slave trade.[36] At the time, King Guezo had a female armed force of about 3,000 women.[37] Forbes drew attention to the legendary military leader Seh-Dong-Hong-Beh (ca. 1815–ca. 1870s). She led an armed force of 6,000 soldiers, men and women, against the Egba, a Yoruba people who raided the fortified city of Dahomey for slaves. Forbes drew a picture of Seh-Dong wearing the traditional women's uniform—a tunic, trousers, and skullcap—posed with a gun, wearing knives in her belts, and holding a decapitated victim's head. It is important to note the impact of these first images of Dahomean female warriors, and how they morph into what Augusta Savage would have seen by the time she arrived in Paris in 1929, almost ninety years later.

The French first had a chance to view performers portraying female warriors from Dahomey in 1891.[38] A British entrepreneur named John Wood brought a dance group from Dahomey to Paris, where they were housed in the exhibition hall of the Jardin d'Acclimatation (an amusement park and former zoo in Paris). This group had already performed the year before in the Netherlands. Wood advertised that there were twenty-four so-called Amazons in this group. Europeans began to refer to Dahomean women soldiers in this manner, borrowing from Greek mythology. France was fascinated with the idea of female African warriors, having recently engaged them in combat during the 1890 war with Dahomey. A French journalist, however, found out that there were no Dahomean women from the armed forces in this dance troupe. At the same time, France was still engaged in violent conflict with Dahomey, fighting a second war with the African kingdom between 1892 and 1894. It is therefore unlikely that King Behanzin could spare his female armed forces to go dance in Europe in 1891.

The African women in this first performance group were instructed to dress and perform in ways that emphasized the savage state of primitive peoples as envisioned by Europeans. They wore a bustier or bra-like type of clothing trimmed with many cowrie shells and bells, which was not the traditional military dress for female warriors.[39] However, eyewitness accounts point out that the dances were realistic, suggesting that the African performers, who did originate from Dahomey and neighboring ethnic groups like the Yoruba, were familiar with and had studied some of the ritual dances associated with the military, incorporating such movements into their performances. Accompanied by two drummers, they created dances based on military exercises like marching and re-enacted fighting sequences with muskets, swords, and hand-to-hand combat. French spectators were mesmerized by the piercing cries, rattling shields, foot stomping, and drumbeats, making the troupe amazingly successful in Paris.

Again in 1893, Parisians were entertained by one hundred and fifty African women performing as female warriors for crowds at the Champ de Mars.[40] This group would go on to perform across Europe, and even in America at the World's Fair in Chicago in 1893.[41] Even after King Behanzin was conquered and Dahomey was incorporated as a French protectorate in 1894, Dahomean themed entertainment at Paris exhibitions continued to attract the most visitors. The fascination with African female performers was thoroughly documented in nineteenth-century European print culture, including the press,

magazines, posters, and photographs (fig. 7). African women were visualized as both threatening and erotic. Portrayed with male muscular strength and agility in colorful posters advertising their performances, the women were frequently labeled as "black devils." The French public was thrilled by the Black female body, aroused by the physicality and provocative costumes enhancing their semi-nudity. The French expressed a subversive admiration for these African female warriors who had fought against French soldiers. The "othering" of the African woman's body caused it to be viewed as a site of transgression that upset the boundaries of modesty and reserve that regulated the lives of European women.[42] For the Parisian public, the combination of shock and pleasure they encountered was central to their exposition experience of the savage "Amazons" of Dahomey. The legacy of sexualized exploitation continued into early twentieth-century Paris, exemplified in the words of the French poet and novelist of the Symbolist school Jean Lorrain, who described the performance of the Dahomean dance troupe at the Paris Universal Exposition of 1900 thus: "the bronze nudes bristling with feathers, bejeweled with shells, the superb beasts of Dahomey, the white teeth and white eyes of the warriors of Behanzin."[43] Contemporary scholarship argues that ethnological expositions and museums played an important role in disseminating degrading and racist displays emphasizing cultural differences between colonized peoples and the civilized West.[44]

The goal of the Colonial Exposition of 1931 was to promote the benefits the French empire had brought to her subject peoples.[45] By this time, colonial exhibitions, world fairs, and universal expositions were elaborate, popular spectacles staged throughout Europe. According to Petrine Archer-Straw in *Negrophilia: Avant-Garde Paris and Black Culture in the 1920s*, the visual impact of colonial imagery, academic theory, and advertising converged in events and exhibitions that ignored the histories of slavery and colonial atrocities, justifying French exploration, conquests, and exploitation of the African continent.[46] African art, animals, and colonial produce were all "exhibited" as trophies of empire, while Africans in native costume entertained and lent a semblance of savage authenticity. The Colonial Exposition featured full-scale imitations of indigenous architecture like palaces from the Cameroons or the replica of the Great Mosque in Mali (fig. 8).[47] The theatrical visual splendor of the exhibits dramatized the African and Asian cultures appropriated by the French Empire from around the globe.

The Colonial Exposition of 1931 was indeed a remarkable visual experience for African American artists initially drawn to Paris due to its reputation as the world's foremost art center. It reinforced the impact of Paris as a "gateway to Africa at a time when travel to the continent was a distant reality."[48] The exposition presented a visual culture of the African diaspora that inspired artists to explore new content and forms. Black American artists became interested in depicting peoples from Africa and the Caribbean. In a letter to Du Bois, Nancy Elizabeth Prophet exclaimed: "Heads of thought and reflection, types of great beauty and dignity of carriage. I believe it is the first time that this type of African has been brought to the attention of the world in modern times. Am I right? People are seeing the aristocracy

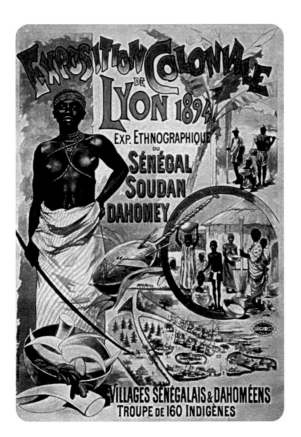

Fig. 7 Poster, Exposition Colonial, Lyon, 1894. Private collection, Memphis.

Fig. 8 Postcard, Paris International Colonial Exposition, 1931. Private collection.

of Africa."[49] Augusta Savage responded to the French fascination for the exotic with her own unique interpretation of European colonialist constructions, winning a gold medal for the sculpted bust of the African female warrior that Paulette Nardal titled *Amazon* in her article "La femme sculpteur noire."[50] Paris, an international metropole at the center of one of the world's great colonial empires, played a significant role in Black American artists' early and complicated experiences with the continent of Africa, its peoples, and expressive cultures.[51]

A Hidden Transcript: Artist Augusta Savage and Writer Zora Neale Hurston

Savage's engagement with the visual context of French colonialism and ethnographic exhibitions influenced how the artist chose to portray the women warriors of Dahomey. However, one is struck by how Savage envisioned them beyond the spectacle of sexuality and unleashed savagery embedded in the European imagination. Even though the figures have been described as such, European sources—specifically, the mythologies about Amazons— are difficult to visually reference in Savage's sculptures.[52] Her women warriors even rupture Dahomean norms of representation as well, since the warriors do not wear the traditional shirt and leggings of female soldiers. In neither of the historical situations suggested, the European context or the African, do the African women warriors Savage created display the character of merciless killers.

I argue that the experience of Africans enslaved in both Africa and the Americas is Savage's subject in the Dahomean series because she was directly influenced by the story of the *Clotilda*, the last slave ship to arrive in America, and its final survivor, Oluale Kossola, also known as Cudjo Lewis. I propose that Savage was familiar with the story about the *Clotilda* published by Zora Neale Hurston, another talented Black woman artist (writer, filmmaker, and anthropologist) and an associate of Augusta Savage who was also part of the New Negro Movement. Hurston published the story as an article in 1927 under the title "Cudjo's Own Story of the Last African Slaver."[53]

In 1927 Hurston had traveled to Plateau, Alabama, to interview Kossola, who was then in his eighties. Hurston documented the firsthand account of the raid that led to his capture and enslavement fifty years after the Atlantic slave trade had been outlawed in the United States. Although best known today as an important writer associated with the Harlem Renaissance, Hurston began her professional career as an ethnographer working with the eminent anthropologist Franz Boas conducting fieldwork on African

diasporic cultures in the American South, Haiti, and Jamaica. Boas helped establish Columbia University's anthropology department in the 1890s and was part of a school of anthropological thought concerned with challenging the scientific racism shackling the discipline during the late nineteenth and early twentieth centuries.[54] Hurston's fieldwork on the survivors of the *Clotilda* was also sponsored by American historian Carter G. Woodson, founder of the Association for the Study of Negro Life and History in 1915, which resulted in the publication of her article in the organization's scholarly periodical, *The Journal of Negro History*.

Hurston's article was criticized for plagiarism. She had borrowed from a story about the *Clotilda* survivors by Alabama writer and artist Emma Langdon Roche, published as *Historic Sketches of the South* in 1914. Forgiving her a young researcher's mistake and understanding that it was due to a lack of primary resource material, Boas sent Hurston back to the field to get the full story the next year in 1928. This time the research was largely funded by Charlotte Osgood Mason, a major patron of African American artists and writers, who continued to support Hurston's research as the materials were prepared for publication.[55] Hurston also received the advice of Alain Locke. Both Locke and Mason cautioned Hurston about protecting this "rediscovery of our folk material" from other folk collectors.[56]

Upon returning to Alabama, Hurston strived to develop a relationship based on trust that permitted Kossola to tell his own story in his way.[57] Over a period of three months, Hurston conducted in-depth oral interviews, photographed Kossola and his family, and made short films documenting his everyday life in Africatown, the community he and his fellow survivors had created a few miles north of Mobile, Alabama. They ate peaches and watermelon growing in Kossola's backyard garden, and Hurston helped him clean the Baptist church he had helped to launch and where he worked as the sexton.

Kossola related how he was born Oluale Kossola in an African village called Bante.[58] In 1860, when Kossola was nineteen years old, he was kidnapped by warriors from the kingdom of Dahomey and forced to march three days to Ouidah, a city on the coast of modern-day Benin. First enslaved on the African continent, he was brought with about 110 other captives to Mobile, Alabama, on Captain William Foster's ship *Clotilda*. Freedom arrived after the Civil War, and the Africans became naturalized citizens in 1868 because they had not been born in America. Kossola saved his meager earnings and purchased land from his former slaveowner. He founded Africatown, Alabama, with the assistance of another freedman, a place where the displaced Africans endeavored to preserve their roots and culture.

Hurston completed the manuscript in 1931, but it was not published. The few presses that expressed interest demanded she change Kossola's dialect into standard English. Hurston refused. She believed telling the story from "Kossola's first-person point of view," in a style of writing that also expressed his storytelling sensibilities and authenticity, demanded that he speak in his own words and voice.[59] The rejections, the impact of the Great Depression, the demands of her patron, and Hurston's interest in other projects all contributed to the book's lying dormant in the Alain Locke Collection at Howard University's Moorland-Spingarn Research Center for more than half a century until publication under the title *Barracoon: The Story of the Last "Black Cargo"* in 2018.[60]

Alice Walker wrote the foreword for the 2018 publication, in which she proposes the most plausible and complicated explanation about why this creative work has almost died.[61] Walker writes:

Reading *Barracoon* one understands immediately the problem many black people, years ago, especially black intellectuals and political leaders, had with it. It resolutely records the atrocities African peoples inflicted on each other, long before shackled Africans, traumatized, ill, disoriented, starved, arrived on ships as "black cargo" in the hellish West. Who could face this vision of the violently cruel behavior of the "brethren" and the "sistren" who first captured our ancestors? Who would want to know, via a blow by blow account, how African chiefs deliberately set out to capture Africans from neighboring tribes, to provoke wars of conquest in order to capture for the slave trade, people—men, women, children—who belonged to Africa? And to do this in so hideous a fashion that reading about it two hundred years later brings waves of horror and distress. This is, make no mistake, a harrowing read.[62]

There is evidence that this knowledge concerning African participation in the slave trade was quite shocking to Hurston as well. In her autobiography *Dust Tracks on a Road*, Hurston emphasizes the impact of Kossola's story with this description:

One thing impressed me strongly from these three months of association with Cudjo Lewis. The white people had held my people in slavery here in America. They had brought us, it is true, and exploited us. But the inescapable fact that struck me in my craw, was: my people had *sold* me and the white people had bought me. That did away with the folklore I had been brought up on—that the white people had gone to Africa, waved a red handkerchief at the Africans and lured them aboard ship and sailed away. I know that civilized money stirred up African greed. That wars between tribes were often stirred up by white traders to provide more slaves in the barracoons and all that. But if the African princes had been as pure and innocent as I would like to think, it could not have happened. No, my own people had butchered and killed, exterminated whole nations and torn families apart, for a profit before the strangers got their chance at a cut. It was a sobering thought. What is more, all that this Cudjo told me was verified from other historical sources. It impressed upon me the universal nature of greed and glory. . . . Cudjo's eyes were filled with tears and memory of fear when he told me of the assault on his city and its capture.[63]

Walker's reasoning for why the book was rejected and Hurston's response to Kossola's truth both draw attention to the New Negro Movement's complicated bond with African history. In 1884 the European partition of Africa solidified Europe's control over a continent that, except for Ethiopia and Liberia, it considered bereft of history or high civilization. The inferior status of African Americans was therefore directly linked to that of colonized Africans. According to Earl E. Thorpe in "Africa in the Thought of Negro Americans," "Many Blacks in the United States at the end of the nineteenth century shared these stereotypes about their race."[64] The material culture brought back as trophies and loot from conquered colonies filled European museums. By the turn of the twentieth century, European artists were beginning to exploit the African art forms and expressive culture of the "Dark Continent," promoting their own notion of the exotic primitive.

During the 1920s a broader "primitivist" movement began to include the disciplines of history, anthropology, and archaeology. Scholars debated whether one could speak of "histories" in reference to the African continent.

Leaders of the New Negro Movement like Alain Locke and W. E. B. Du Bois challenged stereotypes by promoting the embrace of a grand African history and arts tradition. They initially highlighted ancient civilizations such as Egypt and Nubia, familiar to Americans due to recent excavations. This approach, however, sometimes endorsed an African heritage that resided in a static, remote past as well as a hierarchy that resembled the way ancient European civilizations were romanticized.[65] At the same time, Black historians studying Africa, including William Leo Hansberry, began formal in-depth investigations into early Africa, focusing on Ethiopia.[66] Black historian Carter G. Woodson, in his 1923 publication *The Mis-Education of the Negro*, critiqued the tendency to despise anything African and laud everything European. The search for African history and cultures was also at the center of Jewish-American scholar Melville J. Herskovits's work. In 1926 the anthropologist published the article "Negro Art: African and American." Herskovits's research grew out of his discussions with associates in the New Negro Movement about Black cultural retentions, or Africanisms. In his article, Herskovits put forth the value of examining the aesthetic aspects of cultures in order to investigate historical connections, specifically between African and African American cultures.

It can be argued that Hurston's own research practices exemplified the search for Black identity. She was at the heart of her "Black and African heritage" when immersed in the "lives of the people who live it."[67] Hurston was likewise a young scholar and folklorist trained in the participant observer techniques she mastered while working with Franz Boas. She successfully documented the *Clotilda*'s "grisly story," as Walker describes it, from one of the last people able to tell it. Hurston revealed the horror of one who survived the murderous raid upon his village by Africans; endured the barracoons, or dungeons, where Africans were detained for sale and exportation to Europe or the Americas; and lived through enslavement on a plantation in the American South. Such a controversial diasporic tale unsettled some of the elite guardians of the New Negro Movement, who were unprepared for challenges to their "racial uplift" construction of Black African identity.

A New Critique: Reinterpreting the Dahomean Woman Warrior
In "The New Negro Movement and the African Heritage in a Pan-Africanist Perspective," Sonia Delgado-Tall contends that Harlem artists never adopted a proscribed African aesthetic.[68] She claims that Africa was a stepping stone for artists influenced by their own individual artistic temperaments. Like Zora Neale Hurston's literary achievement with *Barracoon*, Savage's Dahomean series realized a similar ambition. These sculptures are early twentieth-century artworks depicting the Black female subject within the aesthetic tradition of the nude in Western art, created by a Black female artist trained in the academy. Are these among the works Savage referred to in a letter describing her exploration of new themes, stating that she was almost afraid to show them as they were so different from anything she had done before?[69]

The bust *Amazon* portrays a Black female warrior grasping a javelin in her right fist (1930; fig. 9). To some degree, this depiction of the Dahomean warrior standing in a rigid position with breasts bared and holding a spear is most closely modeled after the posters and prints generated by decades of European world fairs and expositions. Savage engraved the outline of the figure's pupils and hollowed out the irises so the warrior's eyes would catch the light. This classical approach to portrait sculpture invigorates the subject's face by creating contrast between light and shadow. It enhances her emotional expression and provides clarity by encouraging the viewer to

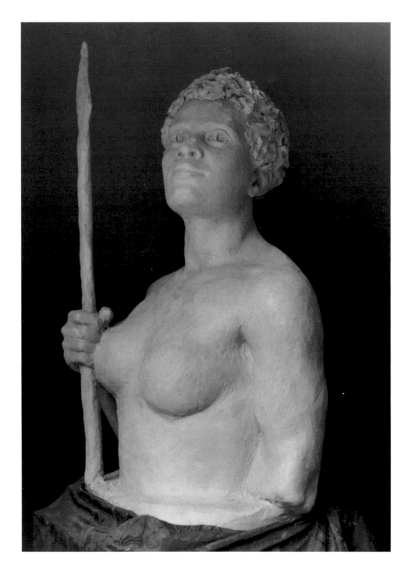

follow the direction of the subject's gaze. Here, as the warrior turns her face at a strong angle, the eyes are directed sharply to the side and upward. The short, curly hairstyle is likewise distinctive, resembling *Head of a Young Girl*, the bust by this name profiled in Paulette Nardal's article. Leininger-Miller notes that the model for this portrait was likely the same woman who posed for the bust of the Dahomean warrior and *Mourning Victory*.[70]

Mourning Victory (ca. 1930; fig. 10) portrays the Dahomean female warrior as a full-length nude figure, notable in the absence of a machete or firearms. Savage wrote a descriptive title on the bottom of the photograph affirming that the piece was related to the legendary female fighters of Dahomey. The separate plaster sculpture of the beheaded young male at the warrior's feet also provides clarification. The visual impact of the two pieces, along with a contradictory title that seems to question the violence associated with the subject matter represented, confirms that Savage's intended theme was the women warriors of Dahomey. Unlike the depiction of Dahomean warriors in Parisian print culture, however, Savage does not allow the viewer to witness such atrocity. Instead, with bowed head, the warrior slumps forward, as if about to collapse before her victim's face. The violence in the piece is therefore portrayed in the warrior's response in the aftermath of what has been done. While the facial features are obscured, the hair is thick, animated with curls, and cropped short, confirming that this is the same young woman who posed for the bust pictured in Nardal's article. In Nardal's interview with the artist, Savage spoke about how difficult it had

Fig. 10 Augusta Savage, *Mourning Victory*, ca. 1930. Clay, dimensions and location unknown.

been even to hire Black models in the United States. In Paris, the opportunity to work with Black female models was apparently transformative.

How, then, did Savage integrate her academic training with new subject matter? One of the instructors Savage worked with in preparation for the Julius Rosenwald Fellowship was the Italian-American sculptor and painter Antonio Salemme.[71] Known for his classical nudes and expressive portrait style, Salemme was the premier American sculptor between the 1930s and 1950s, whom many considered to have bridged the gap between nineteenth-century Impressionism and twentieth-century modernism.[72] Although trained in the classical mode, Salemme experimented with different textures as well as expressive modeling techniques and gestures in his work with the nude form. For example, while his work is restrained, he created figures that move in a direct, natural, and relaxed manner. Salemme likewise sculpted figures with strong psychological content.[73] He was also known for his sculptures of prominent African American cultural figures, including Paul Robeson and Ethel Waters.

Training with Salemme prepared Savage to meet the challenges of adapting the limitations of a classical aesthetic constructed upon the body of the White female form in European art to the portrayal of Dahomean women warriors. At the same time, it can be argued that the restraint typical of the Greek classical and neo-classical styles of the nineteenth century was particularly suited to the gravity of her subject. Savage's adaptations to tradition included experiments with texture, gestures, and directness of expression.

For example, the naturally textured surface of the clay—the result of the artist working the material—yields a lively, animated appearance that heightens the subject's emotional intensity. Is Savage rejecting the detached, smooth, classical nudes typical of nineteenth-century European art? The stance of the female warrior presents another alternative to tradition. While the Dahomean warrior still moves in the archaic contrapposto position, she is off balance, appearing unsteady on her feet. The right leg is strongly bent, causing her body to slump downward. These rather moderate adjustments to the classical tradition allowed Savage to work more radically in reference to her subject matter, constructing a visual narrative specific to the experiences of women belonging to the African diaspora.

Mourning Victory, I believe, references the most harrowing passages Hurston wrote about in her 1927 article "Cudjo's Own Story of the Last African Slaver." Kossola described the raid on his village and the forced march to the slave port in Dahomey. Hurston writes:

> The village was surrounded at daybreak with great slaughter. The surprised village was helpless before the cruel forces of Dahomey. The women warriors perpetuated the most awful butchery. Some of the men when attacked were already in the field working to get their work done before the heat of the day. They were butchered without quarter. Not one escaped. The invaders fell upon the sleeping women and children. All were either killed or captured. Dahomey's women warriors overpowered and bound the most stalwart men. The women in their paint and dress looked like men. The victors cut off the heads of the dead, leaving the bodies where they had fallen. The heads were taken home as evidence of individual valor and as trophies. . . . On their march to the Coast, they were forced to behold the dangling heads of their relatives and friends.[74]

Kossola's account is a view of the Atlantic slave trade from the inside. He witnessed the activities of a widely feared African kingdom that facilitated the conquest of neighboring tribes and nations. Slave raiders from Dahomey negotiated with slavers from Alabama in 1859, resulting in Kossola's capture. When Hurston traveled back to Alabama to conduct more in-depth research, she extended her work to show the dire, permanent after-effects of the trauma of capture and enslavement on the survivors of the "last African slaver." In powerful, descriptive writing, she conveys Kossola's reaction to retelling and reliving the horrible experience of witnessing the murder of his entire family. Her words emphasize the lifelong burden of memory that Kossola endured: "Kossola was no longer on the porch with me. He was squatting about that fire in Dahomey. His face was twitching in abysmal pain. It was a horror mask. He had forgotten that I was there. He was thinking aloud and gazing into the dead faces in the smoke. His agony was so acute that he became inarticulate. He never noticed my preparation to leave him. So I slipped away as quietly as possible and left him with his smoke pictures."[75]

Savage's work therefore directly confronts the participation of Africans in the Atlantic slave trade. She reconsiders the stories about Dahomean female warriors that proliferated in 1920s France, modeling female bodies that retain their strength but are also feminine. In this way Savage brought vulnerability to the experience of the Dahomean female warrior absent from European portrayals of them as bloodthirsty savages. Savage offers up a Dahomean female fighter stripped of her ferocity. Savage's Dahomean warrior is conscious of her act of killing the defenseless. Like Kossola, who lost the power of speech in his remembering of the horror wrought upon his people, the warrior is almost incapacitated, physically deprived of her

strength. How else to explain the fallen, sinking stance the young woman
assumes before the decapitated head lying on the ground at her feet?

In 1859, the time of the raid on Kossola's village, Dahomey was ruled by
King Gelele (1856–1889), the tenth ruler of Dahomey. Like his father, Gelele
successfully led war campaigns and slave raids, but he also signed treaties
with the French and resisted English diplomats in opposition to the slave
trade. France abolished slavery in the late eighteenth century but allowed
the practice to continue in its colonies. In 1833, Britain abolished slavery in
the United Kingdom and its colonies, and in 1840 the British navy began
making anti-slavery raids along the western coast of Africa. Slavery contin-
ued in Dahomey until the end of the nineteenth century when Behanzin, the
country's last king, suffered defeat in the French Dahomean wars in 1891
and 1893.

Unlike the Amazons of Greek mythology, Dahomey's female troops
were a specialized branch of the country's military. This position may
have originated as a corps of female soldiers serving as palace guards
during the early 1700s.[76] The need for female troops stemmed from the
considerable depopulation of men in Dahomey from either war or the slave
trade. European travelers to the kingdom during the eighteenth century
noted the extent to which women outnumbered men in the villages. Daho-
mean rulers began to train women as soldiers out of necessity, not from
any modern-day progressive notions about gender equality. King Agaja
(r. 1718–1740) was the first ruler to successfully use female corps in battle in
1729.[77] By the 1760s, a female division of six hundred women made up part
of the Dahomean army. King Ghezo (r. 1818–1858) formalized the structure
of the women's military and expanded the corps to between five thousand
and six thousand by the mid-1840s.[78] He recruited female and male sol-
diers from foreign captives who were slaves by origin.[79] Large numbers of
women soldiers were therefore slaves by origin and legal status.[80] Service
with the military provided opportunities for women in Dahomean society:
they could accrue wealth, achieve high status, and participate in political
decision making about the kingdom. A few extant war chants preserved
by Europeans travelers record how women felt about their indoctrination
as soldiers. They sang that their nature was transformed and how, after
training was completed, they were no longer women; they were men. In the
1880s, Dahomey's women warriors were drawn into the country's involve-
ment in what is now known as the Scramble for Africa, or the European
colonization of the continent. Under King Behanzin, Dahomey was forced
to fight the French for its independence. The Franco-Dahomean wars were
fought between 1890 and 1894. The wars with the French decimated the
women warriors, ending a long history of military service and sacrifice that
had begun with serving as palace guards in the 1700s and ended with fight-
ing for the country's independence from colonial rule in 1894.[81]

These were the Dahomean female troops of 1859 that Kossola described
to Hurston in 1928 when he told her about the beheading of the king of his
homeland, who was also captured in the raid. The King of Takkoi (modern-
day Togo) tells the King of Dahomey: "'Since I been a full man I rule. I die a
king but I not be a slave.' De king of Dahomey askee him, 'You not goin to
Dahomey?' He tell him, No, he ain' goin off de ground where he is de king. . . .
De king of Dahomey doan say no mo.' He look at de soldier and point at de
king. One woman soldier step up with the machete and chop off de head of
de king, and pick it off de ground and hand it to de king of Dahomey."[82]

Savage's portrayal of such violence elicits unsettling feelings about
women in the armed forces. The placement of the young man's bodiless
head raises the question: how can women kill other women's children? The

artwork forces us to consider our values and beliefs about the maternal role in human societies. What is the long-term impact of women deeply engaged in the organized violence of warfare? It is known that Dahomean female soldiers had serious difficulties re-engaging with society after the troops were disbanded and the country became a French colony. It appears that the sacrifice may have been too great.[83]

Savage never attempted anything as directly African and female for the remainder of her career. Even during the mid-1930s, when several major exhibitions on African art were brought by European collectors to New York City, Savage questioned the influence of African art on Black American artists. She stated: "For the last 300 years we have had the same cultural background, the same system, and the same standards of beauty as white Americans. In art schools we draw from Greek casts. We study the small mouth, the proportions of the features and limbs. It is impossible to go back to primitive art for our models."[84] Still, she believed that certain traits and characteristics survived, evident in "the sense of rhythm and spontaneous imagination."[85]

Only in Paris in the early 1930s did Augusta Savage feel free to experiment with subject matter that directly challenged New Negro Movement ideas about African history and heritage. She was aware of this factor as she wrote to her benefactors about how different these original works were, and she was unsure of their reception. In fact, one patron wrote back that he hoped she would not be unduly influenced by trends in European art. The Black intelligentsia associated with the movement were uncomfortable with disquieting African themes. Savage also had to consider the Black patrons for her work and the community context in which Black art was often shown during the 1930s and 1940s, as opposed to museums and art galleries, where it was rarely exhibited. Savage returned to working with the realist portrait tradition preferred by her patrons. But had she been given the opportunity to study abroad longer, Savage likely would have continued to explore the complicated topic more deeply from her distinct perspective as a Black American woman artist. Augusta Savage described the artwork she felt liberated to create abroad, including the Dahomean series, accordingly: "It is African in feeling but modern in design, but whatever else might be said, it is original."[86]

Notes

1. See Theresa Leininger-Miller, *New Negro Artists in Paris: African American Painters and Sculptors in the City of Light, 1922–1934* (New Brunswick, NJ: Rutgers University Press, 2001). According to Leininger-Miller, Savage produced almost twenty artworks when she lived in France between 1929 and 1931. Three of the works are in collections in the United States and one is in a private collection in France. The others are presumed lost, known only through various documents, including photographs of some of the works in the Julius Rosenwald Fund Archives at Fisk University.

2. Ibid., 185.

3. Romare Bearden and Harry Henderson, *A History of African American Artists: From 1792 to the Present* (New York, NY: Pantheon Books, 1993), 169.

4. A. Philip Randolph and Chandler Owen, "The New Negro—What Is He?" *The Messenger*, no. 2 (August 1920): 74.

5. Alain Locke, "Enter the New Negro," *Survey Graphic* VI, no. 6 (March 1925): 631–34.

6. For diverse studies examining the development of Black communities during the late nineteenth and early twentieth centuries within the contexts of the Great Migration and the New Negro Movement, see Earl Lewis, *In Their Own Interests: Race, Class, and Power in Twentieth-Century Norfolk, Virginia* (Berkeley, CA: University of California Press, 1993); Kenneth W. Goings and Raymond A. Mohl, eds., *The New African American Urban History* (Thousand Oaks, CA: Sage Publications, Inc., 1996); Kevin K. Gaines, *Uplifting the Race: Black Leadership, Politics, and Culture in the Twentieth Century* (Chapel Hill, NC: University of North Carolina Press, 1996); Marlon B. Ross, *Manning the Race: Reforming Black Men in the Jim Crow Era* (New York, NY: New York University Press, 2004); Michele Mitchell, *Righteous Propagation: African Americans and the Politics of Racial Destiny After Reconstruction* (Chapel Hill, NC: University of North Carolina Press, 2004); Ann Elizabeth Carroll, *Word, Image, and the New Negro: Representation and Identity in the Harlem Renaissance* (Bloomington: Indiana University Press, 2005); Martha Jane Nadell, *Enter the New Negroes: Images of Race in American Culture* (Cambridge, MA: Harvard University Press, 2004); Cherene Sherrard-Johnson, *Portraits of the New Negro Woman: Visual and Literary Culture in the Harlem Renaissance* (New Brunswick, NJ: Rutgers University Press, 2007); Davarian L. Baldwin, *Chicago's New Negroes: Modernity, the Great Migration, and Black Urban Life* (Chapel Hill, NC: The University of Carolina Press, 2007); Anna Pochmara and Jacques Thomassen, *The Making of the New Negro: Black Authorship, Masculinity, and Sexuality in the Harlem Renaissance* (Amsterdam, the Netherlands: Amsterdam University Press, 2011); Elizabeth Gritter, *River of Hope: Black Politics and the Memphis Freedom Movement, 1865–1954* (Lexington, Kentucky: University of Kentucky Press, 2014); Gabriel A. Briggs, *The New Negro in the Old South* (New Brunswick, NJ: Rutgers University Press, 2015); and Earnestine Jenkins, *Race, Representation & Photography in 19th-Century Memphis: From Slavery to Jim Crow* (London: Routledge, 2016).

7. For more on the Fontainebleau incident, see Theresa Leininger-Miller, "'Une Femme Sculpteur Noire': Augusta Savage in Paris, 1929–1931," in *New Negro Artists in Paris*, 162–201.

8. Jeffreen M. Hayes, *Augusta Savage: Renaissance Woman* (Jacksonville, FL: Cummer Museum of Art & Gardens, 2018), 21.

9. *The Richmond Planet*, Richmond, Virginia, May 5 and June 16, 1923.

10. T. Denean Sharpley-Whiting, *Bricktop's Paris: African American Women in Paris Between the Two World Wars* (Albany, NY: SUNY Press, 2015), 133–41.

11. Leininger-Miller, "Augusta Savage in Paris," 170.

12. Ibid., 168.

13. Ibid., 167–69.

14. Ibid., 168.

15. Ibid.

16. Ibid., 173.

17. Ibid., 174.

18. Ibid., 177.

19. "Académie de la Grande Chaumière." https://en.wikipedia.org/wiki/Acad%C3%A9mie_de_la_Grande_Chaumi%C3%A8re.

20. Leininger-Miller, *New Negro Artists in Paris*, 180.

21. Sharpley-Whiting, "Women of the Petit Boulevard," in *Bricktop's Paris*, 137.

22. Leininger-Miller, *New Negro Artists in Paris*, 180.

23. Sharpley-Whiting, "Women of the Petit Boulevard," 137.

24. Tyler Stovall, *Paris Noir: African Americans in the City of Light* (New York: Houghton Mifflin Company, 1996), 64–65.

25. Ibid., 65.

26. For more on the impact of African American culture on European modernists, see Petrine Archer-Straw, *Negrophilia: Avant-Garde Paris and Black Culture in the 1920s* (New York: Thames & Hudson, 2000).

27. Julius Rosenwald Archives, Box 445, Fisk University, Nashville, Tennessee.

28. Sharpley-Whiting, "Women of the Petit Boulevard," 138–39.

29. For more on Nardal's interest in the question of Black culture and the relationship between Black American writers and French-speaking Black intellectuals, see Stovall, *Paris Noir*, 104–12, and Sharpley-Whiting, "Femme Négritude: Jane Nardal, *La Dépêche Africaine*, and the Francophone New Negro," in Manning Marable and Vanessa Agard-Jones, eds., *Transnational Blackness: Navigating the Global Color Line*, Critical Black Studies (New York: Palgrave Macmillan, 2008), 205–14.

30. Sharpley-Whiting, "Femme Négritude," 15.

31. Paulette Nardal, "Une femme sculpteur noire," *La Dépêche Africaine*, September 15, 1930, p. 5.

32. Fisk University Library, John Hope and Aurelia E. Franklin Library, Special Collections, Rosenwald Collection, Nashville, Tennessee.

33. Leininger-Miller, *New Negro Artists in Paris*, 185.

34. Since the 1990s multiple diverse scholarly studies have examined the visual impact of colonialism on European cultures. See Jan Nederveen Pieterse, *White on Black: Images of Africa and Blacks in Western Popular Culture* (New Haven: Yale University Press, 1992); Robert J. C. Young, *Colonial Desire: Hybridity in Theory, Culture and Race* (London: Routledge, 1995); Bernth Lindfors, ed., *Africans on Stage: Studies in Ethnological Show Business* (Bloomington: Indiana University Press, 2000); Anne Maxwell, *Colonial Photography and Exhibitions: Representations of the "Native" and the Making of European Identities* (London: Leicester University Press, 1999); Chris Gosden and Chantal Knowles, *Collecting Colonialism: Material Culture and Colonial Change* (Oxford: Berg, 2001); Anandi Ramamurthy, *Imperial Persuaders: Images of Africa and Asia in British Advertising* (Manchester: Manchester University Press, 2003); Alec G. Hargreaves, *Memory, Empire, and Postcolonialism: Legacies of French Colonialism* (Lanham, MD: Lexington Books, 2005); Dana S. Hale, *Races on Display: French Representations of Colonized Peoples, 1886–1940* (Bloomington: Indiana University Press, 2008); Mary D. Sheriff, *Cultural Contact and the Making of European Art Since the Age of Exploration* (Chapel Hill: The University of North Carolina Press, 2010); T. Jack Thompson, *Light on Darkness? Missionary Photography of Africa in the Nineteenth and Early Twentieth Centuries* (Grand Rapids: William B. Eerdmans Publishing Company, 2012); and Eve Rosenhaft and Robbie Aitken, *Africa in Europe: Studies in Transnational Practice in the Long Twentieth Century* (Liverpool: Liverpool University Press, 2013).

35. On the history of Africans in Paris expositions, see Dana S. Hale, "Sub-Saharan Africans: 'Uncivilized Types,'" in Hale, *Races on Display*, 23–45.

36. For histories of the female warriors in Dahomey, see Edna G. Bay, *Wives of the Leopard: Gender, Politics, and Culture in the Kingdom of Dahomey* (Charlottesville: University of Virginia Press, 1998), and Stanley B. Alpern, *Amazons of Black Sparta: The Women Warriors of Dahomey* (New York:

New York University Press, 1998).

37. For a discussion on the number of Dahomean women troops, see Alpern, *Amazons of Black Sparta*, 72–75. On the evolution of women in the military during the first half of the nineteenth century, see "The Growth of the Palace and Development of the Army of Women," in Bay, 198–213.

38. Christiane Demeulenaere-Douyère, "Between Knowledge and Spectacle: Exotic Women at International Exhibitions (Paris, 1899 and 1900)," in Myriam Boussahba-Bravard and Rebecca Rogers, eds., *Women in International and Universal Exhibitions, 1876–1937* (New York: Routledge, 2017), 175–91.

39. Ibid., 184.

40. Ibid.

41. On the Dahomean village exhibitions and performances in the United States, see Robert W. Rydell, "'Darkest Africa': African Shows at America's World's Fairs, 1893–1940," in *Africans on Stage*, 136–55.

42. Demeulenaere-Douyère, "Between Knowledge and Spectacle," 184–85.

43. Ibid., 183.

44. Hale, "Sub-Saharan Africans," 37–38.

45. For more on the legacy of these exhibitions in reference to the arts and museums, see Benoît de L'Estoile, "From the Colonial Exhibition to the Museum of Man: An Alternative Genealogy of French Anthropology," in *Social Anthropology* (2003), 341–61; Anne Monjaret and Melanie Roustan, "A Palace as Legacy: The Former French Colonial Museum-Perspectives from the Inside," *Journal of Material Culture* 22, no. 2 (2017): 216–36; Janine Mileaf, "Body to Politics: Surrealist Exhibition of the Tribal and the Modern at the Anti-Imperialist Exhibition and the Galerie Charles Ratton," *Anthropology and Aesthetics* 40 (Autumn 2001): 239–55.

46. Archer-Straw, *Negrophilia*, 33–34.

47. Mileaf, "Body to Politics," 240.

48. Stovall, *Paris Noir*, 102.

49. Ibid.

50. Ibid.

51. Ibid., 99.

52. The Bible also has been suggested as a reference in a claim that *Mourning Victory* might represent the story of Salome; the beheaded victim is therefore John the Baptist. See Leininger-Miller, *New Negro Artists in Paris*, 189.

53. "Cudjo's Own Story of the Last African Slaver," *The Journal of Negro History* 12, no. 4 (October 1927), 648–68. For more about Hurston's retrieval work on this project, see Genevieve Sexton, "The Last Witness: Testimony and Desire in Zora Neale Hurston's 'Barracoon,'" *Discourse* 25, nos. 1–2 (Winter and Spring 2003): 189–210.

54. Sexton, "The Last Witness," 190.

55. See Deborah G. Plant's introduction in Zora Neale Hurston, *Barracoon: The Story of the Last "Black Cargo,"* ed. Deborah G. Plant (New York: Harper Luxe, 2018), xxiv.

56. Ibid. For more on Hurston's strained relationship with White patron Charlotte Mason, her chief benefactor, see Andrew Delbanco, "The Political Incorrectness of Zora Neale Hurston," *The Journal of Blacks in Higher Education*, no. 18 (Winter, 1997–1998): 103–8.

57. Sexton, "The Last Witness," 194.

58. Hurston lays out the core of the narrative in her introduction to *Barracoon*, pp. 5–18, where she recounts her first visit to Kossola in 1927.

59. Plant, Introduction to *Barracoon*, xxix.

60. See Torry Threadcraft, "The Power of Untold Slave Narratives," Books, *The Atlantic*, October 1, 2018, https://www.theatlantic.com/entertainment/archive/2018/10/zora-neale-hurston-highlights-unpopular-narratives-barracoon/571789/.

61. Alice Walker, "Foreword: Those Who Love Us Never Leave Us Alone with Our Grief—*Reading Barracoon: The Story of the Last 'Black Cargo,'"* in Hurston, *Barracoon*, xi–xv.

62. Ibid., xii.

63. Zora Neale Hurston, *Dust Tracks on the Road* (New York: HarperCollins Publishers,

1996; J. B. Lippincott, Inc., 1942), 165–66. Citations refer to the HarperCollins edition.

64. Earl E. Thorpe, "Africa in the Thought of Negro Americans," *Negro History Bulletin* 23, no. 1 (October 1959): 5–10.

65. See Charles I. Glicksberg, "Negro Americans and the African Dream," *Phylon* 8, no. 4 (4th Qtr., 1947): 323–30.

66. See William Leo Hansberry, "The Material Culture of Ancient Nigeria," *The Journal of Negro History* 6, no. 3 (July 1921): 261–95.

67. Sonia Delgado-Tall, "The New Negro Movement and the African Heritage in a Pan-Africanist Perspective," *Journal of Black Studies* 31, no. 3, Special Issue: *Africa: New Realities and Hopes* (January 2001): 288–310.

68. See Sonia Delgado-Tall, "The New Negro Movement."

69. Leininger-Miller, *New Negro Artists in Paris*, 192.

70. Ibid., 185.

71. Ibid., 175.

72. Steve Siegel, "A Remarkable Coup: Antonio Salemme, whose sculpture of actor Paul Robeson shocked the 1930s elite, lived and worked in Williamstown Township for a third of his life. Now his art has a permanent home in downtown Allentown," *The Morning Call*, January 17, 2010, https://www.mcall.com/news/mc-xpm-2010-01-17-4511249-story.html.

73. Geoff Gehman, "Salemme, sculptor, makes exile profitable," *The Morning Call*, March 30, 1986, https://www.mcall.com/news/mc-xpm-1986-03-30-2506033-story.html.

74. Hurston, "Cudjo's Own Story," 655–66.

75. Hurston, *Barracoon*, 58.

76. For a discussion of how the military evolved in Dahomey, see Bay, "The Struggle to Maintain the State," in *Wives of the Leopard*, 119–66.

77. Alpern, *Amazons of Black Sparta*, 29.

78. Bay, *Wives of the Leopard*, 204.

79. Ibid., 205.

80. Ibid., 206.

81. See "What They Sang," in Alpern, *Amazons of Black Sparta*, 113–21.

82. Alpern, *Amazons of Black Sparta*, 208–11.

83. Bearden and Henderson, *African American Artists*, 173.

84. Ibid.

85. Leininger-Miller, *New Negro Artists in Paris*, 192.

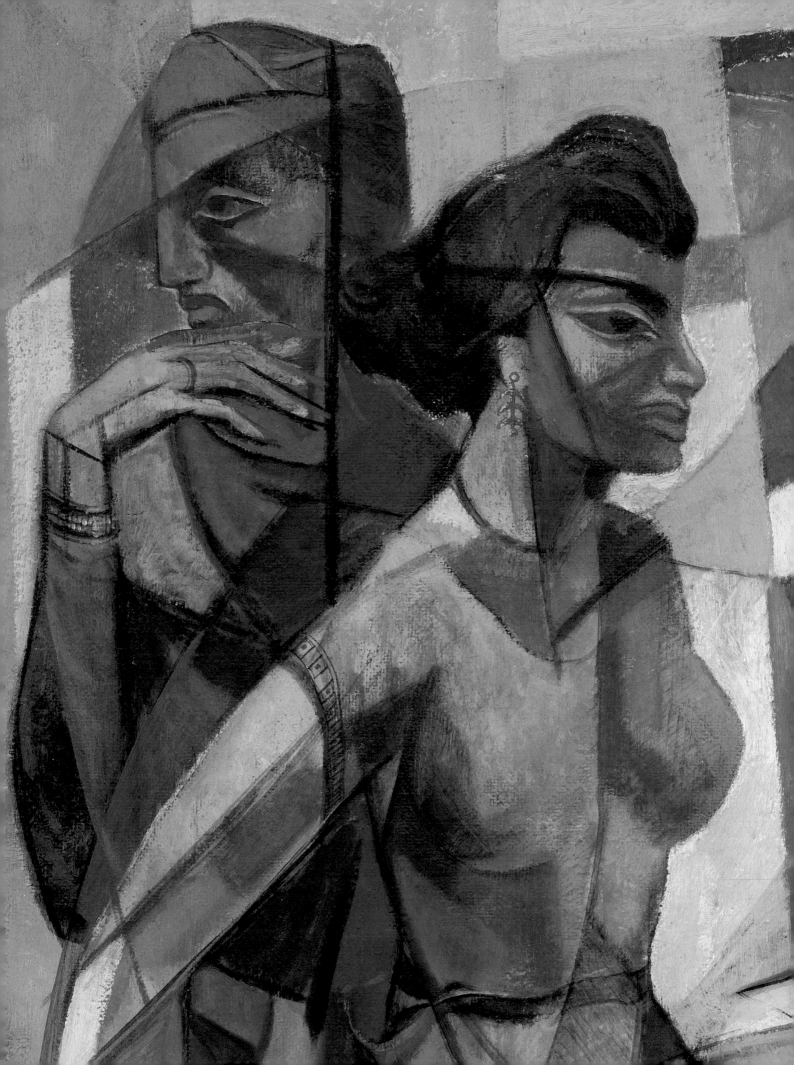

Walter Augustus Simon

Abstract Expressionist, Art Educator, and Art Historian

Walter Augustus Simon

Abstract Expressionist, Art Educator, and Art Historian

The impact of African American artist educators and art historians deserves more attention. Walter Augustus Simon (1916–1979) was among the ground-breaking Black artists during the first half of the twentieth century whose educational achievements in the arts supported their peers in building long careers as artists, art educators, and scholars in the field (fig. 1). For example, Samella Lewis (born 1924), an artist, art historian, educator, and curator, earned a BA in art history from Hampton Institute in 1945, an MA in studio art history from Ohio State University in 1948, and a PhD from Ohio State in 1951. John Biggers (1924–2001) earned BS and MA degrees from Pennsylvania State in 1948 and a PhD in art education from the same institution in 1954. Walter Simon earned professional certificates in commercial design and fine arts from Pratt Institute and the National Academy of Design, BA and MA degrees in art education from New York University, and a PhD in art history from New York University in 1961. Travel abroad experiences in North Africa, the Middle East, and Asia during the 1960s were unique components the artist educator brought to his arts practice and teaching. This essay focuses on the first half of Simon's long professional career as an artist, art educator, and art historian throughout the first half of the twentieth century.

From "Child Prodigy" to Artist and Soldier

Diverse childhood experiences shaped the young Simon, who grew up during the Great Depression in Brooklyn. His father, Walter Simon Sr. (fig. 2), was an emigrant from Bombay, India (today known as Mumbai).[1] He belonged to the ancient Muslim communities that had settled in India

Fig. 1 Walter Simon, 1960s. Stuart A. Rose Manuscript, Archives, and Rare Book Library, Emory University, Atlanta.

123

following the birth of Islam in the Arabian Peninsula during the seventh century. However, like other members of his family, Simon converted to Catholicism. As a young man, he led an adventurous life as a seaman, working as a sailor in India, Britain, and the Caribbean, before settling in New York City.[2]

Simon Jr.'s mother, Gay Crichton, was from a middle-class family of color in Lynchburg, Virginia (fig. 3).[3] Her father, Henry Crichton, was the town's best barber. He provided high school educations for his eleven children as well as lessons in classical music. Gay Crichton migrated to New York at the invitation of her sister to take a teaching job at a Brooklyn orphanage. After Gay and Walter Simon Sr. were married, Walter "identified himself as 'Negro' whenever racial identity was required or expected."[4] Simon Sr. built a successful business as a real estate dealer that enabled the family to move into their own home at 278 Macon Street, a typical brownstone with fourteen rooms dispersed over three floors. They were the first Black family in the neighborhood, which was mostly made up of Irish Catholics.

Success in the arts came early for Walter Simon Jr. When he was eleven years old, his father bought him a complete painting set.[5] He came to "love painting more than anything else in his life" and hoped his father would send him to Paris to study.[6] In 1929 Simon won the John Wanamaker Prize for Excellence in Art at his elementary school for the seascape *Last of the Clipper Ships*.[7] By the age of fourteen he was exhibiting paintings in local galleries in Brooklyn, including the International House on Riverside Drive and the Art Center at 65 East 56th Street. The next year, his parents enrolled him in Saturday Morning Children's Classes at Pratt Institute. He also had a "permit to sketch in the galleries" at the Metropolitan Museum of Art.[8]

By the time he was sixteen, Simon had completed more than seventy oil paintings and fifty drawings and watercolors. In 1932 the *Brooklyn Daily* published an article about his success, "Art Prodigy, 16, Doing Roosevelt in Portrait Piece." Simon appears to have based his painting of Roosevelt on a photograph used for the politician's first presidential campaign in 1932, absent the slogan at the top of the poster, "A Progressive Candidate with Constructive Policies for President."[9] It is a conventional but skilled approach to portraiture, faithfully rendered from a photograph, and the expected result of training that is at this point primarily copying from pictures.

Other portraits Simon completed during this period include *Judge Samuel S. Leibowitz* (1933) and *Fiorello La Guardia* (1934). The works are traditional portraits of prominent political figures. Leibowitz was the famous lawyer who served as counsel on the notorious case of the Scottsboro Boys, nine Black male youths falsely accused of rape and sentenced to death in Alabama in 1931.[10] Fiorello La Guardia was the acclaimed ninety-ninth mayor of New York City, whose reforms cleaned out corruption, built the city's modern infrastructure, and supported a diverse constituency broadened to include immigrants and ethnic minorities.[11] The portrait of the mayor appeared in the *New Yorker* magazine on June 2, 1934; Simon described it as his "finest work."[12]

Simon continued his professional training, graduating with a certificate in commercial design from the Pratt Institute School of Fine and Applied Arts in

1935 and finishing high school the same year. The technical training established a solid foundation for future work in the fine arts. He then enrolled in the National Academy of Design. In addition to intermediate and advanced courses in oil and watercolor painting, his coursework included costume design, jewelry crafts, mural painting, printmaking, ceramics, woodworking, art education, art history and appreciation, and mechanical drawing as well as several courses in the sciences, psychology, literature, colonial problems in Asia, and American history. According to a biography penned by his wife, Virginia Spottswood Simon, Walter Simon emerged as a "facile, accomplished painter of conventional portraits, landscapes, and murals."[13] L. D. Reddick, in his 1954 article "Walter Simon: The Socialization of an American Negro Artist," similarly critiqued the school's approach to fine arts training, describing the institution as a place of "pure traditionalism."[14] Reddick claimed that it was literally untouched by modern developments in the art world, especially the modernist movements of the early twentieth century. The leadership at the academy was content to rest on its reputation of the past as one of the "finest craft schools in America."

Simon did not stand out as a student in this environment. Although he recalls a few classmates who were exciting colleagues, there was no teacher who actively mentored or inspired the young artist. He received the certificate in fine arts from the Academy in 1937. Afterward, Simon applied to New York University and was accepted into the art program. Unfortunately, a diminishing interest in his career choice, evidenced by poor grades, led to Simon's failing out of school. He left home for Washington, DC, where he spent the next three years. He worked as a laborer moving boxes and books at a government printing office. No effort was made to establish relationships with the Black art community in Washington, centered at Howard University. Simon met the philosopher Alain Locke as well as James V. Herring, who started the art program at the college, but nothing developed from these introductions. Perhaps his ethnic-racial heritage and experience growing up in New York made it difficult to relate to leaders and artists linked to the Harlem Renaissance. I would argue that, by the late 1930s, Walter Simon's isolated experience as a non-White student at mainstream institutions where he lacked significant engaged mentorship is what almost derailed his youthful passion for painting.

During this time, New York artist Robert M. Jackson painted a portrait of Walter Simon that ironically references his predicament (fig. 4). Simon met Jackson, a wealthy graduate of Princeton University, in 1939. Jackson paid Simon to model for a portrait he intended to exhibit in a show titled *Types of Negroes*.[15] He painted Simon in profile, emphasizing his dark, rich color and definitive profile, and portrayed him holding a paintbrush in his right hand, emphasizing the Black subject as artist. The exhibition was held the next year at the Charles Morgan Gallery and was briefly reviewed in the Art News section in the *New York Times* magazine on March 30, 1940. The critic claimed that such an exhibition by a White artist would have been impossible twenty years prior. It was thus considered progressive. However, the other "Negro Types" depicted in the exhibition were all professionals or celebrities of apparently mixed heritage. Simon was chosen because of his mixed East Indian and African American ancestry. Jackson described him as "the half Hindu (*Walter Simon Jr.*)."[16] The designation reflected a lack of knowledge about the diverse peoples of India, as Simon's father was not Hindu but hailed from the Indian Muslim community in Bombay. Jackson's fascination with representing racial mixture likely was influenced by the "race" studies that some Black and White artists, including Archibald John Motley Jr. and Winold Reiss, experimented with during the 1920s and 1930s.

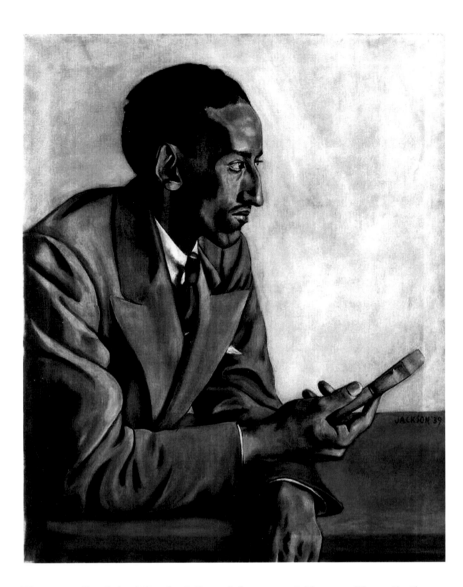

Fig. 4 Robert M. Jackson (American, 1891–1968), *Portrait of Walter Simon as Artist*, 1939. Oil on linen, 30 × 25 inches. Private collection.

These studies linked the depiction of diverse racial types with aesthetics. Simon's African American and Indian identity made for a unique mingling of race and profession for Jackson's experiments in depicting American "Negro Types." It is a portrait painted at a time when Simon was producing limited work himself, unsure where his passion, training, and identity as a professional Black artist would lead him, if anywhere.

Simon was transformed by his service in World War II: he was drafted in 1941 and assigned to the 95th Engineer Regiment.[17] The regiment was deployed to construct the Alaska-Canada Highway.[18] American journalist Richard Neuberger wrote about the Black soldiers building the highway in his article "ALCAN Epic," which described how "Negro engineers built one-third of the Alaska-Canada Army Highway" and told the story of "road-making over the toughest kind of terrain."[19] In addition to constructing the highway, the men built timber-trestle bridges. As a "regimental draftsman," Simon planned segments of the road between Dawson Creek, British Columbia, and Fairbanks, Alaska.[20]

The portrait artist reclaimed his professional credentials in the army and started to paint again, enthralled by the tremendous beauty of snow-capped mountains and the depths of sweeping, dark green valleys. Simon described such panoramas as the most "spiritual" experiences he'd ever had.[21] Once they discovered his talents, White officers commissioned Simon to paint artworks intended to document the regiment's activities. He referred to these artworks as his "regimental history" paintings.[22] Although most of

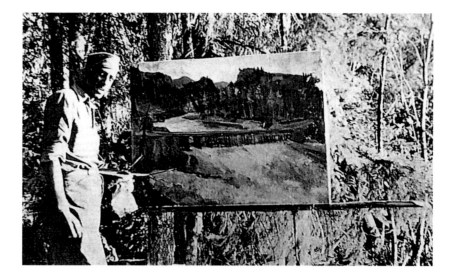

Fig. 5 Walter Simon with his painting *Sikanni Chief River Bridge*, 1942. Stuart A. Rose Manuscript, Archives, and Rare Book Library, Emory University, Atlanta.

Fig. 6 Walter Simon posing with two of his portrait paintings, 1944. Stuart A. Rose Manuscript, Archives, and Rare Book Library, Emory University, Atlanta.

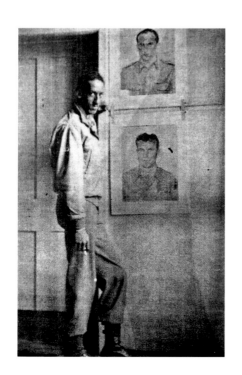

the paintings were lost during the unit's travels, *Sikanni Chief River Bridge*, preserved in a photograph (fig. 5), depicts the type of infrastructure the 95th Engineer Regiment completed in British Columbia. Other opportunities to paint or draw included White officers' requests to paint their portraits and illustrating a newspaper called the *Alcan Dispatch* to help build morale and document regimental activities. This began Simon's practice of volunteering (or being asked) at every post to make oil paintings documenting a regiment's activities or having commanding officers and others asking for portraits.[23] He may have painted between twenty-five and thirty portraits.

Simon's professional degrees made him eligible for Officer Candidate School, and he was commissioned a Second Lieutenant in December 1941.[24] His first assignment as an officer was with the new 366th Engineer Regiment, which was sent to England and Wales to construct new infantry bases and airfield landing strips, remodel old British military quarters, establish supply lines, and reinforce old bridges and build new ones, all in preparation for D-Day invasion troops.[25] Simon was purposely assigned fifty-five Black soldiers considered difficult to lead and an embarrassment to the regiment. He called them together and told them that the "high brass" expected them to fail. Instead, inspired by Simon's leadership, Battalion B completed the camp facilities they were building ahead of time and before the White soldiers.[26] In addition, while stationed in the UK, Simon continued to receive commissions for oil portraits from American and British officers who could afford to pay for them (fig. 6). While Simon was praised for his work with Battalion B, he was not awarded the promotion he had sought. He therefore applied for a transfer and was deployed in 1944 with the 513th Port Battalion to France, where he saw his only combat service.[27]

These experiences focused Simon in a new direction in his evolution as an artist. He thought deeply about the role of the arts in life. His thinking is documented in the letters he wrote to his wife, Virginia—a unique category of love letters totaling approximately 400,000 words.[28] Simon usually wrote his almost daily letters late at night while he listened to a classical music radio program. He theorized about art and art criticism, the Renaissance artists he admired, books he had read and was reading, and the concerts, plays, art galleries, and jazz clubs he had visited while in Europe. One of the most persistent themes was Simon's observance of the racial discrimination legally

sanctioned and practiced by the military and civilians. At one time Simon wrote, "if no change in attitudes toward minorities, Negroes, after this war, I'll hate this civilization."[29] In editing the letters, Virginia Spottswood Simon compiled a separate list about this specific content, titled "References to Race, Racism, and Social Consciousness." Examples of how she archived the material include Black people picking cotton; "barefoot whites" in Oklahoma, Tennessee, Arkansas; a Black chaplain placed in a tent next to a latrine; how Simon was barred from eating at the same mess table as White officers; the color prejudice of his mother, father, and sister; the "unwitting" racism of writer Pearl S. Buck, who stated that "colored people must forget color"; and Black and White officers writing a letter protesting racism that was sent to President Eisenhower. Simon credited these eye-opening experiences concerning race relations, as well as the teaching opportunity that being an officer demanded of him, as pivotal in his professional career. He became interested in the everyday, average student having access to knowledge about the cultural richness of the world rather than "discovering" and developing "gifted" artists.

Art Education and New York Modernism

I would suggest that the conflicted feelings and actions Simon sometimes exhibited toward the arts resulted from his inherent interest in scholarly studies. He had always believed himself to be a "college-type man." The experiences teaching and leading Black soldiers during the war amplified his abilities to mentor and teach. He also had to provide for his family, and a career as a college professor presented itself as the most likely path to success.[30] As a veteran, Simon was able to use the GI Bill to pay for his education, and he re-enrolled in New York University in 1946. He completed his bachelor's degree in 1948, majoring in art and education, and his master's in art education in 1950. Simon was awarded a PhD in art history in 1961 after completing a dissertation titled *Henry O. Tanner—Study of the Development of an American Negro Artist: 1859–1937*. Focus in the disciplines of art education and art history during this formative period were the paths toward further exploration of the role the arts played in everyday life and marked the commencement of Simon's thorough engagement with the study of modernism.

Early 1940s New York emerged as the center of radical new directions in art. A loosely affiliated group of artists known as the New York School promoted a few core ideas that shifted the art world's focus from Europe to the United States. Inspired by European modernism, the key players in this group—known as the Abstract Expressionists, who were all White male artists—included Adolph Gottlieb, Franz Kline, Willem de Kooning, Robert Motherwell, Barnett Newman, Jackson Pollock, and Mark Rothko. They diverged from conservative techniques and subject matter to emphasize their own individuality. Imagery was primarily abstract, and improvisation and expressive force were highly prized. The prevalence of form, medium, and process opposed the clarity of representative subject matter and the illusion of depth. The so-called first authentic American modern art movement claimed a legacy from European modernism that promoted a direct linear narrative and evolution naturally moving toward abstraction, which was associated with progress. Modernism was complicated by the fact that its proponents likewise claimed European antiquity's rich birthright of myth and ritual. American modernists appropriated Native American art and culture in a similar fashion, borrowing imagery and arts practices from the continent's Indigenous peoples. Ultimately, critics and historians argued that the new arts practices and subject matter achieved a universal art that addressed the modern experience.

Hale Woodruff arrived in New York at the height of these developments, joining the faculty of New York University, where he would teach until his retirement in 1968. Woodruff's encounter with the impact of modernism was especially important for African American artists. As an artist at a major university witnessing these developments, he grappled directly with the conundrum of modernism's claim on the arts of Indigenous people, derived from European and American colonial perspectives and practices. The expressive cultures of Indigenous people were chained to a set of myths and preconceptions about them labeled "primitive." Lack of knowledge fostered notions about static, traditional cultures valued by European artists because they were perceived as unspoiled by modern life. The abstraction observed in African, Oceanic, or Native American art was therefore believed to be a simplistic method of making pictures or objects as opposed to a conscious, conceptual approach to representation. While White artists in the West viewed abstraction in Indigenous arts as liberating, they also assumed that the Indigenous artists themselves had produced such work unknowingly.

Black artists such as Woodruff struggled with the artistic challenges of reinterpreting White American modernism. They contended with its narrow view of universalism, the emphasis on formalism, and the rejection of recognizable subject matter, especially socially relevant material. During the 1920s, political oppression and social marginalization had inspired Black artists to create artworks in response to the uniqueness of their experience. How were they to reconcile the two and still be viewed as artistically progressive?

Woodruff, for example, experimented with the core tenets of modernism by broadening the spectrum of humanity to be considered (cat. 41). He adapted a microcosm-within-a-macrocosm way of thinking about the transcendent in art, arguing that one arrives at the universal through the local as the point of departure. Woodruff's struggle to reinterpret modernism from his perspective as a Black American male artist incorporated what became a serious lifelong study of African art. Like most American artists, he first learned in the 1920s about the significance of African art to European modernism. Woodruff then moved beyond European artists' complicated relationship with Africa as muse and engaged deeply with African cultural expression and its global dimensions. Strongly influenced by art history, Woodruff explored the diversity of styles, materials, and forms characteristic of African art, as well as its chronological depth, in relation to the continent's long history with other cultures, such as ancient Egypt, Greece, and Rome. His ideas were most fully articulated in the six-panel mural *The Art of the Negro*, which he began after his relocation to New York in 1946 and completed in 1952.

The year 1946, when Walter Simon began college at New York University, was the same year Hale Woodruff was recruited to be part of the art education department by its chairman, Robert Iglehart. There were other teachers, as well as students, whom Simon found stimulating, but Hale Woodruff was particularly significant, becoming both a mentor and longtime friend of the Simon family.[31] Woodruff challenged his student's defensive obedience to conventional portraiture, telling his protégé, "The modern spirit is here; there's no use to argue against it."[32] Dr. Alonzo Myers was extremely influential as well. He served as chair of Simon's dissertation committee, which included Dr. Frederick Redifer and Hale Woodruff.[33] Years later, after he retired, Myers identified Simon as having been one of his most promising students in an interview that appeared in his local newspaper.[34] The article carried a photograph of Myers in his living room seated beneath an abstract painting by his former student Walter Simon (fig. 7).

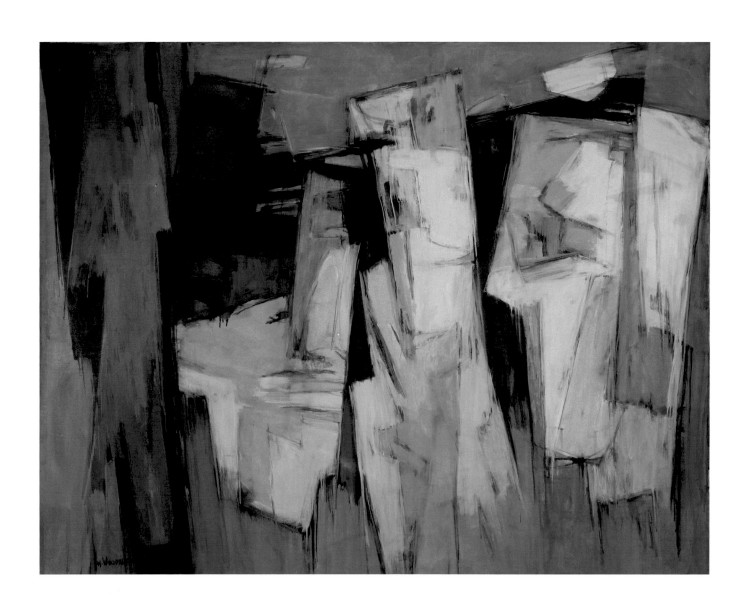

Cat. 41 Hale Woodruff, *Four Figurations*, 1969; Spelman College Museum of Fine Art

Fig. 7 Newspaper clipping about Simon's teacher Dr. Alonzo Myers, *Venice Gondolier Sun*, May 5, 1965, Venice, Florida. Stuart A. Rose Manuscript, Archives, and Rare Book Library, Emory University, Atlanta.

Once Simon had accepted Woodruff's challenge, he set out to explore modernism with great enthusiasm. His efforts to understand the contemporary can be summed up in the title of his master's thesis in the School of Education: "An Analytical Study of Comparable Factors in Representational and Non-Representational Modern Painting: A Survey of Certain Selected Modern Paintings as an Aid in Cataloging the Modern Movements in Contemporary Art."[35] Simon therefore identified the major problem in modern art as a conflict between representational and nonrepresentational painting. In the second chapter, dealing with the history and background on modernism, the author identified sixteen areas of focus to examine: "Impressionism; Post-Impressionism; The Symbolists; Fauvism; Primitivism; Expressionism; Abstractionism; Cubism; Futurism; Suprematism; Non-Objectivism; Constructivism; De Stijlism-Neo-Plasticism; Purism; Neo-Romanticism; Surrealism and Dada." Ten illustrations representing the works of artists chosen to demonstrate his thesis included *Christ Mocked by Soldiers*, Georges Rouault; *Broadway Boogie Woogie*, Piet Mondrian; *Promenade*, Christian Bérard; *The Breakfast*, Juan Gris; *The Serpent-Charmer*, Henri Rousseau; *Suprematist Composition*, Kasimir Malevich; *The Persistence of Memory*, Salvador Dalí; *Composition Segment VII, Fragment 1*, Wassily Kandinsky; *Demon Above the Ships*, Paul Klee; and *Abstract Forms*, Antoine Pevsner.

Simon, after comparing figurative art and abstraction, argued that modern movements exhibited more similarities between them than differences and that representational and nonrepresentational styles were not inherently hostile to each other. Both extracted inspiration from nature; the primary difference was that the former emphasized a perceptual response to nature. He also claimed that certain standards or criteria in relation to techniques were "universal" throughout the variety of modernist styles—namely perspective, chiaroscuro, and the "equilibrium of movement" (dynamic movement).

Simon's thesis was notable as well for including a reference to the impact of modernism beyond the West. At the beginning of the thesis, Simon included a discussion about the arts he had had with Yusuf Meherally, Mayor of Bombay, when he visited New York City in 1948.[36] By then Simon had joined the Eastern Arts Association, and the conversation reflected his lifelong interest in the cultural heritage of Asia. Decidedly absent from the thesis, however, is any discussion concerning the impact of African art on modernism. It can be argued that Simon's study of modernism adhered to the linear European-to-American model promoted by the so-called vanguard of the movement.[37] Simon would not seriously explore the relationship between modernism and African cultural expression until he was appointed Cultural Affairs Officer with the Foreign Service and stationed in Cairo, Egypt, from 1961 to 1964. The work resulting from his years in North Africa marks what I consider a definitive second phase in his career.

By the time Walter Simon completed his master's degree in 1949, his work, according to Virginia Simon, had become predominantly abstract. In describing this evolution, she wrote, "Though he continued to do occasional figure compositions and realistic sea, land, and cityscapes, the bulk of his work was increasingly abstract with a strong base in Cubism." At the time Simon began experimenting with Abstract Expressionism, the family lived in Greenwich Village.[38] He lived with his wife and their two toddlers in a fifth-floor walkup railroad flat. The toilet was in the living room closet and the bathtub on high legs in the kitchen, but for $25 a month, it was affordable on

131

Simon's GI Bill salary. Except for one other family, they were the only Black residents in this Greenwich Village neighborhood. It was in walking distance of New York University, where Simon enjoyed long café conversations with interesting, politically liberal individuals. He brought them all home to Apartment 8: working-class neighbors, professors, artists, dancers, art patrons, writers, painters, doctors, lawyers, actors, musicians, political idealists, and even a few celebrities, to meet his family and share a meal, look at his paintings, and participate in lively discussion about the issues of the day. This was also the time when Simon organized faculty and students at the university into the Unity Council, a diverse group created to pressure NYU to hire more Black employees in roles other than elevator operator.[39]

715 Washington Street, Greenwich Village, 1947

In 1947 the artist painted *715 Washington Street, Greenwich Village*, directly inspired by the unique cultural experience of living in Greenwich Village (fig. 8). There is a strong feeling of architecture that suggests a vertical apartment building with ascending rooms and diverse spaces. The painting is constructed from a building up of intersecting straight lines. Overlapping two-dimensional geometric shapes—including parallelograms, rectangles, rhombuses, squares, trapezoids, triangles, and right-angled triangles—predominate, emphasizing areas of flatness and multiple vantage points. There are almost no flat geometric planes with curved lines. The eye is drawn to the pyramid, placed off center but midway from top to bottom. It is the most dominant three-dimensional geometric shape on the canvas.

The tones range from beiges to browns, greys to blues. Areas of thickly applied paint contrast with dry brushstrokes through which the canvas can be seen. Small squares of red placed in the left foreground, the middle right, and the upper right side move the eye up and toward the back. Horizontal, vertical, and slanted bars placed at intervals from bottom to top help to provide structure, almost like different floors characteristic of a multilevel building. The configurations of parallel lines and checkerboard squares even suggest the diversity of floor patterns in an apartment building. Thin vertical lines strategically placed resemble the railings, staircases, and stairwells that connect floors. The trapezoid-shaped area is filled with sand, heightening the sense of contrasting textures.

The text the artist included, "MEMS-FURN," links Apartment 8 to its larger neighborhood, indicating the businesses and cultural amenities that were within walking distance. Another directional element is the dark red-brown arrow pointing toward the right. It is situated near tall vertical lines that resemble a telephone pole. Together, these elements suggest a streetscape, a scene outside the closed-in space of the apartment building. While the work largely negates linear perspective and any strong illusion of depth, as demanded by Cubism, the shadowy renderings of indistinct lines and soft forms in the upper section of the painting do project to some degree into the background, in contrast with the dominance of hard-edged, flat, geometric forms. Simon's painting of the upper left section is also more realistic, looking like the sides of a building with darkened doorways and a receding walkway to indicate movement and shallow depth. Simon, therefore, like his mentor Hale Woodruff, found that abstraction did not completely negate recognizable content nor interaction with cultural experience.[40]

715 Washington Street presents a signature characteristic of Simon's evolving style. It is a collection of geometric forms, often vertically ascendant, like the Gothic architecture the artist so admired, and best described as architectonic. Simon elaborated on the role architecture played in the development of modernism in his thesis.[41] He notes that

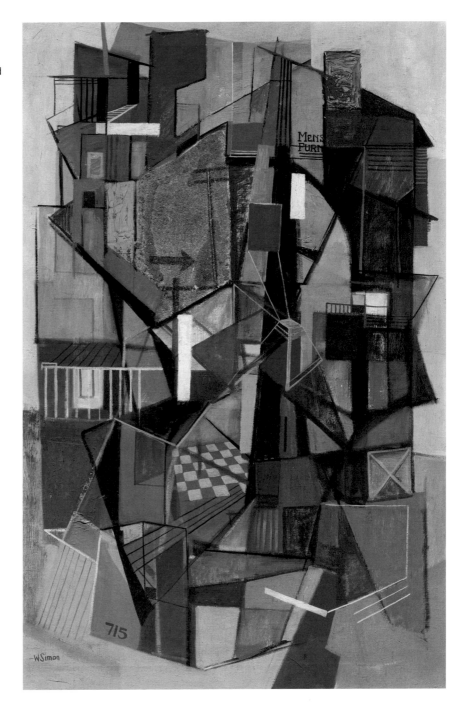

nonrepresentational painting renounces imitation of nature and attempts to create illusion. The canvas possesses only two dimensions: height and width. The goal of painting is in the painting itself. Painting has its own existence "independent of subject matter, nature, or the expression of one's emotions." Painting is an art of related forms and colors. Simon argues that modernist painters also emphasized "architectural qualities." He defines such painting as being "based on a formal structural relationship of line to line and mass to mass, or to the plastic organization of painting."[42]

Simon asserts that Cubism, Constructivism, nonobjectivism, de Stijl, and Purism were influenced by Roger Fry's call to create a purely abstract language of visual music with little resemblance to nature.[43] Of even more significance to Cubists was Paul Cézanne's work transforming what he observed in nature into fundamental geometric forms, upon which artists like Picasso and Braque advanced analytical and synthetic cubism. In conflict with the emotionalism and the exotic associated with the Fauves, Cubist

painters stressed restoration of the "rigid architectural framework" that linked the work of artists including Ingres, Poussin, Seurat, and Cézanne.[44] Painters could achieve formal harmony without representation if they approached the problem like architects. Any form or object on the flat surface of the painting should not recede into space or visual distance. Simon quoted the work of Reginald Wilenski in *The Modern Movement* (1926): the "painter must create pictures which shall be frankly symbols on a flat surface," achievable if the painter's symbols exhibit definitive architectural shapes.[45]

Simon never veered from his fundamental position concerning the role of architectural form in his painting. At a conference panel about the arts held at the Museum of Modern Art in 1955, he declared: "Here in America we have a different kind of creativity not concerned with art and painting but building. Our important art is engineering, or architecture, which is far more vital than our painting, which is pseudo-European."[46] By this time he had secured a position at what is now William Paterson College in New Jersey. His picture in the school yearbook from 1959 reinforces how Simon viewed the relationship between painting and architecture (fig. 9). Simon is seated at his desk holding a small model of a multistory building, across from which is an abstract painting. On the blackboard behind Simon are notes about modern movements in art. Directly in front of the art historical terms "Fauvism, Cubism, Surrealism" is a quote written in larger text from the Roman author, architect, and engineer Vitruvius: "ARCHITECTURE should meet three requirements: utility, strength, beauty." The term *architectonic* was even used by Virginia Simon in her husband's obituary in 1979 when she defined the artist educator "as primarily a painter of architectonic themes."[47]

The artist's interpretation of the apartment complex at 715 Washington Street, multifaceted and dynamic in the style of Cubism, captures the rich cultural, social, and political life the Simons experienced during the three years the family lived at this site. When Walter Simon showed *715 Washington Street* in the 26th annual New Jersey State Exhibition at the Montclair Art Museum, it was described thus: "Contrasting to this is Walter A. Simon's *Washington Street Apartment*, reproduced above. Simon's painting is an inventive abstraction with an experimental approach to technical rendering. It is a complete unity of line, form, and color, resulting in a strong rendering

Fig. 9 Paterson College yearbook, 1959, p. 12. Stuart A. Rose Manuscript, Archives, and Rare Book Library, Emory University, Atlanta.

of his subject matter. This gifted young artist is associate professor of art at Paterson State Teacher's College."[48]

Challenges: A Black Art Educator in the Jim Crow South

Beginning in 1947 Simon started to teach at Black colleges in the South while working on his BS and MA degrees. It was Hale Woodruff who aided Simon in getting his first job, a teaching position as Director of Atlanta University's Summer Art Workshops.[49] He taught art, art education, and art history at the summer workshops in 1947 and 1948. Woodruff took over the helm of the art department at Atlanta University after returning from Paris in the 1930s, and one of his most important goals was to expand the art programs. The Arts and Crafts Workshop was initiated in 1947 as a major feature of the Atlanta University summer school, designed expressly for "teachers and prospective teachers in schools and colleges."[50] The workshops responded to a "long-felt" desire to meet the need for intensive and comprehensive training for Black teachers in the arts. There was a demand for instruction in the "philosophies, techniques, and media of art education, as well as methods of adapting these to the particular problems and environment of the teacher and artist."[51] Therefore, instruction emphasized crafts, creative drawing, and the teaching of art in elementary school. The classes met in facilities conducive to learning that would be available to students for the duration of the school day.

Simon was apprehensive about living in the South, but Woodruff encouraged him to experience things directly for himself.[52] During the summer of 1947 Simon lived mostly on campus and seldom ventured into the city. However, he so thoroughly enjoyed teaching and campus life that he returned to Atlanta to direct another workshop the following summer. The 1948 Summer School Bulletin shows that Simon taught an Arts and Crafts Workshop, Drawing and Painting, Intermediate Painting, and Advanced Painting and Composition.[53] The workshop consisted of both a two-hour lecture and a three-hour lab. Another instructor, Naomi Guthrie, who was from St. Louis, taught the class Art for Elementary and Secondary School Teachers.[54] Here was the opportunity for Simon to implement approaches to art instruction recently learned at New York University, such as the creation of community workshops, little theaters, and art groups. Photographs from the Summer Workshop in 1949, for example, showcase some of the artworks and exhibitions created by the students. They include ceramic production, the construction of newspaper puppets, and hand puppets for theater productions (fig. 10). Extant photographs of the workshops document the students' experimentations with abstract painting and design as well as projects promoting Negro History Week, Music Week, and Book Week.

For beginning students in a college classroom, Simon believed that this approach to art instruction helped to build confidence in self-expression.[55] He argued that our contemporary society was the first to have knowledge about every culture that had preceded it, possibly creating standards that were too high. While standards were important, he believed that humble efforts, especially in reference to beginning students, should be appreciated and

Fig. 10 Walter Simon with student teachers, Summer Workshop, Atlanta University, 1948. Stuart A. Rose Manuscript, Archives, and Rare Book Library, Emory University, Atlanta.

135

encouraged if art educators wanted to achieve better results in breaking down the inhibitions adults often held about creative expression.[56] He also counseled art educators to broaden the experience of the arts beyond learning the techniques of painting or sculpture by participating in public programs at museums and other cultural institutions.

These perspectives on teaching and students are implicit in Simon's discussion about his experience with the Atlanta University Summer School programs, which he viewed as a very successful initiative. He described the students as schoolteachers initially "set in their ways" who registered for the courses to receive the credits that would ensure a raise in salaries when they returned to work. However, over the eight weeks of instruction, teachers put together well-executed exhibitions showcasing all that they had learned, as displayed in the photographs. Simon expressed his belief in the potential of his students in the introductory texts he wrote for the exhibitions:

> Exhibited here are the works of elementary and secondary school teachers. All protested, on registering, that they "had no artistic training or ability," . . . etc., etc. This exhibition is proof of the fact that all people are capable of expressing themselves artistically. These are not "works of art." . . . Education in a democracy is not primarily concerned with developing "great art" or artists (or great talent of any sort). Rather, it should be concerned with helping the "average" student further to develop his sensitivities (and abilities), which in the past education has tended to deaden and frustrate instead of broadening and enriching.[57]

When Simon completed his MA in 1950, White institutions of higher learning were slow to hire African American professors. Simon therefore took the position he was offered at Georgia State College in Savannah. Established in 1890 as Georgia State Industrial College for Colored Youths, it is the oldest public historically Black college or university (HBCU) in the state. The first female students were not admitted as residents on campus until 1921. Simon was employed to activate a program in art education.[58] He chaired the curriculum committee for this arts initiative and introduced the following courses: Art Appreciation, Arts and Crafts for Elementary School, and Drawing and Painting. The school annual that listed him as faculty that year also features a picture of a young female student painting to announce the new program in art education, taken from a photograph of Simon's art class depicting students engaged in sculpting, painting, and drawing. It is interesting to note that all the students are female (fig. 11).[59]

The image might reflect some of the provincial attitudes about the arts that predominated in a small rural community. Most HBCUs had been established with an emphasis on manual training or the industrial arts, as such courses came to be called during the early twentieth century. Simon introduced a fine arts tradition to Georgia State that was largely unfamiliar to the faculty, students, and community. Perhaps fine arts training was something perceived as more suitable for female students than male youth. Dr. Alonzo Myers, chair of the Department of Higher Education and chair of Simon's dissertation committee at New York University, visited the campus that year, along with his wife. This was likely at the invitation of Simon. Dr. Myers was on a one-year sabbatical to visit HBCUs in the South, due to his interest in "Negro education."[60] Although he was in Savannah for only a year (1948–1949), and however conservative the Simon family might have found the situation at Georgia State, the obligation was fulfilled to establish an art program at the school. Simon also exposed students to a broader art world than they had previously known.

Fig. 11 Art class at Georgia State College, 1948–1949. Stuart A. Rose Manuscript, Archives, and Rare Book Library, Emory University, Atlanta.

Simon's longest tenure at an HBCU was at Virginia State College in Petersburg, Virginia (1949–1953). Virginia State was closer to New York University as he began his work on a doctorate in art history.[61] In addition, both his mother and his wife's roots and family were in the state. Having completed his master's and working on his PhD, Simon was offered a sizable increase in salary and an advance in academic rank to associate professor.[62] Advances made to the curriculum included an arts appreciation course covering the prehistoric era to the twentieth century; a course in advertising design encompassing commercial layout, lettering, and display; and a humanities, arts, and music course that taught how the forms related to each other in the modern era.

Simon extended his art education responsibilities beyond teaching while at Virginia State, encouraging the art department to build an art collection, similar to the work accomplished by Black artists teaching at other HBCUs, such as Aaron Douglas at Fisk University in Nashville, or Vertis Hayes at LeMoyne College in Memphis. Simon drew for this initiative upon his close friendship with Robert Jackson, the wealthy White artist and patron who had painted portrait in 1939 (fig. 12).[63] The collection included numerous sixteenth- through nineteenth-century books and prints; paintings by Romare Bearden, Elton C. Fax, and Ellis Wilson; prints by Edward Hopper and James McNeill Whistler; and wood carvings from West Africa and the Philippines.[64] The earliest book in the collection, *Hieronymi Mercurialis de Arte Gymnastica*, was printed on vellum in 1577. Jackson's collection reflected his broad experiences as a New Yorker, education at Princeton University and the Art Students' League, and travels in the United States and abroad. Jackson stated that he was "motivated by the desire to make a contribution to the art education of a student group." Simon was recognized in the acknowledgments in the catalogue for the exhibition that accompanied the gift: "The Department of Art accepts with appreciation this generous initial contribution to the development of a Fine Arts Museum for Virginia State College. The department acknowledges its gratitude for the friendship between the donor and Walter A. Simon, which is partially responsible for the donor's interest in making the gift."[65]

Fig. 12 Walter Simon standing next to donor Robert Jackson, Virginia State College, Petersburg, Virginia, ca. 1949–1953. Stuart A. Rose Manuscript, Archives, and Rare Book Library, Emory University, Atlanta.

137

While he was teaching at Virginia State, Simon was part of an integration experiment that introduced Black faculty to a Southern coeducational college when he began working with the American Friends Service Committee in 1951, an organization founded in 1917 to represent the Religious Society of Friends and to promote the Quakers' ideas in "national and international fields of social action."[66] The philosophy of the organization was rooted in the belief that "respect for fellow human beings and the power of love could counteract prejudice and promote peace around the world, supported by people of many faiths, races, and nations." The visiting lectureship program was established in 1944 to encourage "interracial understanding" in elementary and high schools and colleges and universities. The highly qualified "minority scholars" selected to participate lived on the campuses subsidizing their services for a week or more to engage in college and community activities. Initially, the lecturers were African American, but the organization sought to diversify its pool of lecturers and not saddle the participant with being "exclusively a 'pleader for his people.'"[67] HBCUs were also participants in the program. By 1951, when Simon was selected as a lecturer, several American colleges had recruited Black faculty as a result of this new model of introducing minority faculty to their institutions.

The promotional brochure advertising Simon's availability for 1952–1953 (accompanied by his picture) identified him as an "Instructor of Art Appreciation and History at Virginia State College." The brochure emphasized his unique training and abilities as a minority educator able to speak on the history and philosophy of art. In 1952 Simon was selected, along with African Americans J. Saunders Redding (historian, novelist, and literary critic) and Hugh Gloster (later to become the renowned president of Morehouse College), to be visiting lecturers at Guilford College in Greensboro, North Carolina. Based on correspondence with his friend Chester Bowles, Simon found this to be a very positive experience.[68] I believe that Simon's work with AFSC was instrumental in resolving some professional conflicts at Virginia State College. The outcome was Simon's integration of a college and its arts program in the North.

Walter Simon and his family were never part of the social life at Virginia State College. He felt that the Black middle class was too materialistic and conventional.[69] In addition, after four years, differences with his colleagues came to the fore, and Simon made the decision to resign. He stated that differences regarding basic concepts with the head of the department, Amaza L. Meredith, "are too far removed for an amicable relationship."[70] Without disclosing particulars, Simon revealed only that these were conflicts about core ideas concerning pedagogy. Perhaps he pushed too hard trying to implement more progressive approaches to teaching, curriculum, etc. The letter from Chester Bowles included a statement that Simon "should not hold the South wholly responsible for discrimination" because there were people there working quietly to improve social conditions, suggesting that racial attitudes may have been a factor as well. In May 1953 Simon turned in his resignation letter, writing that he was "motivated by the desire to preserve a measure of unity within the Department of Art."[71] President Robert F. Daniel in accepting the letter regretted that adjustments could not be made in relationships within the Department of Art and that Simon felt that he could not continue. However, he recognized his contributions and wished him well in the future.

Integration and Paterson State College: 1953–1961

In 1953 Walter Simon became the first Black faculty member at the New Jersey State Teacher's College at Paterson in Wayne, New Jersey.[72] He had

convinced Paterson College that a minority professor of art education could make a positive contribution to the fine arts training and education of White students. He was the only African American teaching in the six existing state teachers' colleges.

Simon was an effective, progressive, and popular teacher at Paterson. Among the courses he developed were Experiencing Art, Social Interpretations of Art, Art with Native Materials, and Public-School Art.[73] His courses incorporated visual aids such as exhibitions from area museums; slides and films; books, magazines, and newspapers; and field trips to museums. The curriculum content of the Experiencing Art course emphasized art history more than that of the other courses. The syllabus included the following description: "The evolution of art . . . from the Pre-Grecian era through the Contemporary era is traced with emphasis placed on the development of aesthetic judgement."[74] Simon's goals likewise included teaching an appreciation for the culture of one's time, so he emphasized modern developments of the twentieth century in the course Social Interpretations of Art, designed as a "reasonable vehicle for analyzing the world as we find it in relation to the past—and we do find art very important in this probe."[75]

Given Simon's lifelong interest in building things, architectural history and practices received significant attention in all three art courses. The course Experiencing Art included studying the influence of Greco-Roman, Gothic, and Renaissance styles on American architecture as well as lessons on industrial architecture, the place of individualism in the private home, and furniture design. He included field trips to construction sites where industrial buildings, housing projects, and government buildings were being erected. The Social Interpretations of the Arts course included building-themed project assignments like: "a city house for a family of three," "a suburban home for a family of five," "an office building for an insurance company," and "a small factory for manufacturing fountain pens." Simon's curricula and teaching reflected his belief that the architectural arts and engineering were the more vital creative expressions in America, compared to painting. There was more innovation in building in the United States than in painting, which Simon regarded as largely "pseudo-European."[76]

The course title Art with Native Materials was somewhat misleading, as it was not a course in Indigenous arts, generally not part of college art curricula during the 1950s. It was, instead, instruction focused on the use of "available materials that might be found in a specific community or situation." In contemporary terms, it was a course dealing with found art materials. The Public Arts course allowed Simon to experiment with his ideas about art and psychology. It examined the relationship between art and "therapeutic factors in human development," and looked at how art expression was beneficial for teachers of children and for enriching daily life. It likely drew on a workshop Simon had taken under Dr. Rudolf Arnheim at Sarah Lawrence College: the Workshop in General Education Psychology of the Arts.[77]

Some of the ideas Simon tried to communicate in the latter courses were specifically incorporated into a giant mural, six by sixteen feet, designed for the teachers' cafeteria at Paterson in 1954 (fig. 13). The educational theme was chosen based on a quotation from Thomas Jefferson: "Enlighten the people generally, and tyranny and oppression of both mind and body will vanish." The mural was Simon's idea, and he asserted that it allowed him to demonstrate that murals should relate to their architectural context instead of functioning predominantly as decoration. He applied a paraffin seal on the wall before applying the pigments. The theme explored the relationship between technological and biological sciences, suggesting the evolution of these contemporary forms with the "basic elemental forms

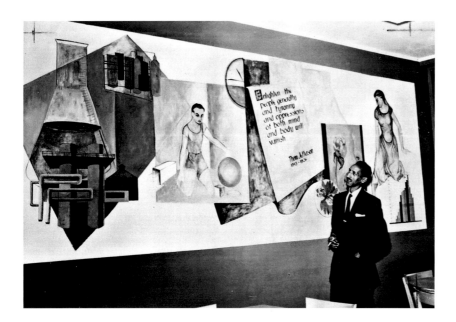

Fig. 13 Walter Simon standing next to Paterson State College mural, 1954. Stuart A. Rose Manuscript, Archives, and Rare Book Library, Emory University, Atlanta.

of children's toys." Recognizable elements were described in a newspaper article: "a chemical lab flash, an oil refinery cracking plant, a timepiece, a world globe, a butterfly lighting on a plant, a rose in evolutionary form, a graph depicting a typical educational measuring device, and a classical concept of woman, the initial educator." Beyond this, Simon refused to interpret the mural, arguing that viewers should work this out for themselves, based on personal background, environment, and ideas.[78]

The impact of Simon's work at Paterson College culminated with the establishment of the art education program in 1959.[79] This coincided with a major gift of art objects from Mr. and Mrs. S. Paul Boochever of Montclair, New Jersey. The Boochevers, avid collectors, donated nineteenth-century American paintings and French and Japanese prints. Mr. Boochever explained that it was his longtime friendship with Walter Simon that accounted for his interest in the college. Boochever had served as executive secretary of the New York City Department of Correction under the administration of Mayor Fiorello H. La Guardia and was an executive at several manufacturing companies. He established the Boochever Art Scholarships in 1964 and, due to his extensive contributions, received an honorary degree in 1966 from what is now William Paterson University. Boochever was also instrumental in helping Simon secure his first foreign service appointment. Today the collection is intact although rarely exhibited. It currently consists of the eighty-five artworks donated by the Boochevers between 1959 and 1968.[80] In addition, Simon's work as advisor with the 1956 college yearbook, *The Pioneer*, was instrumental in the first-place award granted to the collection for general excellence from the Columbia Scholastic Press Association in 1956.[81]

Art Education beyond the Classroom

Simon's experience at Paterson was especially significant for the broadening of his professional arts opportunities and activities as a Black art educator and art historian beyond the classroom. In 1954 he was one of "four nationally known judges" selected to participate in the North Carolina Scholastic Art Exhibition: "painter Walter A. Simon, Art Instructor, New Jersey State Teachers College, Paterson, NJ; painter Hale Woodruff, Associate Professor of Art Education, New York University; sculptor Marie S. Huper, Assistant Professor of Art, Agnes Scott College, Decatur, GA.; and painter Mary Leath Thomas, Art Supervisor, Athens GA., City Schools" (fig. 14).[82] Hale Woodruff and Walter Simon were the two African American art educators invited by the advisory

committee to judge the more than 2,000 entries submitted from art students in grades seven through twelve.

This was North Carolina's first time participating in one of the regional competitions conducted nationally by Scholastic Magazines. During the two-day event the judges participated in an art forum and panel held at the Winston-Salem Public Library. The *Salem Journal* newspaper article covering the event, "Judges Criticize People Who Reject Modern Art," included remarks by all the judges; however, Hale Woodruff was quoted most extensively.[83] His comments highlighted the creative development of children, emphasizing the need to encourage fantasy and imagination. Simon's remarks expressed his views about American art audiences, whom he considered too materialistic, arguing that people should be encouraged toward the view that "cultural things have real validity."[84] In consensus, the judges claimed that modern art did not require explanation or meaning. Abstraction was a style valued for its expressive qualities and emotional power. The careers of both Woodruff and Simon benefitted from opportunities to judge national art competitions and integrate the professional world of the arts at a national level.

Simon was increasingly sought after as a lecturer on modern art. One of the most important opportunities for participation in conferences was the invitation from the Director of Education at the Museum of Modern Art, Victor D'Amico, to lead a three-session seminar on teacher training to be held at that institution in March 1955, a component of the museum's Annual Conference of the Committee on Art Education.[85] The thirteenth conference coincided with the twenty-fifth anniversary of the Museum of Modern Art. Simon was asked specifically to address US teacher training in higher education and its responsibilities from a "world" perspective. The seminars Simon taught were Status of Creativity in Contemporary Society, Challenge of Creativity to Teacher Training Education, and Impact of World Forces on Teacher Training Education—Emerging Asia. Participants came from the following institutions: State University of New York Teachers College, Plattsburgh; University of Michigan, Ann Arbor; State University of New York Teachers College, Buffalo; University of Georgia, Athens; Office of the Ministry of Education, Indonesia; and Girls High School, Jakarta, Indonesia.[86] In April of 1955 he also gave a lecture for the Ada M. Hammond Memorial Scholarship Fund of Paterson College, speaking on the theme "The Layman's Approach to Modern Painting."[87]

In 1955, Simon was asked to participate in two projects that drew upon his growing interest in abstraction and his early training in design and construction. In May of 1955, Simon learned about the Atoms for Peace Conference organized by the United Nations and to be held in Geneva, Switzerland, August 6–20, 1955.[88] This was the first conference whose goal was the creation of an international body charged with regulating the peaceful use of atomic power (nuclear energy). The president of the conference was Dr. Homi Bhabha, the renowned nuclear scientist and founder of the Indian nuclear program. It is possible that Simon was especially interested in the conference because of the important role Bhabha played as well as the recognition of India as a rising power in Asia. The conference coincided with Simon's interests in art educational liaisons with India, as recently observed in his work on Asian topics at the MoMA seminars earlier in March. Simon's

Fig. 14 Walter Simon, Hale Woodruff, Mary Leath Thomas, and Marie Huper, judges for North Carolina Scholastic Art Exhibition, 1954. Stuart A. Rose Manuscript, Archives, and Rare Book Library, Emory University, Atlanta.

drawings were selected by the United States Atomic Energy Commission, and he began designing a mobile radiological unit: floorplans designating the placement of functioning units, windows and doorways, and entering and exiting platforms and stairs. The completed unit was thirty-five feet long and placed in a specially designed trailer. In addition, the project required Simon to design all visual aids that would accompany the exhibit, such as the covers and jacket designs for all official publications. President Eisenhower viewed Simon's exhibit when he attended the opening of the conference.[89]

In October of 1955, Simon was invited to participate in yet another project that drew upon the artist's lifelong interest in architecture. He was part of the committee planning a conference of architects, civic officials, and school administrators to study the challenges of building schools in New Jersey. The key speaker at the conference was Marcel Breuer, the Hungarian-born, internationally renowned modernist architect and furniture designer associated with the Bauhaus.

This time Simon was also being invited to speak of issues specific to the African American community as well as African topics. In 1958 he gave a lecture at St. Paul's Congregational Church in Montclair, New Jersey, titled "Africa Today," addressing social and economic issues in contemporary society.[90] It was noted in the local coverage for the lecture that he was being considered, under the auspices of UNESCO, for a post in Kabul, Afghanistan, to teach art to the local community. That same year the NAACP branch in Plainfield, New Jersey, asked Simon to speak on the "Negro in American culture" or on any related topic addressing problems integrating American society and how the situation might be improved.

It was during this time that the Simons began to persistently research opportunities to teach the arts in Asia, the Middle East, or Africa. It can be argued, then, that the years of teaching at Paterson College, networking and exhibiting beyond the classroom, and at the same time pursuing his PhD all contributed to how Simon envisioned himself as especially suited to live and work on cultural matters abroad. Simon's evolving attitudes about the role of the arts in diverse cultural contexts and the role that artists of color might play internationally is evident in correspondence from this period. An example is a letter of interest in employment overseas written in March of 1958: "I am an American Negro. My father is an Indian (born of Moslem parents in Bombay, India). . . . I strongly feel that the American Negro, when effectively employed, will prove to be an inestimable factor in the expanding of good human and economic relations between the Asian-African world and the business concerns of the United States. I would be most happy to become a party to this expansion should you feel that one with my background might be utilized in your overseas program."[91] Simon would teach painting and art history at Paterson College until he was appointed a foreign cultural affairs officer and left for his assigned position in Cairo, Egypt, in 1961.

Abstract Expressionist

Simon's ongoing interest in geometric abstraction and non-objective art should be understood within the broader context of American art during the mid-twentieth century. The 1950s marked the maturation of his distinctive Abstract Expressionist style (fig. 15). If we harken back to how he was introduced to and studied modernism as outlined in his MA thesis, it can be argued that he remained strongly linked to the European origins of geometric and nonrepresentational styles of art. During the 1940s, American art began shifting its focus from Regionalism, Social Realism, and American Scene Painting and sculpture, styles dominant during the Great Depression and into the 1940s.[92] The selected leaders of the new movement,

predominantly White and male, rejected ideas based in social reform and art accessible to everyone. Instead, they stressed and connected social alienation and personal expression. The New York School grew in prominence because it was where most of these artists, and the newfound critics of the movement, lived and worked. The new style was sometimes called Action Painting due to methods of working associated with artists like Jackson Pollock. Artists and critics were also preoccupied with distinguishing what was happening in post–World War II America from the earlier European movements of abstraction and modernism linked to Picasso and Braque.[93]

By the mid-1950s, modern art had come to be widely understood as American art. Many Black artists were part of the movement, responding in an eclectic fashion.[94] Those who chose to fully embrace Abstract Expressionism practiced all forms of it, ranging from the nonobjective to figurative expressionism. Whatever the style or medium, these artists generally continued to identify with Black culture, history, and heritage, never totally disavowing the great narrative potential of the visual arts nor fully rejecting the creative power of the human figure.

When Simon started the summer workshops in Atlanta in 1948, he also began to participate in the Atlanta University exhibitions that Hale Woodruff had founded in 1941. At the eighth annual exhibition, held in 1949, Simon showed the oil painting *Lot's Wife* and the watercolor *Abstraction—The City—No. 3*. The latter won the Second Atlanta University Purchase Award ($75).[95] At the tenth annual exhibition, in 1951, the jury selected the oil painting *String Dance* for the Atlanta University Purchase Award ($300) for the Best Portrait or Figure Painting.[96] And in 1953 his painting *Venezia* (1951; fig. 16) won the university's John Hope Purchase Award ($250) for the best landscape.[97]

Another important, award-winning artwork from this period was *Pier 27*, shown in the biennial Virginia Artists Exhibition in 1951 at the Virginia Museum of Fine Arts (fig. 17).[98] The 168 artworks by Virginia artists (born, reared, or living in the state) were chosen from 933 entries.[99] The museum also sponsored 60 traveling exhibitions from the show to tour the entire state. The jury, made up of Herman Williams Jr., Director of the Corcoran Gallery of Art, Washington, DC; New York artist Stuart Davis; and New York artist Peppino Mangravite, nominated 20 works for purchase.[100] The

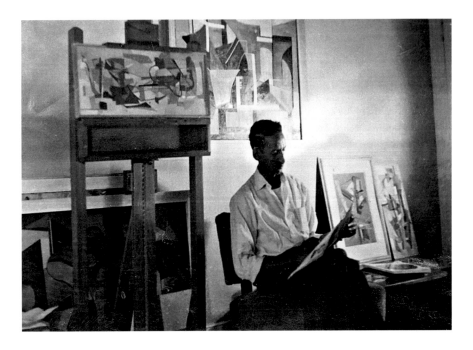

Fig. 15 Walter Simon in his studio, 1952. Stuart A. Rose Manuscript, Archives, and Rare Book Library, Emory University, Atlanta.

recommendations included *Pier 27*, and it was the artwork chosen to illustrate the article written about the exhibition in the *Richmond Times Dispatch*. The Museum initially refused to purchase the work for the price Simon requested, but a compromise was eventually agreed upon. The painting, however, was not given immediately to the museum but accompanied the Simons around the country and on their world travels.[101] A family favorite, it has been a feature of many American homes and was exhibited in Egypt, Afghanistan, and Ceylon during Simon's career as a foreign officer abroad. It returned to the Virginia Museum of Fine Arts in 1977.[102]

Fig. 16 Walter Simon, *Venezia*, 1951. Oil on canvas, 38 × 46 inches. Clark Atlanta University Art Museum.

These award-winning artworks, all of which are abstract urban landscapes, except one, followed a model Simon had established with *715 Washington Street, Greenwich Village*. Many of his paintings throughout the 1950s experimented with urban landscape themes. Although many were simply titled *Abstraction* and distinguished only by their dates, some titles included a place name. Examples from this period include *Abstraction* (1945); *Abstraction* (1946); *Abstraction* (1947); *Abstraction* (1948); *Abstraction with Woman's Head or Cinema* (1948; cat. 50); *Lines from François Villon # 1* (1948; cat. 33) *Abstraction—The City—No. 3* (1949); *Abstraction* (1950); *Steel Construction* (1951); *Structural Facades* (1953); *Industrial Vertical* (1955); *Abstraction* (1956); *Abstraction* (1957, Glassboro, New Jersey); *Abstraction* (1957, Upper Montclair, New Jersey); *Abstraction* (1957, Glen Ridge, New Jersey); *Composition: CR-2* (1958); and *Abstraction* (1959).

By the 1950s then, Simon had fully embraced a geometric style strongly influenced by his love of architecture and design as well as an interest in urban terrains. We have already examined the impact of Simon's scholarly studies, but it can be argued that his mature abstract style had its origins in his childhood. When Walter Simon Sr. first noted his son's interest in art, he asked White friends—a retired architect and illustrator—to mentor him.[103] They took Simon Jr. on walking tours exploring the architectural gems of New York City located along Fifth, Park, and Madison Avenues. Much of what they viewed were nineteenth-century mansions reminiscent of the earlier architectural styles of Europe before being demolished to make way for skyscrapers.[104] These same friends of his father's—the retired architect and the illustrator—expanded Simon's appreciation for Western art traditions by taking him to the Metropolitan Museum of Art.

Fig. 17 Walter Simon, *Pier 27*, 1951. Oil on canvas, 28 × 40 inches. Virginia Museum of Fine Arts, John Barton Payne Fund, 77.70.

As previously noted, Simon's interest in architecture and construction was also strengthened by his experiences during World War II. The twelve-week drafting course included three components: drafting, mathematics and computations, and aerial photographs. Simon learned how to draw cross-sections and earthwork; lettering and conventional signs; simple

Ah God, the days I lost!
Youth and what I loved most
went when my back was turned!
Old age came limping on—
I was less ripe than black!
nothing left on horseback
or foot, alas! What then?
My life suddenly burned.

~François Villon

Cat. 33 Walter Simon, *Lines from François Villon #1*, 1948; Private collection

Fig. 18 Walter Simon, *Abstraction—The City— No. 3,* 1949. Casein, 23½ × 39¾ inches. Collection of Atlanta University.

structures; and mathematics, algebra, geometry of logarithms, and plane trigonometry. He also learned to use map compilation, aerial photographs in mapping, scale problems, and logical contouring restitution.[105] The technical approach to drawing based on mathematics and the study of aerial photographs both contributed to the development of Simon's distinctive architectural paintings. *Abstraction—The City—No. 3* (1949; fig. 18), for example, is an arresting aerial view of New York City. Intersecting diagonal and semicircular lines, squares, and rectangular- and cube-shaped boxes, cross-hatching, and grid patterns are reminiscent of railroads, subways, and highways as viewed from the perspective of airplane flight. Simon's "mapping" of what looks like modern modes of transportation effectively communicates the fast-paced rhythm of urban life in a city like New York.

The works from the 1950s are comparable to those of some of Simon's contemporaries working with abstraction, who likewise remain underresearched. Cedric Dover, in *American Negro Art* (1960), characterized Simon as an art leader who, along with Richard Dempsey, Delilah Pierce, Merton Simpson, and Alma Thomas, formed part of a group of "abstractionists in the old-fashioned sense of abstracting a subject. They do it interestingly, as our few pictures show, and with a working regard for the promotion of Negro art as a whole."[106] Dover, who was also from India, thought it important to mention Simon's Asian heritage, Catholic upbringing, and "workaday philosophy of art." He quoted Simon in reference to his ideas about the relationship between education and democracy, and how the teaching of art should be concerned with enriching the human experience, not creating "works of art." Dover claimed that such artists, along with others including John Howard, Hughie Lee-Smith, Edward Loper, and Stan Williamson, were creating a new and sensitive vision of the country that was just as "American" a view as that of any other mainstream artist.[107] Of the works Dover chose to represent in his text, Alma Thomas's *Tenements* and Richard Dempsey's *Cityscape* exhibit form over content and make use of urban landscape titles, similar to Simon's thematic studies of abstract cityscapes.

Figurative Abstraction

String Dance #1 (1951; fig. 19) was Simon's only award-winning figurative piece from the Atlanta exhibitions. The painting was one of several figurative studies he created during the 1950s that were inspired by dance and emphasized on the female form. The other two works from this period are *String Dance #2* (1951; cat. 38) and *Khambavati* (also known as *Two Dancers*, 1953, cat. 46). Like many American artists, Walter Simon did not completely abandon figurative or representational styles of painting. Throughout his career, he created portraits, landscapes, and seascapes and explored the human figure as influenced by the abstraction of formal elements. The style of Abstract Expressionists who continued to work in a figurative mode was known as Figurative Expressionism.[108] Thomas Hess, one of the most influential critics in the 1950s, was among the strongest advocates of the new figurative painting, arguing that it was part of modernism from the beginning and one of its most important continuities.[109] Although Figurative Expressionists were not viewed as extreme, critics acknowledged them as radicals who considered their approach to the human figure as revolutionary non-objective abstraction. The New York City scene was especially known for the diversity of Figurative Expressionist styles, influenced by Old Master works, history painting, portraiture, and mythological and allegorical painting.

These aesthetic movements were not restricted to the fine arts but occurred across American culture, including modern dance. Modern dance was as much a response to the cultural, social, political, and economic concerns of the early twentieth century as it was a rebellion against classical ballet.[110] During the 1920s and 1930s, theories of human movement and expression, as well as methods of instruction, were developed in Europe and America to interpret and dramatize aspects of the real world. Isadora Duncan, for example, developed unique movements inspired by both nature and her studies of classical art.[111] Duncan's elegant but powerful style was characterized by smooth strides and leaps using lifted heads and outstretched arms. Duncan performed barefoot and uncorseted in flowing tunics. During the 1940s Martha Graham became known for ritualistic dance dramas based on ancient Greek myths. She worked with the Japanese sculptor Isamu Noguchi to design sets for groundbreaking works including *Cave of the Heart* (1946) and *Night Journey* (1947).[112] Graham developed techniques emphasizing the pelvis as the center of all movement, expressed in the powerfully arched or curved back. The movements were harsh and intense, implying a sense of anguish and struggle, but also of deep passion, as they relinquished the need for gestures and positions traditionally considered graceful. Unlike ballet's defiance of gravity, modern dance accentuated body weight, an idea linked to theories held by artists promoting small-town America as a mythic national symbol of working-class communities, self-reliance, and hard work. Doris Humphrey's idea of performance was deeply physical and implied a sense of gravity. The sociopolitical dimension of such dance innovation during the 1930s was supported by the Federal Dance Project, the New Deal program that continued from 1936 to 1939.[113]

All three of the studies under consideration reflect Walter Simon's interest in and response to developments in modern dance between the 1930s and

Fig. 19 Walter Simon, *String Dance #1*, 1951. Oil on canvas, 32 × 27 inches. Clark Atlanta University Art Museum.

Cat. 46 Walter Simon, *Khambavati*, 1953; Private collection

the 1950s. *String Dance #1* depicts two monumental figures. The women's Rubenesque bodies mirror each other as they move in a circle, balancing a string between them. The dancers are dressed as ballerinas, reminding the viewer of how modern dance routines were choreographed integrating fundamental ballet movements. Simon's women are visually buoyant, their bodies expressing a sensuality communicated through the fluid movement of their large, muscular physiques. Their bodies convey power and vigor, expressed in the dark impasto brushstrokes used to outline human form. The raised and lowered positions of the arms, hands, and legs create angular shapes that contrast with the full, rounded shapes of the two women. The geometric spaces created by their raised arms echo the triangular shapes created by the strings. Abstraction is enhanced by Simon's approach to painting the architectural framework of the ballet studio: squared tiles and the oblique angle of the floor, which unevenly tilts, negate a linear perspective or artificial sense of depth. Large flat areas of color delineate the back wall alongside the cutoff view of posters with lettering and the word *vote*. It can be argued that the movements of Simon's dancing figures are directly comparable to modern dance choreography. The body, the space in which it moves, and the sound it responds to are shaped into the circles, triangles, arcs, rectangles, and squares that help the audience visualize the themes expressed in the performance.

String Dance #2, also created in 1951 and further removed from traditional representation, is a more extended abstraction of the human figure. While the two female dancers are still the dominant subject, Simon's overall approach to painting treats the entire canvas with importance. The bold color scheme of complementary contrasts—reds, blues, greens, and yellows—heightens emotional response. It is a complex application of paint wherein overlapping planes share a single color or hue. Anatomical distortion is achieved by breaking up the surface of the human body into geometric shapes (convex and angular) contained within the dark outlines that delineate the figures. Facing each other, the dancers are viewed from multiple angles, including back, frontal, profile, and three-quarter views. The dynamic gestures of the dancers move them around a thick connecting string, looping into curves and broad triangular forms. The interplay between the opposing movements of the dancers' arms and legs is intensified by the color contrasts in their costumes—the blue of the dancer wearing tights versus the red of the other dancer's loose, flowing, two-piece ensemble, which exposes her midriff.

The arc of the dancers' raised arms extends the interplay of geometric forms to the reality of the sides and corner of the two-dimensional canvas. The absence of depth highlights the flat back wall of the studio, painted with an intense yellow. Circular motifs add a dimension of surrealism to the painting. They are placed in the upper left corner, behind the shoulder of the left dancer, on the upper right wall, beside the hand of the dancer in red, and on the floor underneath the feet of the dancer in blue. Connected by dark lines to other geometric forms, they simultaneously appear to be either architectural elements or possibly eyes.

In 1953 Simon completed *Khambavati*. The title, specifically linking the work to Indian culture, probably came into being later, after the Simons attended "Two Evenings of Indian Dance," sponsored by the Museum of Modern Art in 1955.[114] The dance performances were part of the programming for the exhibition *Textiles and Ornamental Arts of India* exhibition at MoMA. They featured the acclaimed Shanta Rao, considered the greatest classical dancer of India. The incorporation of Khambavati, a music tradition associated with classical Indian dance, reinforces the artist's streams of influence specific to Asia.[115]

The artist's overall approach to abstracting the two-dimensional canvas is similar to that in *String Dance #2*. Geometric shapes are encased within the human form. However, the work is absent the contrasting thick black outlines employed in the two previous works. The application of paint is more transparent, using tones of cream, beige, yellow, and brown juxtaposed against limited areas of purple, lavender, pinks, and blue tones. Dark red and white are strategically placed for emphasis. Simon, however, does not abstract the human form seen to the degree in *String Dance #2*, but neither are the figures as realistic as in *String Dance #1*. The adherence to traditional representation as well as the two titles used for this artwork suggest an interpretation for this painting beyond the artist's interest in modern dance. The subjects are racially identifiable, with both exhibiting brown skin tones. Given Simon's ancestral heritage, are the figures intended to represent Black or Indian people? The women in all three of Simon's dance-themed paintings have high cheekbones and almond-shaped eyes, dark hair, and light to light-brownish skin tones. The depiction of ethnicity is generalized enough to represent performers of color from a diversity of origins. The angular facial profiles are likewise reminiscent of women's features in the work of Cubists such as Picasso or Braque and thus reflect the impact of African masks. For example, the face of the woman in red in *String Dance #2* appears decidedly Egyptian. Even in *Two Dancers*, Simon continues to emphasize the female figure, who dominates the canvas, seemingly stepping out in front of her male partner.

I would argue that the subtle representation of ethnic racial identities, as well as the gendered subjectivities on display in *Two Dancers*, indicates Simon's response to how African American women were influencing developments in modern dance between the 1930s and the 1950s. For example, it is likely that the artist was aware of the work of Edna Guy (1907–1982), an important figure in advancing Black dance during the 1930s.[116] She worked to uplift the image of Black Americans—a key goal of the New Negro Movement—through her chosen medium of concert dance performance. Consistent with broader developments in the early twentieth century, Guy also integrated influences from the continent of Asia as well as the Pacific Islands. She co-directed the First Negro Dance Recital in America in 1931, in which she performed a piece titled *A Figure from Angkor Wat*.[117] And in 1937 Guy co-produced *Negro Dance Evening*, which featured Katherine Dunham's company.[118] In the same year she organized *Dance International*, which premiered at Rockefeller Center. As these productions took place in New York, it is likely that Simon may have seen some of them. Most recently, a rare photograph of Edna Guy by Japanese-American photographer Soichi Sunami (1885–1971) was rediscovered (fig. 20). It portrays Guy dressed in an Indian sari, her arms and hands poised in traditional gestures of Indian dance. It is possibly a portrayal of her costume for *A Figure from Angkor Wat*.

When the Simons lived in Greenwich Village between 1947 and 1950, the artist was working on his MA at New York University, where he took two courses in stage design and one course in costume design.[119] According to Virginia Simon, the set design course resulted in an invitation to tea for the entire family from the sculptor Isamu Noguchi in his studio in Washington Square Mews.[120] In return, Noguchi later attended one of the Simons' parties at 715 Washington. As a student, Simon was able to get reduced-rate student tickets to many of the art exhibitions and cultural performances in New York. The Simons took every advantage of these opportunities: music and museums, dance and drama were uptown, and affordable cultural experiences only a brief subway ride away. They always visited the performers backstage, whom they invariably found to be appreciative of their interest.

Fig. 20 Soichi Sunami (Japanese-American, 1885–1971), *Edna Guy*, New York, ca. 1931. Gelatin silver print, 9½ × 7 inches. The Morgan Library & Museum, New York. Purchased as the gift of Douglas Troob, 2018.130.

The Simons attended the dance recitals of the City Center Ballet and saw "wondrous" performances by Martha Graham and African American dancer Katherine Dunham.[121]

Simon began his series on dance in 1951 when Black women pioneers were achieving some success in breaking racial barriers. Janet Collins, one of very few Black women prominent in American classical ballet, was hired as a principal dancer at the Metropolitan Opera House in 1951. During the 1940s, Pearl Primus carried out pioneering research in the West Indies and Africa, fusing African dance forms with ballet techniques and modern dance. Upon her return to the United States in 1951, she presented many performances based on the dances and rituals she had studied. By the 1950s, Katherine Dunham had achieved the highest recognition in America and Europe as a dancer, choreographer, and anthropologist.[122] Dunham's ethnographic practice "restaged native dances into concert dance."[123] She formed the Katherine Dunham Dance Company in 1940, touring the world and performing dances she had choreographed. The Dunham School of Arts and Research was established in New York City in 1943, offering courses in dance, theater, and world cultures. Choreographed dances include *L'Ag'Ya* (1938), *Le Jazz Hot* (1939), *Tropics* (1939), *Bal Nègre* (1943), *Tropical Revue* (1943), and *Shango* (1945).[124] She published three books, the first being *Journey to Accompong* in 1946. Dunham's scholarly work included lectures and demonstrations at institutions including the University of Chicago and Yale University. She also performed in cinema, choreographing a piece for *Stormy Weather* in 1943 that was a "blend of modern dance and ballet movements with Spanish and Oriental touches."[125]

Dunham integrated gestures and movements from African and Caribbean ritual dance, Black American vernacular dance, and European ballet. Although known primarily for her exploration of the African diaspora, Dunham was influenced by Pacific Island dance performance, Hindu and Javanese dance, and yoga positions and movements. Dunham's innovations, strongly based in classical ballet, demanded a meticulous training of movement related to each part of the body: the head, foot, neck, shoulder, leg, hand, spine, etc.[126] As in ballet, the movements were controlled and slow, requiring stamina and skill. Each movement was fully articulated before it flowed into more complex progressions or series of orderly movements. Fluid movements centered around a relaxed upper body and pelvis, arms raised and bent at the elbow.[127] Small gestures of the body swept into larger gestures of movement.[128] The action of modern dance is understood to be made up of such streams of movement and pauses.

These influences might help determine how the figures in *Khambavati* express something different compared to the female subjects in *String Dance #1* and *String Dance #2*. The female dancer's upright back is juxtaposed against the vertical axis of the male dancer's body as if posed in a ballet barre exercise. In the Dunham technique, working from this position enabled torso isolations that stressed percussive and undulating movements characteristic of African dance. Progressions of movements specific to the Dunham technique included second-position jumps, prances, walks,

and elevations (jumps)—all movements rooted in the earth. Much of African dance is often described as "earth centered," as opposed to the ethereal, leaping effects common to European dance forms like ballet. This basic formation in African dance was a means of drawing upon the supernatural force of the earth.[129] Here, the female dancer is aligned against the male but holds her arms in a relaxed manner, elbows slightly bent, and the hands held straight down with fingers closed in a more rigid position, as if they are about to be raised above the head. The elevated position of her bent right leg with pointed foot and toes indicates she is prepared to execute a more complicated series of movements, possibly one of the secondary jumps associated with the Dunham technique. The female dancer, as compared to the male, is therefore more emblematic of the strong-bodied, graceful dancers who executed Katherine Dunham's sinuous choreography.

Simon discusses the relationship depicted between female and male in a one-page analysis of *Khambavati* titled "Two Dancers." He describes his painting as a celebration of "female strength, power, and majesty." The male dancer is a passive figure, emerging from the abstract background to be "dominated" by the female. The contrast in character between the two is evident in the use of dark colors behind the male, while the female side of the canvas exhibits light pastel shades of color and what Simon defines as more "expansive abstract designs." The blackened shades around the male's feet and legs anchor him to the spot, while the female figure, with her leg raised high, is positioned to move forward. Simon explains that the colors and abstractions around the head of the male dancer express his struggle in opposition to the female dancer, who is "poised gracefully and squarely."[130] Although Simon does not mention the significance of gesture in communicating emotional content, the male dancer simply standing behind the female with raised arm and elegant hand gently touching his face (impassive and turned away) altogether conveys a sense of passive nonengagement. This interpretation of the subject still intersects with Simon's discussion of his work, intended to express the feelings of tension between the two, activated by the strength of the female dancer.

Conclusion

Walter Augustus Simon was a talented artist, art educator, and art historian who entered the professional arts at a time when his mentor and colleague Hale Woodruff was urging Black artists to compete on an equal playing field with White artists. Woodruff emphasized the importance of integrating the academy, cultural institutions, and the marketplace, arguing that the arts inherently encouraged social change and that high-quality work eventually would be accepted by mainstream culture.[131] Simon was uniquely suited to meet this challenge. Born in Brooklyn, New York, in 1916, he earned professional certificates in commercial design and fine arts from Pratt Institute and the National Academy of Design and bachelor's and master's degrees in art education from New York University. In 1961 Simon was awarded a PhD in art history from New York University. He began his undergraduate studies as an accomplished painter in traditional portraiture and murals. Simon emerged from his graduate studies as an Abstract Expressionist, having embraced modernism at the height of its development as New York City became the epicenter of contemporary art. His multifaceted career as an artist, educator, and art historian was distinctly enriched by a decade abroad as a cultural affairs officer in the United States Information Agency (USIA) during the 1960s.

Notes

1. See L. D. Reddick, "Walter Simon: The Socialization of an American Negro Artist," *Phylon* 15, no. 4 (4th Qtr., 1954): 373–92.

2. Ibid., 375.

3. Ibid., 374.

4. Ibid., 375–76.

5. Ibid., 378.

6. "14-Year-Old Artist Prodigy Hopes to Study in Paris," *Brooklyn Daily*, 1930, newspaper clipping in Walter Simon MSS 1057, Box 1-1 (Youth, periodicals and photographs, 1916–1940), Walter Augustus Simon Papers, Stuart A. Rose Manuscript, Archives, and Rare Book Library, Emory University, Atlanta (hereafter cited as Simon MSS).

7. Ibid.

8. Ibid.

9. "Art Prodigy, 16, Doing Roosevelt in Portrait Piece," *Brooklyn Daily*, August 14, 1932, newspaper clipping in Simon MSS 1057, Box 1-1.

10. "The Scottsboro Defense Attorney," *The American Experience*, https://www.pbs.org /wgbh/americanexperience /features/scottsboro-defense -attorney-samuel-leibowitz/.

11. See "Fiorello La Guardia: Mayor of New York City," *Encyclopedia Britannica*, last modified December 7, 2020, https://www.britannica.com /biography/Fiorello-H-La -Guardia.

12. *The New Yorker*, June 2, 1934, p. 14.

13. See Virginia Simon, "Walter Augustus Simon: 1916–1979," unpublished article for *International Review of African American Art: Special Issue on Master Artists at Colleges and Universities* (July 1997), Simon MSS 1057, Box 1-4 (Art prints, featured articles, biographical literature, 1938–2014), Walter Augustus Simon Papers.

14. Reddick, 380.

15. *The Art News*, Simon MSS 1070, Box 1-1.

16. Ibid.

17. Virginia Simon, "Walter Augustus Simon," p. 2. Find extensive documents on Simon's experience as a Black soldier and officer in World War II in Simon MSS 1057, Boxes 1-6 to Box 1-10 and Boxes 2-1 to 2-5.

18. Ibid.

19. See Richard Neuberger, "ALCAN Epic," Simon MSS 1057, Box 1-7.

20. Virginia Simon, "Walter Augustus Simon," pp. 2–3. See also Simon's military records, which describe his occupational specialties as "regimental draftsman," "topographic drafting," and "engineer unit commander," in Box 1-7.

21. Reddick, 383.

22. Virginia Simon, "Walter Augustus Simon," 3.

23. Correspondence with Virginia Spottswood Simon, 1941, Simon MSS 1057, Box 2-1.

24. Ibid.

25. Ibid.

26. Reddick, 385.

27. Ibid., 383.

28. Correspondence, Simon MSS 1057, Box 2-1.

29. "Some References to Race, Racism, Social Consciousness in the Wartime Letters of Walter A. Simon," 1–5, in Correspondence, Simon MSS 1057, Box 2-1.

30. Reddick, 388.

31. Virginia Simon, "Greenwich Village: 1946–1949: A Reminiscence," *The International Review of American Art* 15, no. 2 (1998): 29–36.

32. Ibid., 34–35.

33. Thesis committee members identified from title page of thesis proposal for the Ph.D. degree, Simon MSS 1057, Box 5-7.

34. Notes from Museum of Modern Art Conference panel in which Simon participated, held at Paterson State Teachers College (March 1955), p. 15, Simon MSS 1057, Box 4-6.

35. Simon MSS 1057, Box 4-4.

36. Ibid., pp. 4–5.

37. For a current discussion on Black artists and modernism, see Sarah Lewis, "African American Abstraction," in Eddie Chambers, ed., *The Routledge Companion to African American Art History* (New York: Routledge Taylor & Francis Group, 2020), 159–73.

38. Virginia Simon, "Greenwich Village," 32.

39. Ibid. For more documents pertaining to the Unity Council, see Simon MSS 1057, Box 4-3.

40. For more on Woodruff's work with abstraction and African art, see John Ott, *The Art Bulletin* 100, no. 1 (March 2018): 124–45.

41. Walter Simon, "Chapter IV: The Non-Representational Phase Analyzed," pp. 45–50, in the unpublished thesis "An Analytical Study of Comparable Factors in Representational and Non-Representational Modern Painting: A Survey of Certain Selected Modern Paintings as an Aid in Cataloging the Modern Movements in Contemporary Art," 1–94, Simon MSS 1057, Box 4-4.

42. Simon, "An Analytical Study of Comparable Factors in Representational and Non-Representational Modern Painting," 45–48.

43. Ibid., 46–47.

44. Ibid.

45. Ibid., 48.

46. Notes from Museum of Modern Art Conference panel, pp. 1–15, Simon MSS 1057, Box 4-6.

47. Virginia Simon, *Obituary: Walter A. Simon*, Simon MSS 1057, Box 15-6.

48. The artwork was most recently discussed in reference to its purchase by the Museum of Fine Arts, Boston, in the article "13 Artist Records Set at Swann Galleries' African American Fine Art Auction," *Antiques and Arts Weekly*, November 21, 2008. The Museum of Fine Arts, Boston, purchased *715 Washington Street, Greenwich Village* for $36,000, then a record price for a work by the artist. At that time, the MFA also purchased an "untitled abstract expressionist oil on canvas" by Norman Lewis for $312,000. It was not only an auction record for Lewis but the "highest price ever realized at auction" for an abstract painting by a "Modern African American artist."

49. Atlanta University Summer School Bulletin, 1948, p. 8, Simon MSS 1057, Box 4-1.

50. Ibid., p. 31.

51. Ibid.

52. Reddick, 389.

53. Atlanta University Summer School, p. 9.

54. Ibid.

55. Museum of Modern Art Conference panel, pp. 1–15, Simon MSS 1057, Box 4-6.

56. Ibid., p. 5.

57. Cedric Dover, *American Negro Art* (New York: New York Graphic Society, 1966), 51.

58. "Biographical Data," pp. 1–3, Simon MSS 1057, Box 5-2 (Paterson State College, clippings and correspondence, 1956–1958).

59. *The Tiger: Georgia State College, Savannah, Georgia*, p. 25, Simon MSS 1057, Box 4-2 (Georgia State College, bulletin, clippings and photographs, 1948–1949).

60. "Exhibit #: Report Dated 10-22-52, Made by Confidential Informant 'A' in the Case of Walter A. Simon," p. 4. This is one of several investigative reports conducted on Simon as part of his application for foreign service. See Simon MSS 1075, Box 6-2 (Department of Justice and the Federal Bureau of Investigation, correspondence and records of employment, 1952–1977).

61. "Biographical Data," pp. 1–3, Simon MSS 1057, Box 5-2.

62. Reddick, 390.

63. Virginia Simon, "Concerning Walter Simon's Connection with Robert M. Jackson, Lady Eve Balfour and Robert M. Jackson Collection of Rare Books and Art Objects at Virginia State College," Simon MSS 1057, Box 4-5 (Virginia State College, correspondence and clippings, 1949–1953).

64. Catalogue for an exhibition of a gift presented to the College by Mr. Robert M. Jackson, Simon MSS 1057, Box 4-5.

65. Ibid.

66. American Friends Service Committee brochure, Simon MSS 1057, Box 4-5.

67. Ibid.

68. Correspondence with Chester Bowles, April 12, 1954, in Simon MSS 1057, Box 4-5.

69. Reddick, 390.

70. Two letters from President Daniel on Virginia State College letterhead, along with Simon's resignation letter deal, are linked to this situation but do not reveal details, Simon MSS 1057, Box 4-5.

71. Resignation letter dated May 7, 1953, Simon MSS 1057, Box 4-5.

72. Virginia Simon, "Walter Augustus Simon," p. 4.

73. See syllabi for these courses, which Simon refers to as "course outlines," in Simon MSS 1057, Boxes 4-6 and 4-7.

74. Simon MSS 1057, Box 4-6.

75. Ibid.

76. Museum of Modern Art Conference, Simon MSS 1057, Box 4-6, p. 15.

77. Simon MSS 1057, Box 5-7 (New York University, clippings, correspondence and research papers, 1957–1961).

78. "Art Instructor at Paterson State Teachers College Completing Giant Mural for Cafeteria," newspaper clipping, Simon MSS 1057, Box 4-7.

79. Boochever Art Collection pamphlet, Simon MSS 1057, Box 5-3.

80. This is in marked contrast to the situation at Virginia State College, where the fine arts collection Robert Johnson donated to the school—consisting largely of works by Walter Simon—is no longer extant.

81. Simon MSS 1057, Box 5-3.

82. North Carolina Scholastic Art Exhibition, 1954 brochure, p. 4, Simon MSS 1057, Box 4-7.

83. *Salem Journal*, February 13, 1954, Simon MSS 1057, Box 4-7.

84. Ibid.

85. "Walter Simon to Lead Conference Seminar," *The Montclair Times*, March 10, 1955, Simon MSS 1057, Box 4-6.

86. Ibid.

87. Simon MSS 1057, Box 4-7.

88. See Atomic Energy Commission contract and other related papers, including the newspaper article "Radiological Unit Will Be Exhibited," in the *Montclair Times*, July 28, 1955, in Simon MSS 1057, Box 4-7.

89. Ibid.; see newspaper clipping "Eisenhower Sees Brooklyn Native's Exhibit at Summit," *Amsterdam News/Brooklyn-Queens New York*, Saturday, August 6, 1955.

90. Simon MSS 1057, Box 5-2.

91. Ibid.; see letter addressed to Mr. L. W. Fay, Overseas Division, Proctor & Gamble Company, March 31, 1958.

92. See Erika Doss, *Twentieth-Century American Art* (Oxford: Oxford University Press, 2002), 114–37.

93. Ibid., 119–20.

94. Lisa Farrington, *African American Art: A Visual and Cultural History* (Oxford: Oxford University Press, 2017), 217–44.

95. Letter dated April 19, 1949, from the Office of the President, Atlanta University, Simon MS 1057, Box 4-5.

96. Letter dated April 18, 1951 from the Office of the President, Atlanta University, Simon MS 1057, Box 4-5.

97. Letter dated April 27, 1953 from the Office of the President, Atlanta University, Simon MS 1057, Box 4-5.

98. Virginia Simon, "Walter Augustus Simon," 8.

99. "Local Museum to Show Work of 110 Artists," *Richmond Times Dispatch*, April 18, 1951, Simon MSS 1057, Box 5-2.

100. Ibid.

101. Virginia Simon, "Virginia Museum Purchases 'Pier 27,'" Simon MSS 1057, Box 1-4 (Art prints, featured articles, biographical literature, 1938–2014).

102. Ibid.

103. Virginia Simon, "Greenwich Village," p. 34, Simon MSS 1057, Box 1-4.

104. Ibid.

105. Drafting Course for Enlisted Men—The Engineer School, 1942, Simon MSS, Box 1-8 (World War II, Officers Training School, Fort Belvoir, Virginia, Records, 1942).

106. Dover, 50.

107. Ibid., 112.

108. Lisa Farrington, *African American Art*, 230.

109. Judith E. Stein, "Figuring Out the Fifties: Aspects of Figuration in New York, 1950–1964," in *The Figurative Fifties: New York Figurative Expressionism* (Newport Beach, California: Newport Harbor Art Museum, 1988), 37–51.

110. See Barbara Haskell, *The American Century: Art & Culture, 1900–1950* (New York: Whitney Museum of American Art and W.W. Norton & Company, 1999), 307–8, 345–46.

111. Ibid., 33–35.

112. Ibid., 345.

113. Ibid., 307.

114. Two Evenings of Indian Dance program, Simon MSS 1057, Box 5-1.

115. See "Deepak Raja's World of Hindustani Music," http://swaratala.blogspot.com/2011/05/raga-khambavati-jhinjhoti-sibling.html.

116. See John O. Perpener, *African-American Concert Dance: The Harlem Renaissance and Beyond* (Urbana: University of Illinois Press, 2001).

117. Ibid., 37.

118. Ibid., 121.

119. Office of the Registrar/New York University, Simon MSS 1057, Box 1-2 (Personal records, including school documents, death certificate, will and passport, 1932–1980).

120. Virginia Simon, "Greenwich Village," 35.

121. Ibid.

122. Leila Keough, "Katherine Dunham," in *Africana: The Encyclopedia of the African and African American Experience*, ed. Kwame Anthony Appiah and Henry Louis Gates Jr. (New York: Basic Civitas Books, 1999), 640–41.

123. Elizabeth Chin, "Historical Review: Katherine Dunham's Dance as Public Anthropology, *American Anthropologist* 112, no. 4 (December 2010): 640–42.

124. Keough, 641.

125. "Notes on *Stormy Weather*," Selections from the Katherine Dunham Collection at the Library of Congress, https://memory.loc.gov/diglib/ihas/html/dunham/dunham-notes-stormy-weather.html.

126. Stephanie L. Batiste, "Dunham Possessed: Ethnographic Bodies, Movement, and Transnational Constructions of Blackness," *The Journal of Haitian Studies* 13, no. 2 (Fall 2002): 8–22.

127. Shane Vogel, "'Stormy Weather': Ethel Waters, Lena Horne, and Katherine Dunham," *South Central Revue* 25, no. 1, *Staging Modernism* (Spring 2008): 93–113.

128. Batiste, 16–17, 20.

129. "Essence of African Dance," in "African Dance: Essence of African Dance," in *New World Encyclopedia*, https://www.newworld encyclopedia.org/entry /african_dance.

130. Simon MSS 1057, Box 5-2.

131. Sharif Bey, "Aaron Douglas and Hale Woodruff, African American Art Education, Gallery Work, and Expanded Pedagogy," *Studies in Art Education* 52, no. 2 (Winter 2011): 112–126.

132. For curriculum vita, see folder "Personal Records including School Documents and Death Certificate," in Walter Simon MSS 1057, Box 1-2.

133. Simon MSS 1057, Box 1-2.

Catalogue of the Exhibition

Cat. 1
Vertis Hayes
American, 1911–2000
The Lynchers, ca. 1930s
Oil on canvas
19½ × 15¼ inches
Georgia Museum of Art,
University of Georgia; The
Larry D. and Brenda A.
Thompson Collection of
African American Art, GMOA
2012.127

Cat. 2
Augusta Savage
American, 1892–1962
Gamin, ca. 1930
Plaster
9 × 5¾ × 3½ inches
Dixon Gallery and Gardens;
Museum purchase, 2013.2

Cat. 3
Archibald John Motley Jr.
American, 1891–1981
Brown Girl After the Bath,
1931
Oil on canvas
48¼ × 36 inches
Columbus Museum of Art,
Ohio; Gift of an anonymous
donor, 2007.015

Cat. 4
Hale Woodruff
American, 1900–1980
*Untitled (Autumn in
Georgia)*, 1931
Oil on canvas
20 × 24 inches
Museum Collections, Uni-
versity of Delaware Library,
Museums and Press, Univer-
sity Purchase, 2006

Cat. 5
Allan Rohan Crite
American, 1910–2007
Late Afternoon, 1934
Oil on canvas
32⁵⁄₁₆ × 24³⁄₁₆ inches
Boston Athenæum, Gift
of the artist, 1971, UR77

Cat. 6
Archibald John Motley Jr.
American, 1891–1981
Jazz Singers, ca. 1934
Oil on canvas
32⅛ × 42½ inches
The Federal Art Project
Collection of Western Illinois
University
Courtesy of the Fine Arts
Program, U.S. General Ser-
vices Administration
New Deal Art Project

Cat. 7
Claude Clark
American, 1915–2001
In the Groove, 1934–43
Lithograph
12½ × 9½ inches
Private collection, Memphis

Cat. 8
Hale Woodruff
American, 1900–1980
Giddap, 1935
Linoleum cut with chine
collé
12 × 9 inches
LeMoyne-Owen College

Cat. 9
Hale Woodruff
American, 1900–1980
By Parties Unknown, 1935
Linoleum cut with chine
collé
11¹⁵⁄₁₆ × 8⅞ inches
LeMoyne-Owen College

Cat. 10
Nancy Elizabeth Prophet
American, 1890–1960
Walk among the Lilies,
ca. 1935
Polychromed wood panel
24 × 18 × 2¼ inches
Private collection

Cat. 11
Charles White
American, 1918–1979
Lust for Bread, 1935–45
Oil on canvas
15 × 11 inches
Jonathan Green Studios, LLC

Cat. 12
Charles Sebree
American, 1914–1985
Still Life, 1936
Oil on canvas
24 × 30 inches
Private collection

Cat. 13
Beulah Woodard
American, 1895–1955
Maudelle, 1937
Painted terra-cotta
12 × 12 inches
Petrucci Family Foundation
Collection of African American Art, PFF216

Cat. 14
Walter Ellison
American, 1899–1977
Just Business, ca. 1940
Oil on paperboard
18 × 24 inches
The John and Susan
Horseman Foundation for
American Art

Cat. 15
Vertis Hayes
American, 1911–2000
Untitled, ca. 1940s
Mixed media on canvas
36¼ × 44 inches
LeMoyne-Owen College

Cat. 16
Aaron Douglas
American, 1899–1979
Portrait of a Lady, ca. 1940
Oil on canvas
20¼ × 24 inches
LeMoyne-Owen College

Cat. 17
Rex Goreleigh
American, 1902–1986
The Mourners, 1940
Oil on canvas
37 × 32 inches
Collection Thom Pegg,
St. Louis

Cat. 18
Laura Wheeler Waring
American, 1887–1948
After Sunday Service, 1940
Oil on canvas
30 × 14½ inches
Petrucci Family Foundation
Collection of African American Art, PFF231

Cat. 19
Laura Wheeler Waring
American, 1887–1948
Woman with Bouquet,
ca. 1940
Oil on canvas
30 × 25 inches
Brooklyn Museum; Brooklyn
Museum Fund for African
American Art in honor of
Teresa A. Carbone, 2016.2

Cat. 20
William H. Johnson
American, 1901–1970
Sowing, 1940
Gouache
10¼ × 14 inches
The James E. Lewis Museum
of Art, Morgan State University, Baltimore

Cat. 21
John Biggers
American, 1924–2001
The Mandolin Player, 1940s
Oil on canvas
Framed: 36 × 26 × 1 inches
The Charles H. Wright
Museum of African American History, Detroit

Cat. 22
Frederick D. Jones Jr.
American, 1913–1996
Madonna Moderne, undated
Oil on canvas
23½ × 11½ inches
Clark Atlanta University Art
Museum, 1954.003

Cat. 23
Elmer Brown
American, 1909–1971
Gandy Dancer's Gal, 1942
Oil on canvas
24 × 32 inches
ARTneo; Gift of the Elmer
Brown Estate

Cat. 24
John Wilson
American, born 1922
Deliver Us from Evil, 1943
Graphite on paper
19 × 21 inches
Collection of Kimberly and
Elliot Perry

Cat. 25
Loïs Mailou Jones
American, 1905–1998
Eusebia Cosme, 1944
Oil on canvas
22 × 15½ inches
Private collection

Cat. 26
Jacob Lawrence
American, 1917–2000
*No. 2, Main Control Panel,
Nerve Center of Ship*, 1944
Watercolor and gouache
on paper
20 × 24 inches
United States Coast Guard
Heritage Asset Collection

Cat. 27
Samella Lewis
American, born 1924
Water Boy, 1944
Oil on canvas
47⅛ × 39 inches
Hampton University
Museum, Hampton, VA

Cat. 28
Horace Pippin
American, 1888–1946
Holy Mountain I, 1944
Oil on canvas
30½ × 36 inches
Art Bridges

Cat. 29
Claude Clark
American, 1915–2001
The Runner, 1945
Oil on board
21 × 20 inches
Collection of Kimberly and
Elliot Perry

Cat. 30
Thelma Johnson Streat
American, 1912–1959
Baby on Bird (Untitled),
ca. 1945
Oil on panel
20 × 28 inches
The John and Susan
Horseman Foundation for
American Art

Cat. 31
Elizabeth Catlett
American, 1915–2012
Pensive [Bust of a Woman],
1946, recast 1995
Bronze
18 × 9⅜ × 9 inches
Eli and Edythe Broad Art
Museum, Michigan State
University; purchase, funded
by the Friends of Kresge
Art Museum Endowment,
Offices of the Vice President
for Research and Graduate
Studies and the Dean of the
College of Arts and Letters,
MSU Development Fund,
Blue Care Network/Health
Central, 95.11

Cat. 32
Rose Piper
American, 1917–2005
The Death of Bessie Smith,
1947
Oil on canvas
25 × 30 inches
The John and Susan
Horseman Foundation for
American Art

Cat. 33
Walter Augustus Simon
American, 1916–1979
Lines from François Villon #1,
1948
Casein on board
23¼ × 13 inches
Private collection

Cat. 34
Eldzier Cortor
American, 1916–2015
Southern Souvenir No. II,
ca. 1948
Oil on board mounted on
Masonite on wood strainer
21 × 50 inches
Art Bridges

Cat. 35
Archibald John Motley Jr.
American, 1891–1981
Bronzeville at Night, 1949
Oil on canvas
30 × 40 inches
Art Bridges

Cat. 36
Hooks Brothers
Photography
American, active 1907–1979
*Rev. Brewster at Pilgrim
Baptist Church Preaching in
front of Vertis Hayes Mural*,
1949
Gelatin silver print
8 × 10 inches
Private collection, Memphis

Cat. 37
Charles Alston
American, 1907–1977
Jazz, ca. 1950
Oil on canvas
40 × 30 inches
Private collection

Cat. 38
Walter Augustus Simon
American, 1916–1979
String Dance #2, 1951
Oil on canvas
32 × 27 inches
Private collection

Cat. 39
Charles White
American, 1918–1979
Our Land, 1951
Tempera on panel
24 × 20 inches
Art Bridges

Cat. 40
Norman Lewis
American, 1909–1979
Untitled, 1952
Oil on linen
20 × 28 inches
Collection of Kimberly and
Elliot Perry

Cat. 41
Hale Woodruff
American, 1900–1980
Four Figurations, 1969
Oil on canvas
60 × 71 inches
Spelman College Museum
of Fine Art, Atlanta

Cat. 42
Hooks Brothers
Photography
American, active 1907–1979
*Unidentified Church with
Mural*, 1952
Gelatin silver print
7½ × 9½ inches
Private collection, Memphis

Cat. 43
Hooks Brothers
Photography
American, active 1907–1979
*Chairman of Lemoyne
Alumni Day*, published in
Memphis World, February 15,
1952
Gelatin silver print
7⅝ × 9½ inches
Memphis Brooks Museum of
Art, Memphis, TN; Memphis
Brooks Museum of Art
purchase; funds provided
by Sara and Kevin Adams,
Deupree Family Foundation,
Henry and Lynne Turley,
Kaywin Feldman and Jim
Lutz, and Marina Pacini and
David McCarthy, 2006.31.129

Cat. 44
Ernest Crichlow
American, 1914–2005
Harriet, 1953
Gouache on board
17 × 13 inches
Collection of Kimberly and
Elliot Perry

Cat. 45
Jacob Lawrence
American, 1917–2000
Harlem Hospital Surgery,
1953
Egg tempera on hardboard
20 × 24 inches
Private collection

Cat. 46
Walter Augustus Simon
American, 1916–1979
Khambavati, 1953
Oil on wood panel
48 × 24 inches
Private collection

Cat. 47
Hughie Lee-Smith
American, 1915–1999
Contemplating My Future,
1954
Oil on canvas
24 × 36 inches
The John and Susan
Horseman Foundation
for American Art

Cat. 48
Irene Clark
American, 1927–1980
A Mansion at Prairie Avenue,
ca. 1955
Oil on plywood
14¼ × 13 inches
The Art Institute of Chicago,
Walter M. Campana Memo-
rial Prize Fund, 2003.40

Cat. 49
Reginald A. Morris
American, 1920–1997
Salvator Mundi, 1956–57
Oil on canvas
2 panels at
36 × 48 inches each
2 panels at
98 × 39 inches each
1 panel at 108 × 52 inches
Second Congregational
Church, Memphis

Cat. 50
Walter Augustus Simon
American, 1916–1979
*Abstraction with Woman's
Head or Cinema*, 1958
Casein on board
9 × 14½ inches
Private collection

Index

This publication was produced in conjunction with the exhibition *Black Artists in America: From the Great Depression to Civil Rights*, on view at the Dixon Gallery and Gardens, Memphis, from October 17, 2021, through January 2, 2022.

Dixon Gallery and Gardens
4339 Park Avenue
Memphis, TN 38117
(901) 761-5250
www.dixon.org

Published in association with
Yale University Press
302 Temple Street
P.O. Box 209040
New Haven, CT 06520-9040
www.yalebooks.com/art

Library of Congress Cataloging-in-Publication Data
Names: Jenkins, Earnestine, author. | Sharp, Kevin, 1957– writer of foreword. | Dixon Gallery and Gardens, organizer, host institution.
Title: Black artists in America : from the Great Depression to civil rights / Earnestine Lovelle Jenkins.
Description: Memphis, Tennessee : Dixon Gallery and Gardens, [2021] | Includes bibliographical references and index.
Identifiers: LCCN 2021028378 | ISBN 9780300260908 (hardcover)
Subjects: LCSH: African American art—20th century—Exhibitions. | Savage, Augusta, 1892–1962—Exhibitions. | Simon, Walter Augustus, 1916–1979—Exhibitions.
Classification: LCC N6538.N5 J46 2021 | DDC 704.03/96073007476819—dc23
LC record available at https://lccn.loc.gov/2021028378

Produced by Lucia | Marquand, Seattle
 www.luciamarquand.com
Edited by Heather S. Medlock
Designed by Ryan Polich
Typeset in Söhne by Brynn Warriner
Indexed by Enid Zafran
Proofread by Bruno George
Color management by iocolor, Seattle
Printed and bound in China by Artron Art Group